CREATIVE
DRAWING
TECHNIQUES

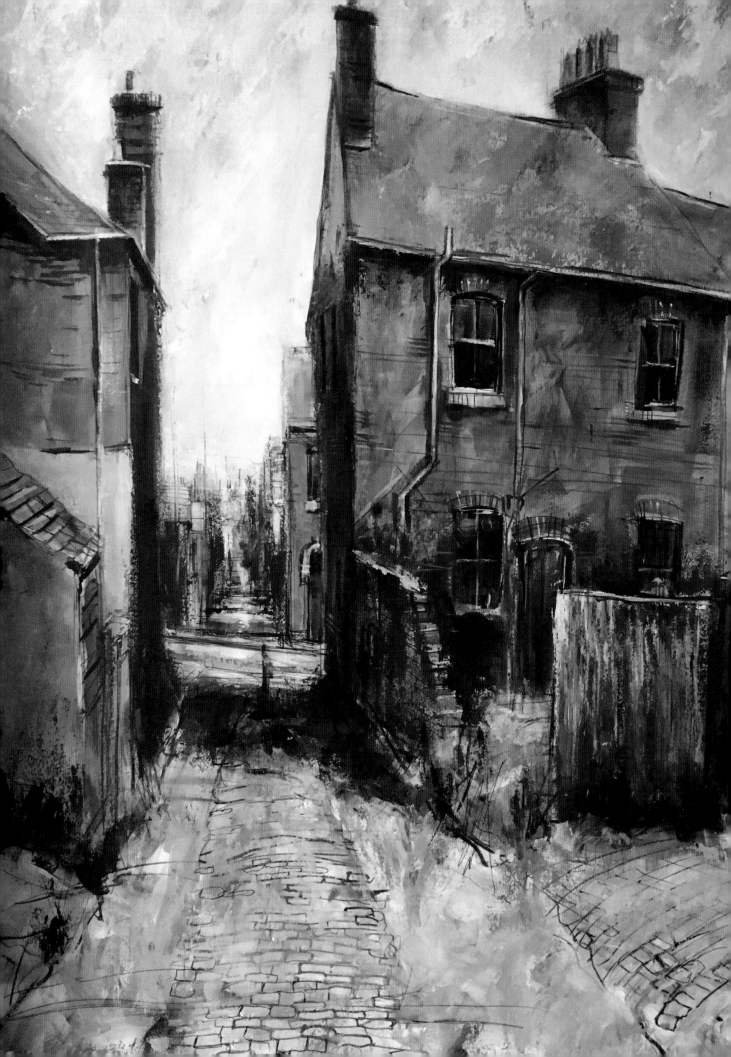

CREATIVE
DRAWING
TECHNIQUES

from **first mark**
to **full expression**

David
Brammeld

✳ THE CROWOOD PRESS

First published in 2021 by
The Crowood Press Ltd
Ramsbury, Marlborough
Wiltshire SN8 2HR

enquiries@crowood.com
www.crowood.com

British Library Cataloguing-in-Publication Data
A catalogue record for this book is available from the
British Library.

ISBN 978 1 78500 912 9

Cover design: Peggy & Co. Design
Front and back cover wraparound image: *Spring Green
(Delamere Forest)*, acrylic on board, 28 × 39cm
Frontispiece: *Potteries Memory: Alleyway*, acrylic on A1 paper.

Image credits: All photographs and illustrations by the
artist except the two top photographs on p.85, showing the
artist painting in Trentham Gardens, by kind permission of
Annette Hewetson.

Disclaimer: The views and techniques expressed in this book
are the artist's own, and have been formed by many years of
experience and experimentation, and are entirely subjective.
There are many alternative ways and different media that
can be used to achieve similar results. The intention is to
encourage the reader to explore, experiment, enjoy and find
their own personal artistic vision.

Graphic design and typesetting by Peggy & Co. Design
Printed and bound in India by Parksons Graphics

CONTENTS

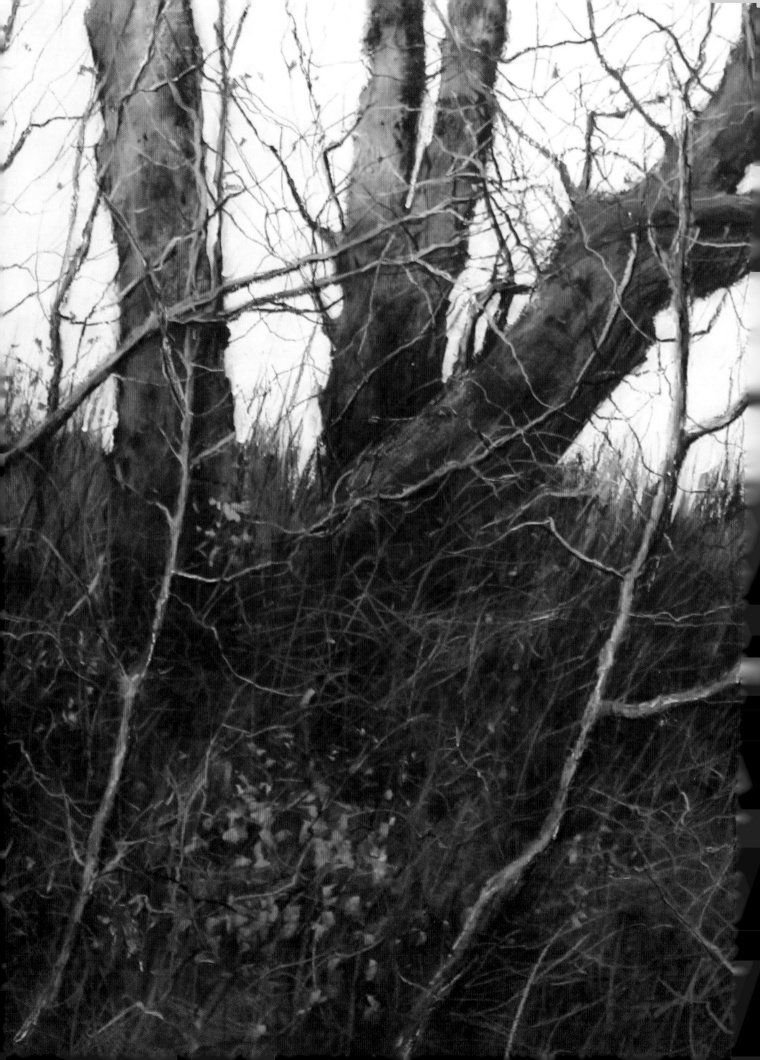

INTRODUCTION

rawing is *the* most enjoyable thing. That is a bold opening statement, but the joy of being in front of a subject that you have chosen to draw – and then of trying to figure out how to get it down on paper with a pen or pencil so that you capture something of its essence – is simultaneously frustrating, challenging, but also immensely rewarding and worthwhile.

This book's intention is to be a celebration of drawing in all its forms, and to challenge perceptions of what drawing is and what it can be. It will encourage you to experiment with new techniques to build on your existing skills, enabling you to follow a more creative path in your art. It will explain and explore creative ideas that will inspire you to try new things. Above all, it will help you find an expressive response to the chosen subject.

It is also the intention of this book to impart good practice and to give sound, practical advice informed by my many years of experimentation and development as a professional artist.

Good drawing will always be admired and revered because it is very difficult to do well. People gaze in wonder and admiration when an artist captures a likeness of a sitter with just a few well-chosen marks. Fellow artists admire different qualities of mark-making in the drawings of their peers; they acknowledge and respect good drawing. Drawings by the Old Masters will always be a source of reference, inspiration and wonder that have stood the test of time, proving that examples of good drawing have been around for a long time.

As our own drawing progresses, we develop a personal, recognizable style of mark-making that is unique to ourselves. In the same way that we have an individual handwriting style, so do we have a recognizable drawing style: our individual way of making marks.

You will find within these pages guidance on sound drawing principles and advice on the choices of materials available, so you can make informed choices as your experience grows and you seek new challenges. You will find different approaches and styles, as well as encouragement to experiment wherever possible and be more creative. The idea is to help you develop your own style through practice and experimentation.

The book is meant to be a creative resource, something you can pick up again and again as your skills develop. It will challenge you to try new things. Indeed, you will discover that it is through exploration, making mistakes and learning how to rectify these mistakes that you can make progress. A good artist always pushes forward, seeking a new challenge, and is willing to take chances.

Autumn Wood (detail), pastel on A1 paper.

A great subject to draw in its own right: the physical evidence of many hours drawing. I have a jar that I keep these worn-out pencils in. There is still more mark-making to be had from these stubs – they can be used with a pencil holder – and sometimes they are easier to draw with in certain conditions than a new pencil.

The importance of drawing

A few years ago many people were mourning that drawing was dead. As art schools removed traditional, mandatory activities like life drawing from the curriculum, a whole generation of art students began their careers without actually having been taught sound drawing skills. The focus at the time was on 'the concept' rather than traditional drawing and painting. The 'idea' was more important than 'practical' skills. Drawing from the life model was traditionally considered to be one of the best activities to develop drawing skills: proportion, form, line and tone would all be tested during the sessions. The ability to accurately represent the human figure is one of the most challenging subjects for an artist.

Thankfully that situation is no longer the case, with successful representational art societies leading the charge. The popularity of the Mall Galleries, which hosts nine top art societies, is considered the epicentre of figurative art, showcasing work by the best of this country's practitioners of representational as well as abstract art in a variety of different media, from oils, acrylics, watercolours, pastels and printmaking to sculpture and so on. In fact all wet and dry media, and in every combination. There are abundant drawing groups and organizations like urban sketchers, which are continually expanding their memberships and activities. There are many life drawing groups for all abilities. These days, many people enjoy sketching, and the popularity of social media platforms means that results can be shared in an instant.

Drawing is essential to so many creative areas – most obviously as a precursor to painting, but designers and architects rely on drawing skills to convey ideas and concepts (although much of this work is computer generated nowadays). Whether it's using a pencil, charcoal or a paintbrush, drawing can be used as a means of getting ideas down on paper to test if they will work. It can be used as a form of visual note-taking or as an art form in its own right. The addition of a little sketch adds so much more to a holiday diary, even if it's just a little scribble.

Good drawing underpins good painting: no matter how loose or impressionistic the style of painting – the marks still need to be in the right place – the drawing is the foundation.

Perhaps because drawing is undervalued by the art-buying public, the status of a painting is generally considered to have more merit than a drawing; hence the market value of a drawing isn't deemed to be as great as that of a painting. Certainly it is the view of this artist that a drawing can take considerably longer to complete than a painting, but because it is generally considered to be 'only' a work on paper, its value is perceived as lower than that of a painting on board or canvas. And yet the sketches and drawings of great artists such as Leonardo da Vinci, Peter Paul Rubens, Vincent van Gogh, Georges Seurat, Egon Schiele and Gustav Klimt are held in great esteem.

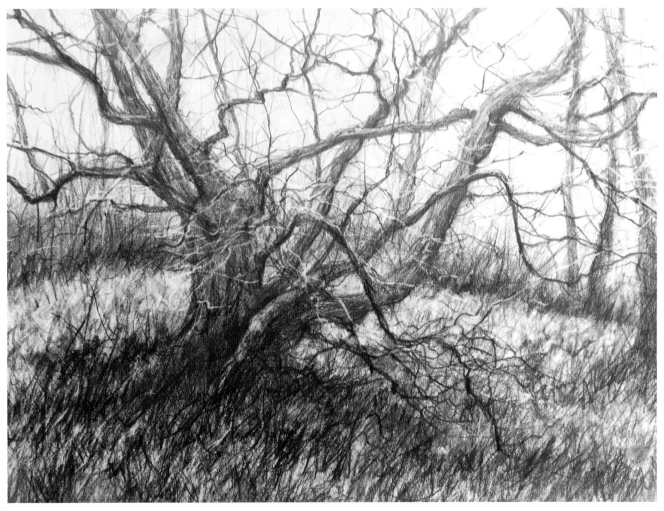

With this treescape I wanted to capture the busy energy of the tree. Absolute accuracy was not the objective. A picture can have many intentions: to convey emotion, movement, calmness and so on. Here I have used a selection of pencils and graphite sticks in a direct way to create texture and movement.

Through exploration, experimentation and studying the work in this book, the reader can find inspiration and guidance. By practising the techniques and following the advice, I hope that you will develop a new confident and creative approach. Indeed the purpose of this book is to build on your existing skills, whatever level they may be, and help you discover new techniques that will lead towards a new creative chapter in your artistic endeavours.

The book presents a logical narrative of suggesting and explaining materials, discussing subject matter, explaining visual language, encouraging best practice and care of materials. You will gain an understanding and working knowledge of techniques by following the practical projects.

There are step-by-step guides describing in detail how certain works have been made, descriptions of different media and processes, sound practical advice, and many examples of work that show spontaneity and creativity made with a passion for drawing in all its forms.

This book is the culmination of my many years' experience as a student, art tutor, artist, demonstrator and workshop leader. It imparts knowledge gained from a lifetime of experimentation, practice and discovery from trying many different media, in various combinations, and sampling a variety of subject areas and genres.

Everything contained in this book is something I have tried, tested, experienced and learned from.

David Brammeld RBA, PS, RBSA, SPDF, MAFA
www.davidbrammeld.com

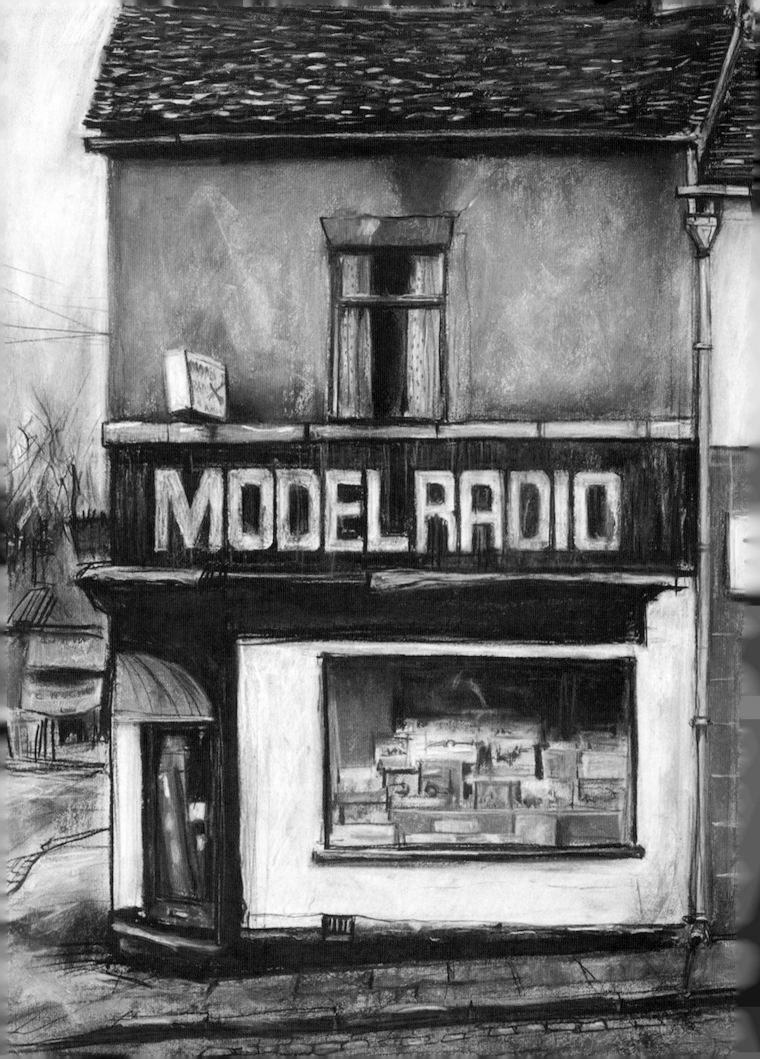

GETTING STARTED

This book does not make presumptions about a particular level of ability, about existing knowledge or skills in the reader. It aims to give inspiration and encouragement to the beginner and experienced artist alike.

Starting from this premise, it is helpful to start at the beginning, with a level playing field, explaining materials – much in the same way as a story unfolds after introducing the characters and setting the scene. It is prudent, therefore, to assume that everyone has a different starting point, since everyone has a different knowledge and experience base. The book can then guide the reader freely through the many discoveries that lie ahead.

The two separate components of drawing

It is helpful to separate the two main parts to the act of drawing:

Firstly, the technical side, which involves, for example, knowledge and handling of materials, developing and mastering skills, and so on: the practical element.

Secondly, the 'seeing' element, which involves training the eye to 'look' closely and analyze what it is we want to commit to paper. This is the cognitive element, and is about hand/eye coordination and how we learn to translate what we see. Naturally, we all see things differently. That is not to say that any one view is the definitive one; on the contrary, I want you to discover your own individual

Model Radio, pastel on A1 paper.

way of looking at and representing things, your vision. Your unique take on the world is a valuable thing and will help your work stand out from the crowd.

If you are aware of the distinction between the technical side and the creative/seeing element, it can help pinpoint areas for development.

What do I need to start drawing?

Drawing requires only the simplest and most basic of materials: a pencil, an eraser, a piece of paper, plus either a craft knife or sharpener for the pencil, and that's about it. These materials are traditional and universally used, as it is

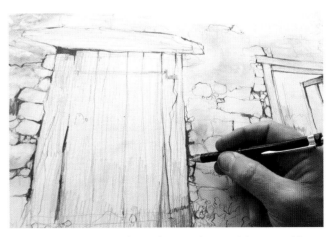

I'm working on an A2 pad of smooth creamy heavyweight paper with a mechanical pencil. Different papers give different results – most of my drawing is done on a whiter paper than this, and I also prefer a bit more 'tooth'. The drawing therefore had a different look and I found I couldn't achieve the level of tonal control that I normally take for granted. It was a beautifully smooth drawing surface, though.

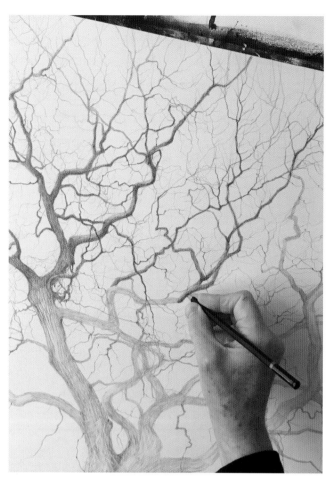

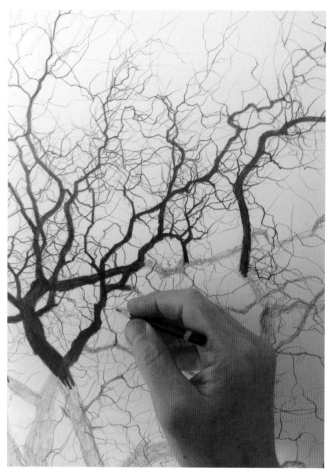

Moorland Tree in pencil. Sometimes for a change and if the right picture comes along, my response might be to produce a really 'tight' drawing: a controlled drawing where I may use just one pencil throughout, with very little eraser work. One of the challenges is to keep the white of the paper ultra clean for the sky, which is very difficult because when you are doing a lot of fine detailed work you need to rest your hand on the surface for control. The point of the pencil should be kept sharp. The drawing needs to be accurate from the very beginning because rubbing out might mark the paper.

This drawing might seem as though it was tedious to work on. Not at all – the slower pace means that marks are more considered, so there was hardly any eraser work involved. It was totally controlled with pencil pressure and layering to build tonal contrast.

natural to reach for a pencil and piece of paper when sharing a thought or explaining an idea to someone. A pencil is possibly the most widely used instrument for mark-making – it's a familiar tool. From our early days of school we have reached for a pencil to write, scribble, share ideas, make notes, draw or otherwise express ourselves.

Great results can be achieved with just a couple of pencils: a 2B and a 6B, two erasers – a hard eraser and a soft putty rubber, plus a few sheets of good quality cartridge paper or sketchbook. Of course, you will need a board and some clips or masking tape to keep the paper in place, and an easel or table to rest the board on. You will also need something to draw – your subject.

Studio or plein air?

Artists broadly fall into two distinct categories, I think: they are either studio painters – working from photos, sketches, still life, life models and so on (or a combination of these) in a well-equipped work space or at the corner of a kitchen table; or they paint 'en plein air' – working outside in all weathers and responding directly to what they see in front of them, whether it is an urban cityscape or the natural landscape.

The plein air painter is concerned with capturing a moment in time, prevailing light and weather conditions, moving objects like people, transport, cloud formations, the sea and so on. All these elements combine to give an impression of a fleeting moment in time. They are always

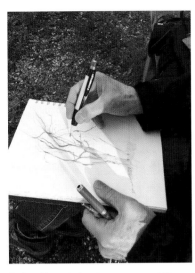

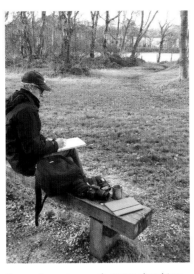

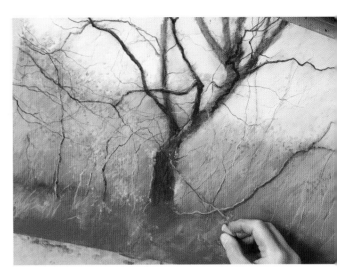

A sketching trip in winter – seemed like a good idea at the time – but the sunlight and shadows belie the fact that this was a bitterly cold day. Despite the cold fingers I managed to produce some sketches.

It was pleasant enough sitting sketching trees on a well-placed bench in a country park with camera, pencils and hot coffee, as long as the sketches were brief.

In this pastel landscape, the background layers have been built up carefully, creating opacity and variety. The main tree has been established in a loose manner and some drawing has been done to suggest smaller branches. Then it was back to the undergrowth to suggest variety and texture.

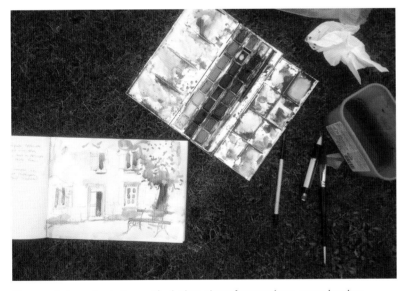

On a very hot evening in France, I had taken a box of watercolours, water, brushes and a small sketchbook to try to capture something of the beautiful ambience of my surroundings. I simply laid the sketchbook on the grass and enjoyed dribbling paint and sketching, not worrying too much about the quality of the drawing itself. Such is the emotional power of a sketch that just a few simple lines can evoke the moment when looking back. When I see this sketch it brings back the memories of people, place, ambience and so on.

Adding watercolour to these pencil studies in my sketchbook brought them to life. It was good to do this while everything was fresh in the memory. I didn't make the sketches for any other reason than the enjoyment of looking and drawing.

painting against the clock, battling against constraints of weather or light. They paint with just enough detail to give an impression of what it was like to be there in that location, at that particular moment in time – afterwards that moment is gone, the painting is finished and a new picture calls.

Studio painters have the advantage of having all their materials to hand, a controlled light source and environment, and once they are set up and ready to go they can focus on the job in hand, go for a break, and return sometime later to continue. It's a consistent, predictable way of working.

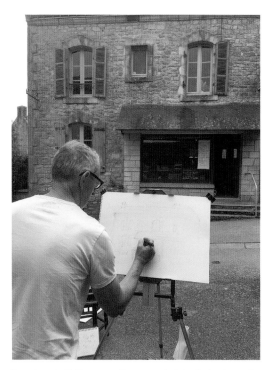

Here I am in Brittany working on a sketch of a *boulangerie*. I was planning to do a pencil drawing first, followed by watercolour washes, then pen and ink. I later applied stronger colour as the work progressed. I thought watercolour would be a good medium to enable me to work quickly and spontaneously. There was a time constraint – it was for a competition and the work had to be completed by a certain time.

In the absence of a conveniently placed seat or dry grass to sit on, a lot of my sketching is done standing. I like the feeling of being able to move around a subject easily and quickly, even though it's a bit more awkward holding the sketchbook in one hand.

It could be argued that the well-equipped and organized plein air painter also has their materials close by, but there will always be uncontrollable elements, such as the weather, intruding on time and focus. Working indoors, the studio painter has the flexibility to paint all day or night depending on preference because they have everything to hand: an image, sketch or still-life composition or life model to work from and a comparatively stable and comfortable environment in which to work. They can work for a few minutes or hours here and there as time permits or finish a work in one sitting.

The joy of drawing or painting outdoors

When I exhibited for the first time in France a few years ago, I had taken various painting materials in the boot of the car. While staying at a château for a workshop, I walked round the grounds one beautiful warm evening, looking for subjects to paint. It was a perfect location.

It was a great moment just to choose a spot, sit on the grass and sketch whatever took my interest. I worked in pencil first then dribbled some watercolour washes over the top. It was so hot that the watercolour dried rapidly on the paper and I was able to start another painting. It was a memorable moment, and when I look back through this sketchbook I am instantly transported back to that time and place.

Such is the power of a sketch (because of the input to make it), that it can evoke fond memories – the photographs I took at the same time do not connect in the same way. A photo is merely a record of an event, a reference, while a sketch is your own personal response, and therefore has more value.

The materials involved were very basic. I had a small bag with a box of watercolours, a few brushes, pencils, small sketchbook and a plastic container for water – very lightweight and not much set-up time involved. A few splashes of approximate colour over the sketch made all the difference to effectively capture the scene.

Materials to begin with

The beauty of drawing is that you don't need a lot of materials or a big budget to get started – just pencils, sharpener, eraser and paper and you're off.

Pictured below are some basic materials to get you started, but as with most things it is always best to buy quality materials from reputable manufacturers. If you buy the cheapest pencils and the cheapest paper, you will not get the best results and may end up being disappointed or disillusioned by the outcome. And you will be denying yourself the opportunity to fully experience the subtleties and different qualities of the materials and to show your abilities to best advantage.

During art classes, I have seen students bring along a cheap pad and pencils – either because they are on a tight budget or simply didn't know what to buy – and start to draw. Later, when I was giving feedback I would look at the drawing and see that the poor quality pencils combined with cheap paper meant that the student was ultimately disappointed with the result even though they may have had good ability. I would then demonstrate how a good pencil combined with quality paper worked so much better and they then realized that it was false economy to buy too cheaply. Buy the best materials you can afford to show off your skills to the best advantage.

Getting started

Pencils: To start with, work within the range of HB to 6B. In practice you should be able to do most things with just a 2B and a 6B. Avoid the harder 'H' pencils at this stage. They are fine for detailed technical work.

Erasers: Choose a good quality 'hard' eraser, and a 'putty' rubber. The hard eraser is for general work, the putty rubber for softer, more subtle work and tidying.

Sharpeners: Either a pencil sharpener or craft knife (or both). Some artists like to work with a long shaped point to the pencil. This is better for more detailed work but increases the fragility of the graphite point.

Paper: A sketchbook of either A5, A4 or A3 size, whichever size you are comfortable with (I like spiral-bound sketchbooks as the pages can fold back, making it easier to hold when sketching outdoors). Choose one with good quality, heavyweight cartridge paper – around 200gsm or heavier.

Apart from a subject to draw, this is about all you need. Later in the book, this materials list is expanded.

Some pencils to draw with, a craft knife or sharpener to keep them pointy, an eraser to make adjustments with, paper to draw on – it doesn't get much more simple or basic than this. It's all you really need to go sketching.

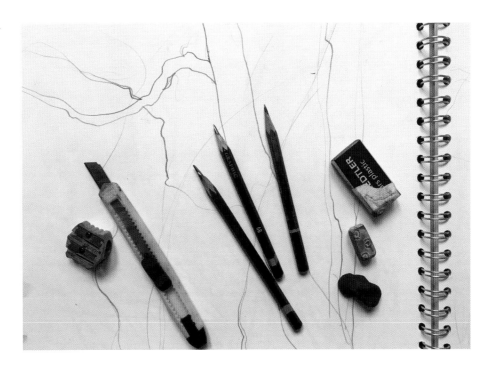

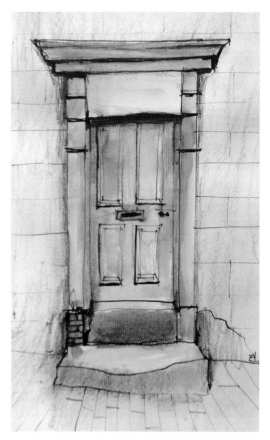

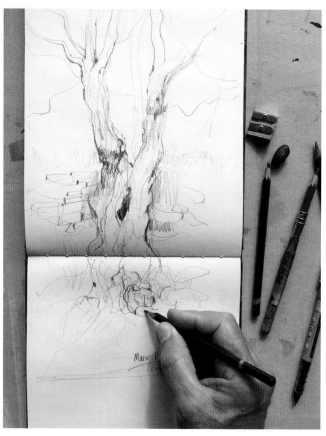

With this little study of a doorway, I added a watercolour wash on top of the drawing to help separate the door and frame from the rest of the building, purely to help me see it better. Later when I look back through the sketchbook it will give me a little reminder of colour.

Here I'm using a double-page spread in my sketchbook to fully explore this dramatic tall tree shape. Sometimes it's good to change conventional formats, for example A4, A3 and so on. I really like the potential of this format for this particular subject and it will be added to the list of paintings I must begin… I may do a further study, adding colour, to make sure it will work on a larger scale. To match the proportion of the double-page spread, I would cut down a sheet of A1 heavyweight cartridge paper.

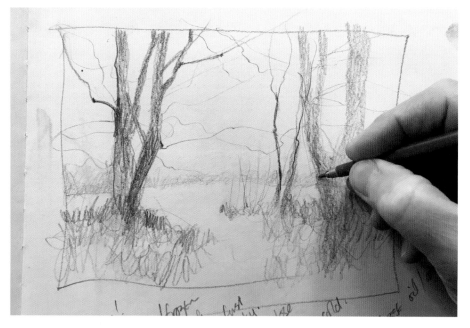

A clutch pencil is versatile for sketching. I have two or three of these in the box with different 2mm 'leads' in – 2B is a favourite for general work. A useful feature of these holders is the convenient little detachable sharpener on the end, to ensure you can always have a sharp point. Great for sketching on the move.

Testing the equipment – warming up

Before a drawing session, it's good practice to do a few warm-up exercises to get used to the pencil, make a few different marks, stretch fingers, loosen the wrist and so on.

Using an eraser can have surprising effects. Because there is always a different amount of graphite on the paper surface, it's a good idea to test it beforehand.

I also like to run through a repertoire of warm-up marks. Every time I do this I am surprised to discover new marks, so it is worthwhile doing a few quick exercises. Do this before you start your drawing and you will have broken the ice and got over making those sometimes-tentative first marks of a drawing.

I do some hatching and scribble marks, produce some flat tones, then use an eraser to cut back into these marks. This is time well spent and is actually quite enjoyable.

Produce a rough sketch

For relaxation, I will often grab a few photos, pick up a sketchbook and a mechanical pencil and just start working my way through them. I search for some good lines, interesting shapes, and compositions for future projects. It really doesn't matter how finished the sketch turns out as I am just really exploring the subject to see if it interests me enough to continue with a larger, more 'finished' work. I may work my way through a pile of images in this way, discover one or two where I can see possibilities, then do further studies of different parts of the same subject.

Sometimes I pick up a photo just to follow a few lines or shapes or perhaps to examine a few bits of interesting detail, then move straight onto the next photo and repeat the process.

This is enjoyable – there is no pressure to finish the drawing or to do the whole picture – and it gives thinking time to proceed with an idea. New ideas form quite easily if you allow yourself a little time to be immersed in the subject.

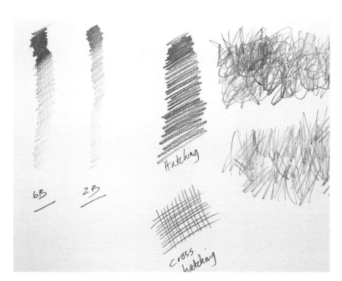

Before a drawing session I often do some warm-up marks – to get the fingers loosened up and also to get the feel of the pencil.

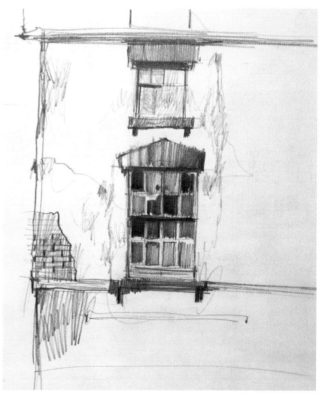

A derelict building study from my sketchbook. I am fascinated by crumbling render on buildings, when the brick structure beneath becomes exposed. Here I wanted to understand the details of the window. It was one of several studies I made before making a large graphite drawing and small acrylic painting.

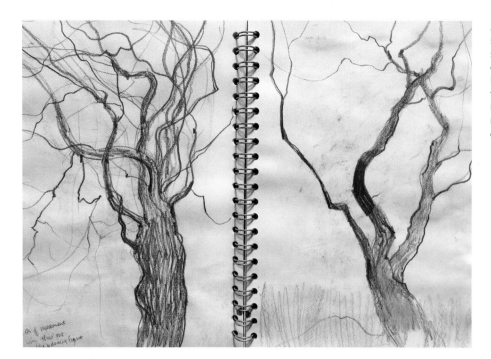

A couple of quick tree sketches, to help satisfy my endless fascination with tree shapes. They are always interesting to draw – always different. The pages are buckled with the effect of washes, and there is some offset where one drawing has rubbed off on the other, but it doesn't matter – the drawings are just for my own reference.

Taking it further

Having made several rough sketches, some will have worked out better than others and warrant further exploration. Selecting one that works well, I will draw it again, strengthen shapes and add more shading to understand the composition better, making darker and heavier lines. I might increase the tonal range to give a better visual representation of the picture.

Which pencil should I choose?

Ideally, the first marks you make on a drawing should be exploratory, and therefore soft and light to act as guidelines. As the drawing develops, the marks can become more confident and bolder. I think it's useful to keep these construction lines right up to the end of the drawing – they create visual interest and show the actual process of making the drawing – but if they bother you or look untidy then use a putty rubber to clean them. Personally, I like to see how a drawing or painting has been made, so I will often leave these exploratory marks in. The artist Euan Uglow (*see* the catalogue for his retrospective *Controlled Passion: Fifty Years of Painting*, Abbot Hall Art Gallery, Kendall) was famous for making many extra marks in his paintings to help line things up and position them. These markers became an integral part of the painting.

Using an HB or 2B to start with, the drawing is less likely to get out of control. Of course you can make similar soft marks with a 6B, but if you are not able to control the lightness of touch needed then you may discover that you are making heavy marks too soon and the drawing quickly gets out of shape. The 6B will also wear down more quickly, losing its sharpness. An HB or 2B pencil will hold its point for longer.

It's important to understand the properties of the pencil you are using so you can see why it's behaving in a certain way.

What is the difference between a soft or hard pencil?

Graphite pencils use a mixture of natural graphite powder mixed with different amounts of clay to give grades of softness or hardness. The resulting paste is extruded and dried, then sandwiched between two halves of a wooden sleeve to create a convenient writing and drawing instrument – the pencil. Major manufacturers such as Faber Castell, Derwent and Staedtler offer excellent quality pencils. Over time you will discover your own favourites.

Pencils have a rating stamped on the end that specifies their grade, for example 6B, 3H, B or HB, but what do these codes mean?

HB is a universal, standard pencil – the norm. It is a general all-purpose pencil, widely used in schools and offices.

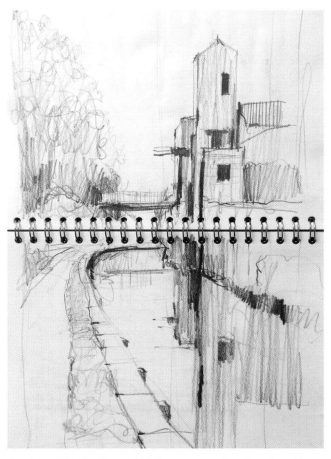

Canal scene. This derelict canalside factory is one of my favourite subjects. I have sketched, photographed and painted it many times over a period of years and changing seasons. One of the things about returning to this place is that it is always different: the foliage changes depending on the season and derelict buildings change too, as nature takes hold and tries to reclaim them. I used a 6B pencil for all the drawing, and used a double-page spread of an A4 sketchbook. I always tend to draw larger than the paper allows, so the option of the extra space was useful.

Lonely Tree, pencil on 300gsm A1 cartridge paper. This drawing was always intended to be quite a 'tight', controlled drawing with lots of detail. I thought it was a beautiful, characterful subject and very good to draw. It was very satisfying to work on the texture of the bark and then the strong shadows cast by the small branches that followed the contours of the trunk.

Soft pencils start at 2B and gradually get softer towards 9B. So the greater the number of Bs, the softer the pencil. Softer pencils wear down more quickly, thereby losing their point, so need regular sharpening to maintain consistency. For normal sketching and drawing it is sufficient to stay within the 2B–6B range depending on your preference. These grades will suit most needs.

Hard pencils start at H and get harder up to 5H. F stands in the middle of Bs and Hs. Hard pencils are used for more technical work as they are capable of fine, light marks that are necessary for precise design work. Harder pencils keep their points longer but will not be able to give a dark tone.

The range from hard to soft runs like this: 5H, 4H, 3H, 2H, H, F, HB, 2B, 3B, 4B, 5B, 6B, 7B, 8B, 9B. Some manufacturers offer different ranges, and some do not offer a complete range.

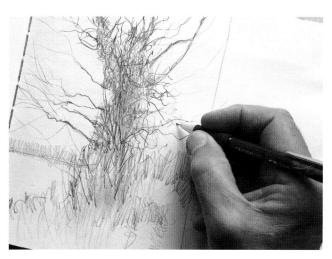

I find a mechanical pencil ideal for small sketchbook work. Here I'm working on a densely ivy-covered old tree and the fine (0.7mm) point is a perfect tool to create an impression of the busy textures. I used a scribble technique that I thought captured something of the lively nature of the subject.

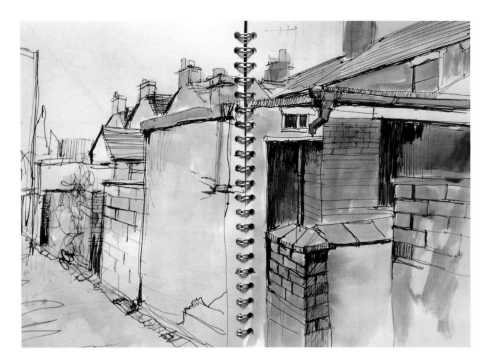

Terraced Houses, Backs. Here I have decided to develop a pencil and pen sketch by adding some watercolour. The colours are not accurate, but it enabled me to see if the subject would work as a larger painting. Even the weakest of washes of colour can add interest to a study. The perspective was a challenge, as well as the variety of colour in the different blockwork and brickwork.

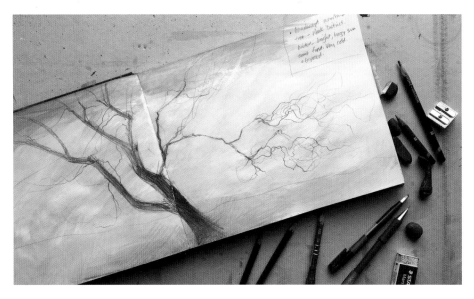

I am exploring the possibility of this dramatic windswept tree for a possible painting, having applied some acrylic washes over a pencil sketch. The inspiration was a group of windswept craggy trees clinging to a remote rocky hillside in the Peak District. The sky was suitably threatening. Whenever I see this sketch it reminds me of being there. I still haven't got around to doing the painting, though.

Which sketchbook or paper should I choose?

A sketchbook is a useful way to keep your sketches, drawings and ideas together in order and will make a great source of reference material as it grows. It is also a record of progression and development of skills and ideas. Choose either spiral-bound, stapled or glued and stitched pages in popular A5, A4, A3 or A2 sizes or a variety of square or rectangular formats, depending on your preference. With a spiral-bound, hard-covered sketchbook it is easy to fold the book back on itself for convenience and robustness, and it is possible to continue a drawing across the spine although there will be a gap and the metal spiral in the middle. With a sketchbook with glued or stapled pages there is a less pronounced division, but they are a little more difficult to hold properly if you are standing while sketching. Choose a good quality cartridge paper – heavier weight papers will take ink and wash, watercolour, pen, charcoal and so on as you begin to experiment with different media.

If you choose loose sheets of paper, you will need a drawing board or some stiff card and some clips or masking tape to keep them in place, and a folder to keep the work together later.

Note: If you are working with watercolour or ink in a sketchbook you will have to wait for it to dry before turning the page, which can be frustrating and time-wasting especially if working en plein air. So you may want to have a few loose sheets of paper to hand or a couple of sketchbooks on the go so you can continue to work on more drawings.

Erasers – hard and soft

Ideally, you will need both a 'hard' eraser and a soft 'putty' rubber. Each has its own special qualities. A normal, universal hard eraser is fine for making general adjustments to your drawing. A putty rubber helps with more subtle graphite removal at the lighter end of the tonal range, for instance working on fluffy clouds. Try erasers from different manufacturers as they do vary a lot. I have many erasers in the box, each one having different qualities: some can be quite rough or 'gritty' when used and can damage the paper surface; some are more effective than others at removing heavy layers of graphite; some have different shapes. So be prepared to sample or buy a few different sorts till you find some that you are happy with.

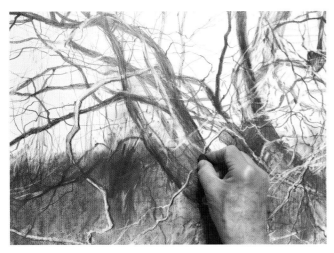

This is a treescape in graphite and tinted graphite on A1 paper. It is a busy scene with many interwoven branches and I am using an eraser to help cut a branch through the trunk. In effect I am drawing with the eraser. I will need to use a pencil to help lift the branch away from the rest of the tree.

What shall I draw?

The short and best answer is: anything and everything!

You have your sharpened pencils, paper and erasers and are eager to get to work to produce great drawings and are wondering what to draw. It's a good idea to start drawing things that are in front of you and that you are familiar with – things you like – rather than working from a photo, as this will be more valuable in helping to understand form, scale, proportion and so on. But, if you find it easier to work from a photo, try not to just copy it.

Some people enjoy the challenge of producing a drawing a day, or doing at least some drawing on a daily basis. It doesn't matter how long you spend on the drawing, but regular practice will ensure a good steady progression of skills. The message is really just to keep drawing as often as you can – it is all worthwhile experience.

As soon as you start to draw familiar everyday things – things around the home or garden, for instance – you will begin to view them in a different light. We are so used to looking at familiar things that our brains quickly assign this information to memory, and we need just a millisecond to recognize them again when next we see them. So we have become used to 'seeing' things with our brains rather than with our eyes. If we try to draw familiar things we scrutinize them more closely and start to understand more about how they are made. New discoveries about familiar things can be surprising.

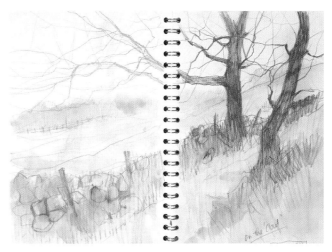

Two-page landscape study in pencil. With this study, I had made the initial pencil drawing because I liked the dramatic, unusual composition. When I looked through the sketchbook some time later and rediscovered it, I had the idea for a painting. So I took it a stage further and added a watercolour wash to see how it would look.

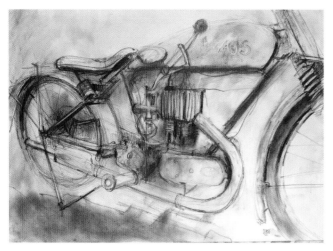

This drawing is one of a series taken from photos I took when visiting a motorcycle show. I was fascinated by the shapes and textures of the patina – it wasn't shiny and new. I had the idea to do an impressionistic drawing that suggested the complex details rather than elaborating too much.

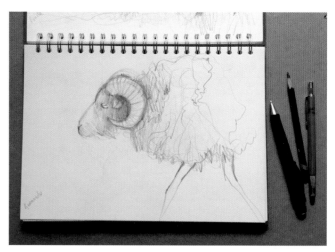

Something different: I thought this sheep would be interesting to draw as I haven't done much drawing of animals. It was a challenge, but it is always good to try something new. The curved, textured horn gave some structure, as there was not a lot of clear detail to focus on. I enjoyed trying to capture the woolly texture in pencil.

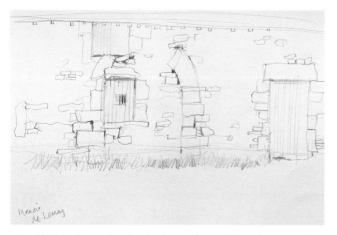

With this little observational plein air study in pencil, I was interested in the shapes of the stonework and discovered, interestingly, that there was once a large doorway or arch that had been filled in and modified at some point earlier in its history. It is so interesting when these little discoveries become apparent, because you are taking the time to look properly and allow some thinking and looking time. I started the sketch in front of the building, then took photos to enable me to study the detail at my leisure.

Each different subject is a new challenge. If you choose a subject you know and love, it is a good starting point to maintain interest and build confidence. Later you can try the unfamiliar to widen your repertoire and test yourself further. So start drawing what you know, get to know it more thoroughly by drawing it from different angles, then move on to other subjects. You will find that certain subjects work better than others, so while it is good to recognize this, it is equally important to attempt new subjects. I think each of us has an affinity with one or two subject areas that enable us to produce better results. For me, urban and natural landscapes work best.

I am also fascinated by portraiture, but the results always fall short of my expectations. It doesn't put me off though, as I love to try to capture a likeness of a person. I think it's one of the ultimate challenges and therefore most rewarding if it works; however, frustratingly, it sometimes doesn't come off as well as other subjects.

The more often you use your sketchbook to draw, doodle or just to look through, the better. Make it a part of your daily activity. Drawing is one of those things where the more you do, the better you get.

A sketchbook is your best friend

I always keep several sketchbooks on the go and use them regularly whether for new drawing or for reference. Using a sketchbook regularly is a great way to check progress and to collate thoughts and ideas. I can develop themes and interests, and go back to them again and again.

Sketchbooks with good quality cartridge paper will handle a range of different media. Sometimes there is a trade-off between choosing paper that is too heavy and one that is too light and buckles too easily when wet. Some artists have personal favourites – whether it's creamy smooth paper or heavyweight white – and always choose the same brand, which is good for consistency. This means that they have a uniform collection of books that will form a unique archive to look back on.

One of the most valuable things that an artist can acquire over time is a collection of sketchbooks. It is always interesting to look back at ideas or studies – often these can lead to other avenues of exploration, or an affirmation of an existing pre-occupation.

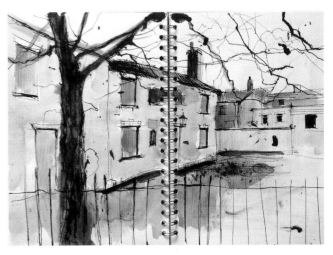

Using a double-page spread in an A4 spiral-bound sketchbook, I enjoyed the freedom and expressive potential of making a direct sketch in pen and ink (without any underdrawing) of this old derelict pub. The ink smudged a little because I turned the page too quickly to do another sketch, but it didn't matter. When I looked back on the drawing, I decided to add some loose watercolour washes to distinguish the building from its surroundings.

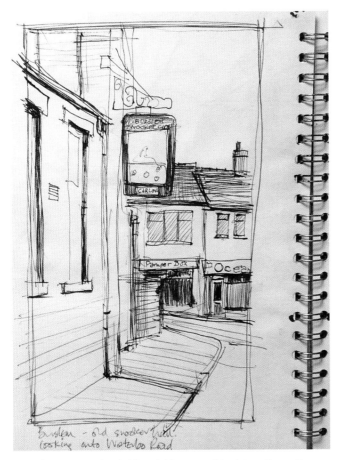

A quick townscape sketch: I found this composition interesting as there was dramatic perspective in the old snooker hall on the left leading to the frontal aspect of the row of shops on the right. I did some directional shading, which helped define some of the planes.

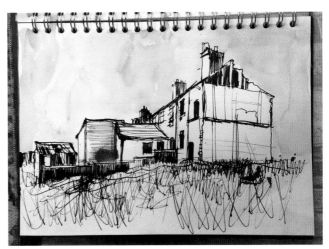

Seeing negative space: After making this pen and ink study of derelict houses on site and once I got back to the studio and was looking through my efforts, I decided to add a simple blue wash to reinforce the negative shape of the sky. It instantly made the buildings more visible, separating subject from background and making the composition clearer. Often, looking at negative spaces helps to 'see' the main subject more clearly.

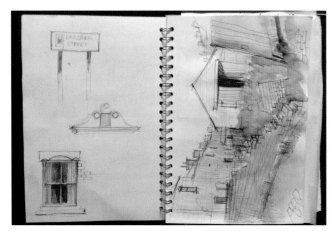

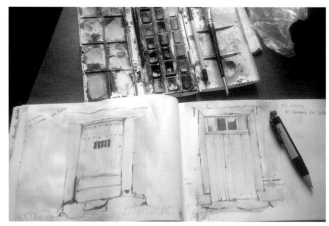

Two pages from an urban landscape sketchbook. On the left are some studies of details, on the right a colour-washed pencil sketch to see if this subject would work as a painting. The addition of a few simple colours helps to separate the different elements.

A couple of pages of studies of doorways made during a trip to France. It's quite interesting looking back on these sketches to see the diverse range of subject matter that I found and wanted to draw. In this instance I was using the sketchbook as a daily diary. I added colour to the day's sketches while everything was fresh in my mind.

Keeping two sketchbooks on the go is a good idea: an A4 or A3 pad for general work, and maybe a small A6 pocket-size book to keep with you all the time. You can work between the two, transferring ideas from one to the other. You will be surprised how often opportunities for sketching present themselves during the course of a day. Drawing little and often is great training.

My own collection of sketchbooks has grown over the years to become an invaluable resource, something that I look through regularly. It can act as a personal diary, especially if you date the work and add notes as you go.

Beginners' mistakes

Relying too much on an eraser

Many times when I have watched beginners start a drawing, they make a few marks then immediately rub them out and start again. This process is repeated over and over, and it is a wonder that the drawing ever gets going. They are convinced that every mark they make is the wrong one. But how can these marks be 'wrong' until other marks have been made alongside against which to judge them?

It is good practice to get most of the subject down first, block it all in with light, exploratory construction marks. If the pencil marks are light, relationships can be made with other marks, and the drawing can start to take shape and move forward, evaluation can take place, and any adjustments made to proportions, perspective, composition and so on. If the construction lines are light enough, there is something to work with.

Drawing too heavily too soon

Making marks that are too strong too early doesn't leave much room for adjustment. If the drawing has to be tweaked, it may be difficult to remove heavy marks cleanly. A drawing needs a variety of mark-making, both in terms of weight and thickness. For example, subjects in the distance need to be drawn lighter than the main subject. Marks in the foreground can be stronger and bolder.

Detail comes later

Some people can be preoccupied with focusing on detail too early in the drawing, sometimes before the main shapes have been established. Detail only works if it is in the right place – it can only work over a sound under-drawing. If, when drawing a house, the windows are drawn perfectly, but are too small or too big in relation to the house, then visually they won't work. Likewise, it is pointless drawing in the bricks before the main proportions of the house are established. It's easy to say 'forget the detail for now', but zoning in on detail too soon can add confusion and ultimately create extra work because if it's in the wrong place at the wrong proportion it will have to be redrawn later.

Try to see big shapes first

When confronted by a scene, whether it's inside or out, there will be a lot of extra 'clutter' to confuse the issue. Try and see the big shapes first; keep it simple. Some artists use a viewfinder to help select the content, in the same way that a camera screen or viewfinder helps frame the picture.

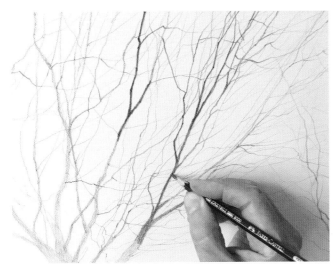

This was quite a controlled drawing of a single tree. I wanted to do a large (A1) drawing using just a pencil. The background (sky) would have no tone – just the white of the paper – so great care was needed to keep everything clean.

Choose good quality materials – the best you can afford

Inferior materials will not give the same effect as good quality ones, which sounds like an obvious thing to say. It is one thing to buy wisely and to shop around for the best deal on a quality product (no one wants to overpay), but it is false economy to buy the cheapest budget-range materials where quality has been compromised. Decent materials will ensure your skills have the best outcome.

It is the same story with paint: for example, cheap acrylics just do not behave as acrylics should because they are made with inferior ingredients. It is why, when you buy artists' quality paints, some colours are more expensive than others because of the varying cost of raw pigment. The whole painting experience can be compromised by low-quality materials. Naturally, when wanting to try out a new medium for the first time you may be unsure whether you will take to it; in this case just buy a few standard colours from a mid-quality range, or test them in an art shop if you can, or ask a friend. Then buy quality artists' materials when you are ready.

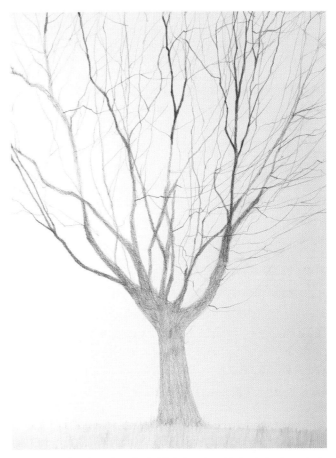

I drew an outline first, then shaded lightly so I could check that it worked. It was then a matter of adding progressively more layers to achieve solidity. It is impossible to draw every branch, but it is vital that the character and detail of the form is rendered accurately. I looked closely at the way the small branches grew. I had the idea to do the grass in coloured pencil, again in a very controlled way.

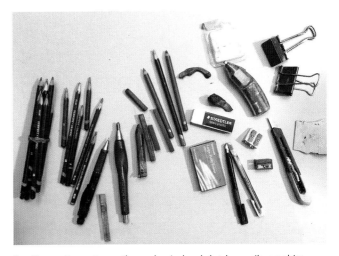

Familiar equipment: pencils, mechanical and clutch pencils, graphite sticks, erasers (soft, hard, mechanical and battery-operated), sharpeners, craft knife and a small sheet of sandpaper for sharpening points. A few coloured pencils for suggesting subtle tints.

Draw what you see, not what you know

Easier said than done, of course. When making a preliminary drawing, we look at and analyze a subject to try to understand it better, whether it is a study for a painting, a sketch for its own sake or an exploratory drawing. It is this personal interaction with a subject – the actual looking and analyzing – that is so fascinating and pleasurable. But it takes a while to train our eyes to see things in a purely analytical way.

When I tutored life drawing sessions, I often reflected that the looking and the analysis were the most valuable aspects, because it is the experience of this process that stays with us and is carried forward to the next drawing, and the next. Often we feel our drawing hasn't done justice to the subject, but it is the process of working through things that is so valuable – seeing how one part relates to another, even if there have been many adjustments along the way. By this, I mean that the actual process of trying to understand the structure and nature of a subject is a valuable lesson for the artist. In a sense, the more adjustments on a drawing, the more the artist has learned.

Drawing the familiar

Some people can draw things without being sat in front of them. We see tens of thousands of different images daily, and because we see things regularly, our brains build up a library of pictures to help us quickly make sense of the world around us. These images are stored in our data bank – our brain – so the next time we come across the same image, just a quick glance and our brain recognizes that we already know it well and moves onto the next thing. This is what we have to overcome as we move forward with our drawing: we are so familiar with the things we see every day that we can probably draw them without looking. It takes a bigger effort to draw the things we are familiar with.

A big part of drawing is actually about unlearning some of the things we 'know', and trying to see them as if for the first time, in a more objective way. This 'unlearning' process can take many weeks of intense analytical looking, but when it happens we are able to represent things more accurately.

A good example of what I mean would be in a life class, where the model is in a reclining pose with head to one side. However, the student draws the head upright and facing directly towards them. The reason is because we are so used to seeing the human face full-on and upright when talking or otherwise communicating with people that

the image has become familiar and we can almost draw it without actually looking. If I ask the question, 'what position is the model in, what are they doing?' the students are able to describe the model's position accurately, then when they look back at what they have drawn they cannot understand why they have drawn it this way.

The whole process of drawing is so interesting: looking, analyzing and understanding. The getting down on paper of a few well-chosen marks with a pencil to represent a subject to me is endlessly fascinating.

As we try to make sense of how the world around us works by drawing something, we endeavour to understand it: how it's formed, how it's made. I believe this is why drawing will always be such an important, essential activity, central to who we are and how we function. It goes some way to understanding the world around us, whether man-made or natural.

Some techniques and tips to get started

We will build on these techniques and tips in more depth as the book progresses. It is not essential to know everything about drawing before starting out. The idea is to offer knowledge and advice to enable progress at your own pace, as and when you have time.

Handling and controlling the pencil

Using a 2B and 6B pencil and a sheet of heavyweight cartridge paper or sketchbook, along with a hard and soft eraser, explore the qualities of each to see what they can do. There is no subject to draw so there is no pressure to achieve a likeness; it's just exploratory mark-making, so enjoy and relax.

First, compare the 2B with the 6B: in practice it can sometimes be hard to discern the difference. If very little pressure is exerted, the 6B marks can resemble those of the 2B. The 6B, being softer, will lose its point more quickly and in use the marks will become thicker and less precise, which can make the drawing 'woolly'.

Use a page in a sketchbook or a separate sheet of paper to practise a few warm-up exercises. It is always a good idea to do some scribbling or mark-making to loosen the fingers and wrist and also to test the pencil. Make lines that start with just a little pressure, then increase the pressure as the line gets longer till it ends up black (providing you don't press down too hard and break the point). Next,

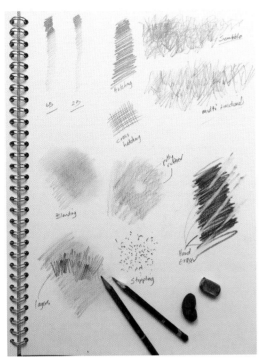

Using a 2B and 6B pencil, try making a sheet of warm-up marks to test the equipment. The 6B pencil can be made to make identical marks to the 2B. However, by applying more pressure, the differences become apparent – the 6B produces blacker marks. Try to remove and shape the marks using soft and hard erasers. Practise making different textural marks.

try some hatching marks and areas of shading light to dark, then some texture marks that mimic, say, grass or tree bark and so on. Cut back into these marks with a hard eraser to see how easy or difficult it is to remove marks. Try stippling, directional shading, and soft subtle shading that can be further softened with your putty eraser.

Shading

When shading (applying tone), right-handed people will usually produce lines at a 45-degree angle as they follow the natural sweep of the wrist. For a left-handed person it is the directional marks you make when you hold a pencil and apply shading. This is called hatching and is the beginning of a logical, controlled process of building up tone. Applying more lines at a 90-degree angle to these (cross hatching) will produce a darker tone, in a controlled way.

For soft smooth shading, hold the pencil at a flatter angle to the paper, then use a finger to smooth it out (smudging). For more expressive, vigorous shading, hold a softer pencil more upright and apply more pressure.

Shading can be directional, for example on a tree to follow the movement of the bark.

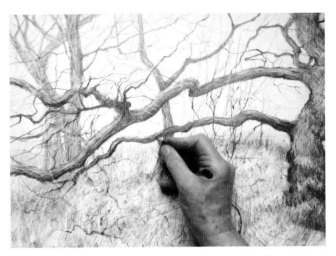

Trees in Graphite. After doing sketchbook studies to get familiar with the shape of this tree, I found the proportions really interesting, along with the relationship between the two main branches. With this drawing I found it quite busy, to say the least, and here it is well on the way to being finished. But even at this late developmental stage, I have kept the undergrowth quite 'open' by using a hard eraser extensively and vigorously to keep the texture workable. I try to keep the balance of a picture in check all the way through, as it is sometimes difficult to work back into an area if it is too solid and overworked.

Understanding line and tone

Good knowledge and control of line and tone is essential to create a realistic depiction of your subject. In figurative representation, the perennial problem is capturing three-dimensional imagery on a flat two-dimensional surface.

Children tend to draw first in outline and then later 'colour in'. When we start a drawing it is instinctive to describe the subject using line, but form and solidity cannot be represented by line alone: line is two-dimensional. Tone or shading needs to be added to make drawings more realistic, because when adding shadow to an object, it creates an illusion of three dimensions. Using tone helps to distinguish between different elements, as a means to separate them.

To draw on paper (a flat surface) is to work in two dimensions. Our figurative subject will almost certainly be three-dimensional, which means that when light hits it, shadows are created; the subject will not only have shadows within the form itself but will also cast shadows according to the direction of the light source. If we are able to correctly observe this light source and translate it by means of adding tone (or shading), then the drawing will better represent our three-dimensional form on a two-dimensional surface (the paper).

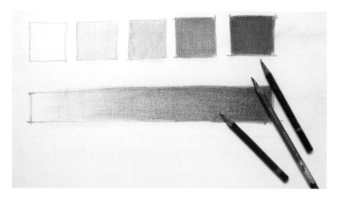

One way to understand tone is to produce a series of panels that show a range from the white of the paper down to the darkest tone your pencil can make – as black as possible. As soon as the lightest and darkest tones are established, try to estimate a mid-tone – something that sits equally between the two extremes. Once you have these three levels, it is fairly straightforward to guess the tones in between. Similarly, it is a useful exercise to produce a strip of continuous tone that goes from light to dark in a seamless transition. This is a great way of practising applying tone evenly.

Creating tone

Practise going from a light to a dark tone in a smooth transition by controlling the pressure and directional movement of the pencil. Produce some light shading, use a finger to blend and smooth everything out, then work over this by applying more pressure to create darker tones, repeating the process until the desired result is achieved. This is a great exercise to practise, because it allows you to develop good pencil control independently from the drawing itself. The more practice you do, the better you will get. Practising applying tones really does improve pencil control.

Use an eraser as a drawing tool

Produce a largish area of tone, then try 'drawing' into this with a sharpened piece of eraser to remove or modify it. Cut a slice off a hard eraser then use it to make directional marks to remove the pencil tone – this technique is very important in drawing as you will often need to adjust things. This is also a great way to create texture. Make some random marks; remember, you are testing what the equipment will do, it doesn't necessarily have to represent anything. You are now using an eraser as a drawing tool.

If the pencil shading is too heavy and black and the eraser not hard enough to cut through the graphite, it may have the undesired effect of polishing or burnishing the graphite surface; it is then almost impossible to remove.

Of course you can still use the eraser simply as a rubbing-out device, but take care that the surface of the paper isn't damaged in the process.

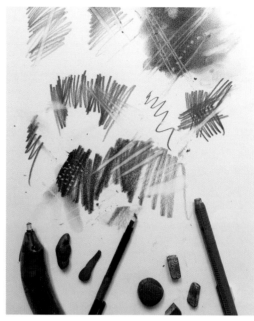

Try this practice sheet – it is a very useful exercise to do. Make some random marks with a pencil and graphite stick, some heavy, some soft. Give yourself some space to move around – so use at least an A3 sheet. Then use different erasers to cut into and modify the graphite – another example of drawing with an eraser.

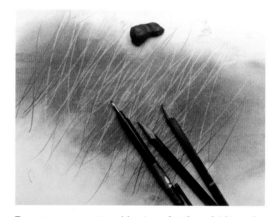

Two extremes: a putty rubber is perfect for soft lifting of graphite; a mechanical eraser gives great precision. On this patch of soft graphite the putty rubber will soften edges and create subtlety, whereas the mechanical eraser has been able to cut in more directly.

Working with a putty rubber

A good putty rubber is essential as a means of keeping your drawing clean as you go along, and also for making adjustments to the drawing at the lighter end of the scale. It will also soften off lines that are too bold, or parts of the drawing that need to be 'knocked back'.

Make a variety of random marks on paper and also some areas of light to mid tones. Take the putty rubber and rub or roll gently over these marks to see what happens.

With any subject try to see the big dimensions first – how tall and how wide is it? In these two illustrations, I have laid an overlay to show the house contained in an imaginary rectangular box to show how I started the drawing. By breaking it down even further you can position the elements contained within the box.

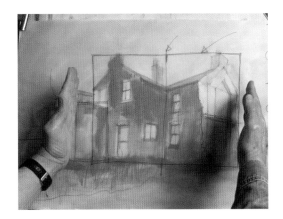
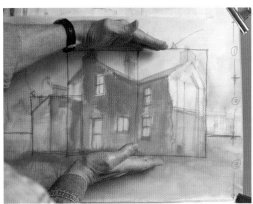

Establishing the main parameters of a subject

It is important to be able to accurately calculate the main parameters of a subject. Ask yourself these questions, for example: is it wider than it is tall? Does the main subject fit within a square or a rectangle? Sometimes we are confused visually by the actual dimensions of a subject, so it's useful to get this right at the beginning to save work later. If the main parameters are wrong, any subsequent building of the picture is on weak foundations, and unnecessary corrective work can be tedious.

Using a pencil to measure

The pencil is an extremely useful tool to help get proportions right. If the subject is a human figure, for example, taking a measurement of the depth of the head and using it as a unit of measure to calculate the height and width of the figure will keep things in proportion. As soon as the unit of measurement is established, you can work out how tall or wide the figure is in relation to the head. The head is in effect a key unit by which the rest of the figure is measured.

The same procedure can be used whatever you are drawing, whether it is buildings, a landscape, still life and so on. Taking some big measurements of the main subject, for example the height compared to the width, means that everything can be worked out subsequently.

Avoid detail until later and simplifying forms

We have discussed previously the importance of seeing big shapes first. Detail should only be added on top of sound shapes and form.

The next step is to try to break this down even further by seeing smaller shapes and forms within the bigger shapes. The idea is to get everything working before getting into the detail.

In the picture on the right I am using a pencil vertically to measure the height of the building. I am using the whole length of the pencil to illustrate this point. Now, shown below, I hold the pencil horizontally to check where the pencil length reaches to. Effectively, the pencil is a unit of measure by which I can check the proportions of the whole picture.

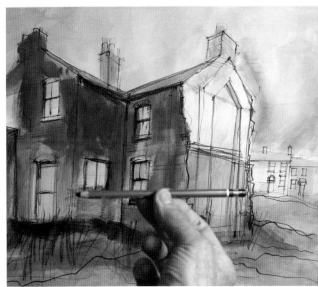

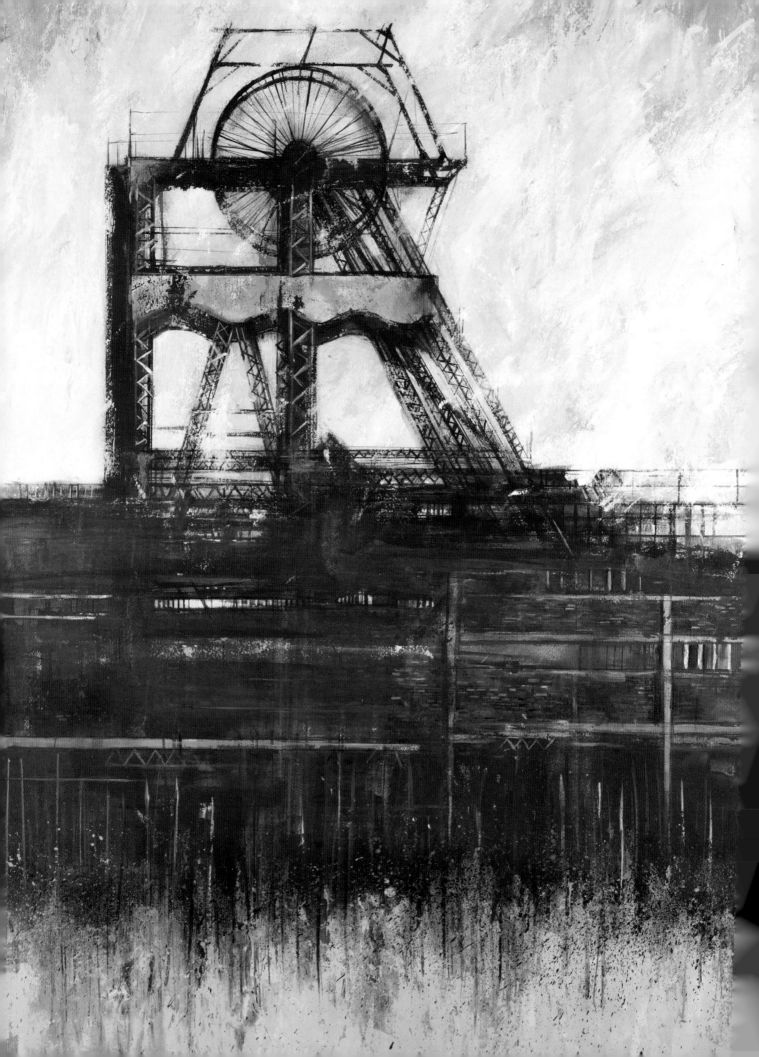

THE LANGUAGE OF DRAWING

t is not essential to have a complete knowledge of the language of drawing, but if you want to develop your skills then an understanding of how a drawing is perceived by an onlooker is necessary to make improvements in your own work. Sometimes we know when something is not quite right – perhaps an issue with perspective, scale or composition and so on – but we can't quite put a finger on what it is. It is therefore helpful to understand some of the reasons a drawing may not work as well as it should, so the next time we come across a similar problem we are able to better understand and then resolve it. Take scale, for example: are the figures too big or small in relation to the size of the buildings? Is the head too small for the body? And so on.

We sometimes instinctively know when something doesn't quite work with (say) an architectural scene but we don't quite know what is amiss. If we know and apply the rules of perspective, we can check eye level and vanishing point. To find out if the picture is unbalanced we can look at the composition.

All pictures will have elements of these 'rules'. Understanding what they are and when and where to use them will ultimately benefit your work. In this chapter some of these formal elements are examined and explained in more detail.

Potteries Monument: Chatterley Whitfield Pit Head Winding Gear, acrylic on A1 paper.

Understanding the formal elements of picture-making

Every successful artist will have an understanding of the sound principles for making a successful picture. These principles form a set of criteria with which to judge the picture. Such criteria include, for example: line, tone, composition, proportion, scale, perspective, texture, when and where to use warm and cool colours, and so on.

When we look at the work of an artist, we may want to discuss, for instance, how they used colour to portray emotion, depth or distance; how well the composition works – does the picture have balance? Is the viewer's eye guided through and into the picture? Is there good tonal contrast, or are all the tones in the mid range so that nothing stands out? If the picture portrays an urban landscape or cityscape, does the perspective work to create the illusion of distance? When we have figures and buildings together, do the proportions work to good effect?

Proportion and scale need to work together to place figures or objects further in the distance. Perhaps one of the most difficult things to achieve is placing a series of similarly sized subjects at various points within the picture plane. Not only do they need to be smaller as they recede, but they also need to appear softer, more out of focus, and if colour is used then cooler colours need to be chosen. So the problem might be a combination of many different elements.

Understanding how this 'language' works, and what adjustments need to be made to the drawing to make it work better, takes time, practice and experience. It is impossible to implement everything in one go, but you will

see improvements little by little if you focus on one thing at a time. It takes a lot of experience and much trial and error to fully understand the intricacies of best practice in composition, but if you are aware of what constitutes good composition, then you can work on it gradually and over time start to see improvements in your work.

Sometimes progress is imperceptible and it appears as though things are not grasped at the time, but it is often surprising when looking back through past work that evidence of improvements is visible. This gives confidence to continue, to do more, and build on what has been learnt.

The list of criteria is in no particular order of importance, and it is by no means exhaustive; rather it is one that I have arrived at through my own journey of experimentation and discovery. I find it really useful to ask questions of my own work when something doesn't look right but I can't quite put my finger on it. It is important, although very difficult, to be able to analyze your own work and the work of others.

Line

When we first start drawing it is natural to use line to describe things. It is instinctive to describe objects by putting a line around them: in effect a border. Of course in reality there are no lines around objects, so therefore this is an unrealistic way to describe things. As a picture develops these initial outlines need to be removed or subdued to give a more natural representation.

Line describes shape and can be used to great expressive effect, but the use of line alone does not have the capacity to effectively describe solidity or form. Shading or tone needs to be used in combination with line to create shadows and give weight to elements within the picture. Three-dimensional objects rely on directional light hitting them to create shadows within the form itself and also shadows that are cast by the form.

The line drawings of Picasso, Henri Matisse, Egon Schiele and David Hockney are examples of true masters who have used line alone to describe their subjects. It requires a certain visual accuracy and confidence in drawing skills to be able to capture the essence of a subject and to explain it using line alone.

URBAN LANDSCAPE IN ACRYLIC PAINT AND ACRYLIC INK

MATERIALS
Acrylic paint, brushes, acrylic ink, dipper pen, charcoal, pigmented permanent markers, on A1 300gsm heavyweight paper.

BACKGROUND
This is one of my favourite architectural subjects: vernacular terraced housing viewed from a cobbled rear entry. Because of the tight viewpoint there are big challenges with steep angles of perspective. There were also challenges with scale – the sizes of the bricks as they receded further back in the picture plane. I did corrective drawing all the way through the making of this painting, sometimes with pencil, sometimes with charcoal, alternating between drawing and painting.

I love the process of making pictures on paper; the feel of a pencil on its surface feels so natural. The next step of painting loose washes of colour over the top to distinguish the different elements, followed by more drawing then more painting, creates a natural rhythm. Naturally a lot of the drawing gets lost as the work progresses, and has to be found again, but the whole process is very enjoyable.

I have made many pictures based on this subject matter in pastel, charcoal, graphite, mixed media as well as acrylic. With each new picture I see a different aspect to explore, so it is always interesting.

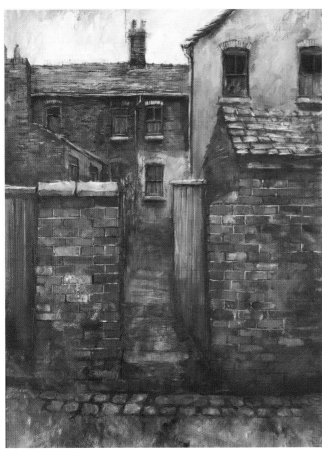

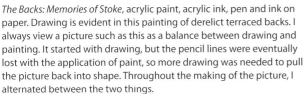

The Backs: Memories of Stoke, acrylic paint, acrylic ink, pen and ink on paper. Drawing is evident in this painting of derelict terraced backs. I always view a picture such as this as a balance between drawing and painting. It started with drawing, but the pencil lines were eventually lost with the application of paint, so more drawing was needed to pull the picture back into shape. Throughout the making of the picture, I alternated between the two things.

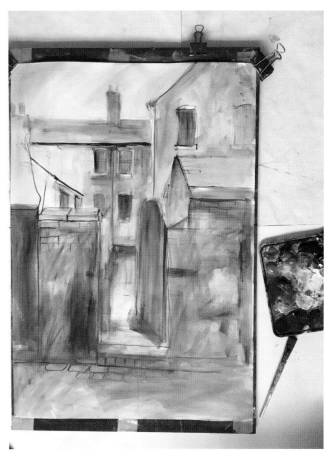

The picture started out with the briefest of underdrawings before diluted washes of acrylic were added to begin the process of layering colour using a big brush. I especially like the early stages of a picture when the possibilities are endless and there are many avenues the picture can take. Changes can be made quickly: there is the freedom to exaggerate a colour, for example, just to see where that might lead. Note how the gate started out as round topped, but later was changed to a straight edge.

I always enjoy painting brickwork. Here the bricks are all different colours and textures, so the challenge was to build up sufficient layers of paint before defining the shapes by painting the mortar in between. I'm doing that here with the aid of a rigger.

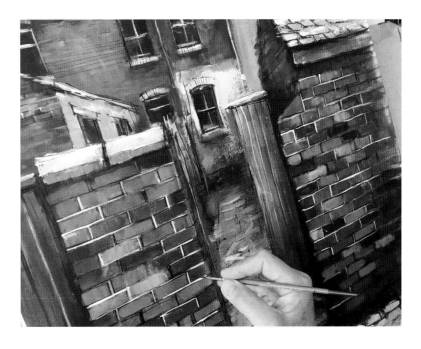

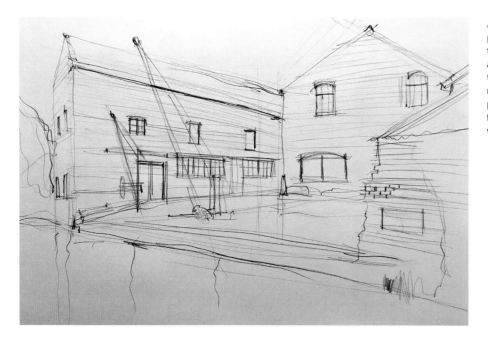

A large line drawing on A1 paper as preparation for an acrylic painting. For me there is always excitement when starting a new work. I love making those first tentative marks that eventually become more assured as things start to fall into place. This amount of drawing is sufficient for me to start laying thin transparent washes of colour over.

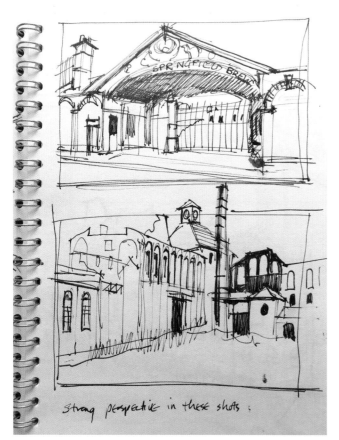

A couple of pen and ink studies of a derelict brewery in Wolverhampton made during a field trip. The architectural features of this building were fantastic to draw. It was a great subject to explore through drawing, although despite having collected many photographs and studies I never got around to doing a painting. It's something I can go back to because I have many references.

Line drawings can have their own sparse, beautiful qualities as exemplified by the nudes of Matisse, particularly when made using pen and ink or brush.

Tone

Tone is a very important element in drawing and painting. In fact I would argue that, in general, tone is more important than colour in figurative representational work. I do not say this to lessen the importance of colour in a painting. What I mean is that colour itself has a tonal quality, so when working in colour, an awareness of the tonal value of colours is needed.

Colour has tone

The world exists in colour and the artist using a pencil is at a disadvantage and has to learn how to translate colour into an appropriate tone. Some artists painting in colour use a greyscale swatch to match colour to a tonal value. These artists understand the importance of tone over colour in a painting: their preoccupation is to make their picture work in a range of tones. The actual colour is a secondary consideration. Of course, I generalize here, because a painting can be about many things, and I am not suggesting that a painting is any more or less important if the artist is a 'colourist' and places colour above tone.

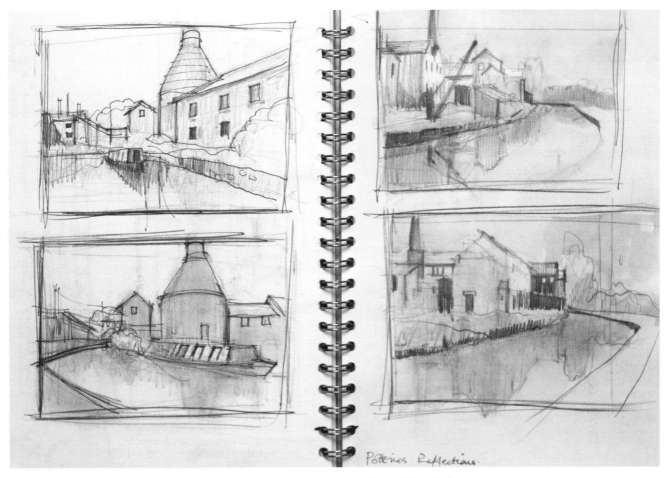

Potteries Reflections.

A double-page spread of studies of canalside factories. All were made as pencil sketches initially, with the two on the right having watercolour added to explore the possibilities for a painting. The left-hand page offers two slightly different viewpoints – I walked a bit further to see if it gave a better composition. Simple tone is used to separate the different elements.

Tone adds solidity and form

There can be no true impression of solidity or weight using line alone. We need to add tone (shading) to give a sense of reality when describing three-dimensional objects. As already discussed, the main difference between two and three dimensions is that two-dimensional shapes are flat – they have no thickness – whereas three-dimensional form relies on a light source hitting it to give us clues as to its structure. When light hits a three-dimensional form, shadows are cast by the object and shadows are created within the form itself. By observing these shadows correctly, an effective rendition of the form should follow.

When drawing a head, the skull beneath gives form, shape and proportion to the features. It is logical therefore to establish a sense of form first, followed by the features (eyes, nose, mouth, and so on), which can then be built up over the form – in the same way that sculptors need the head shape before they can model the eyes or mouth and

so on. Establishing the form first will give a solid foundation to locate and position the features: after all, the eyes are where they are because of the eye sockets in the skull. The skull determines the location of the features, so it is logical to build detail on top of this solid form.

A combination of line and tone therefore is needed to successfully draw the head. Of course a likeness can be created with line alone: simply look at the portraits of David Hockney or Egon Schiele for excellent examples by these master portraitists.

A landscape needs tone to give solidity to terra firma. When representing undergrowth, it is sometimes more useful to start off with a dark tone and use an eraser to make lighter areas: in effect, working dark to light.

It is important to understand when and where to use line and tone, because there will be occasions when perhaps the overall tonal weight is quite weak, and if shadows aren't dark enough the picture will lack depth. If the

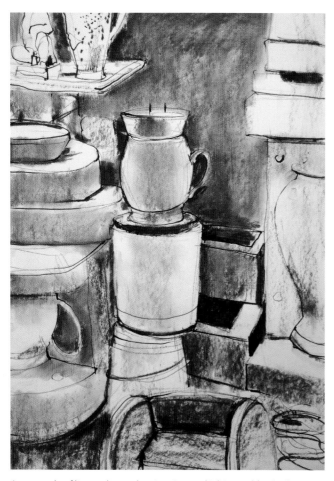

An example of line and tone drawing. Pen and ink is used for the line, charcoal supplies the tone. It is the best of both worlds – a clear precise line with the pen, and endless variety of tone with the charcoal. The unusual subject matter is a group of plaster moulds and forms in a pottery works.

picture has a main foreground subject with a busy background, it may need tonal adjustments to help separate the two.

If there is too much emphasis on the outline around a subject, it will appear a little unnatural – as in real life there are no outlines around things, merely a change in tone or colour where one thing meets another.

Composition

A successful drawing or painting will have many qualities, but one with good composition means that the drawing has more potential to create interest, be pleasing on the eye, and have more impact and balance. A well thought-out composition should lead the viewer into the picture, where the eye moves around and is guided finally to the subject. Good composition in a painting may go unnoticed

because nothing seems out of place – the painting essentially works.

Put simply, composition is a set of informal rules that can be applied to a two-dimensional work to enable it to read as a balanced picture that is interesting and 'looks right'.

Bad composition, for example, might have a pictorial element cut the picture in half, or position the main subject exactly in the middle. It is boring and obvious. Of course, many portraits have the head in the centre of the picture, but there are alternative ways to present a portrait to create different meanings, for instance if the head is positioned to one side and looking into the empty space. Only when a picture clearly doesn't work do we need to ask questions of the composition.

Rule of thirds

One of the principles of composition involves an understanding of the 'rule of thirds'. To avoid symmetry, it is useful to be aware of this rule, which suggests that the ideal place to position a subject is on an imaginary line a third of the way along the picture. The same goes for an horizon line – either a third of the way from the top or bottom. Either would work: effectively giving a seascape a big sea and small sky, or a big sky and small sea, for example.

When I am starting a new painting, working out ideas in my sketchbook or producing a study, I may not be thinking primarily about what makes a good composition. If a picture looks right, then that's fine, but as the painting develops and something doesn't quite sit right, adjustments may be needed to improve the composition. A drawing or painting regularly needs to be assessed and reassessed and adjustments made: it is the nature of painting. An adjustment is made here and something becomes unbalanced somewhere else. Every element has a relationship to another.

However, these rules should not dominate picture-making to the point where starting becomes too tentative. On the contrary, let the drawing develop but keep on reviewing it at regular intervals. This is why it is useful to make at least one study first and look at it critically to see if it has any obvious compositional or other errors, then make the necessary adjustments at this early stage. Sometimes things look different when paint starts to be applied of course, so keep an open mind and always be prepared to make adjustments as you go along. Let the drawing commence, keeping the marks light and flexible.

In this study the unusual stretched letterbox format was drawn with some understanding of basic composition – I positioned the horizon line so that it occupied the bottom third of the picture. When positioning the trees, I was aware of positioning the main two trees away from dead centre so that they didn't split the picture in two.

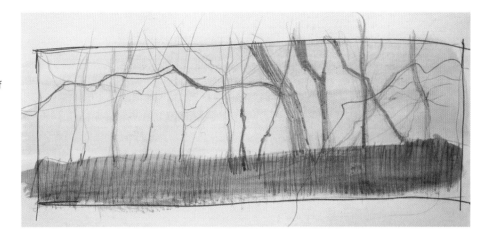

A grid on top of the study has lines drawn in red that split it into thirds horizontally and vertically. You can clearly see the horizon line and main trees conforming to the principle of thirds.

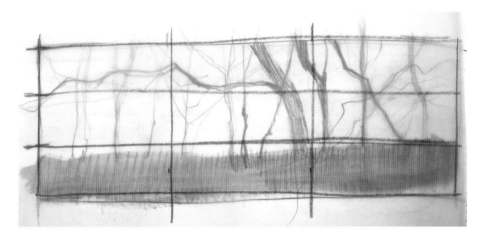

It is useful to analyze drawings and paintings by other artists, and ask yourself which ones work or not and why. You will be surprised to find even the great artists have occasionally made 'errors' of composition, yet a painting can have many other qualities to make this almost irrelevant.

Perspective

Perspective is a visual convention, a set of rules, devised many centuries ago as a device to make paintings appear more realistic and therefore believable. Prior to this, paintings appeared flat and conveyed different meanings: pictorial realism was secondary to symbolic significance.

If a painting, especially one featuring an architectural or urban landscape, does not follow rules of perspective, then to our modern, critical eyes it will be quite noticeable and detract from the believability of the picture.

Perspective places the viewer of the picture in the shoes of the artist. It literally gives the artist's point of view: where they were sitting or standing when they took the reference photo or made the drawing or painting.

It is not the intention of this book to cover perspective in minute detail – there are countless books wholly devoted to this subject alone – so I will just cover some basic points with examples. Perspective exists to underpin the believability of a picture, especially one with an architectural subject. If you have the ability to assess angles accurately, however, then you're halfway there – but having the tools to check everything is very useful.

Perspective appears in other subject areas, not just architectural subjects. An understanding of it is needed for an interior painting or still life for example, or sometimes even a landscape. A group of items positioned on a table, people in a street or a room will all rely on the principle of perspective. However, not all pictures rely on perspective to the same degree, and some don't really need it at all, for example a portrait taken full-on.

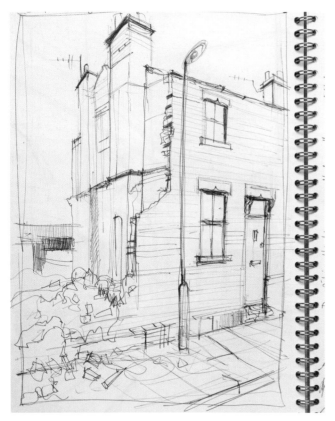

Because of my relatively low point of view here and the fact that I am standing relatively close to the building, there is a strong perspective element here. This is most apparent when looking at the roofline. The broken 'corner' of the building is nearest to me, the roof on the left slopes downwards, as does the roof on the right, along with the windows.

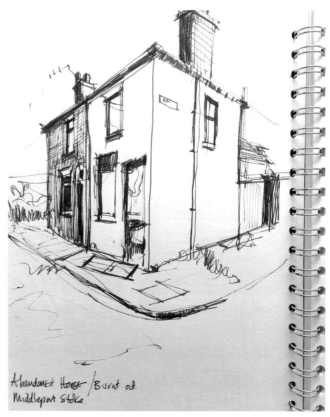

With this pen and ink study, perspective is very evident. The (imaginary) eye line, which corresponds to a point where I look straight ahead, lies approximately a third of the way up the building. The eye line would be the same as a line of bricks that appear horizontal – neither sloping up or down.

Perspective relies on two main criteria:

The eye line or eye level (EL): This needs to be established first. It is an imaginary horizontal line that corresponds to the position of wherever it is you are standing or sitting, assuming you are looking straight ahead. The eye line will change, if for example you are standing on the ground or sitting on a chair, because what you see changes in relation to your position.

The vanishing point (VP): An imaginary fixed point (or points) that is (are) a destination for converging lines to meet, often a point of infinity. The normal vanishing point will sit on the eye line/level.

Background

Some understanding of the convention of perspective is essential for architectural or urban subjects, but not exclusively so. It is a formula (or set of rules) established around 1400, formally accredited to Italian architect and designer Filippo Brunelleschi (1377–1446), to create a sense of depth within a picture, enabling pictorial elements to either advance or recede within the picture plane. Architectural subjects will need to follow rules of perspective if they are to be portrayed realistically when represented two dimensionally. Prior to this set of rules, paintings appeared visually quite crude and flat with elements appearing on the same picture plane, neither receding nor advancing. Everything appeared unrealistic.

But an intricate knowledge of perspective is not essential to accurately portray architecture. Having a good eye and the ability to judge angles with your pencil or brush precisely means that things can still work, but it is always good to have some 'back up' knowledge so you can check everything. It is useful, for example to know where eye

Here I have used an overlay on a painting in progress to illustrate how the structure of the building conforms to the rules of perspective (with the two vanishing points and the eye level). It is a way of checking all the angles before continuing with the painting. In a more complex view such as this it is easy to get angles wrong – so this is a good way of making sure it all works. Note how the vanishing points are positioned way beyond the width of the picture.

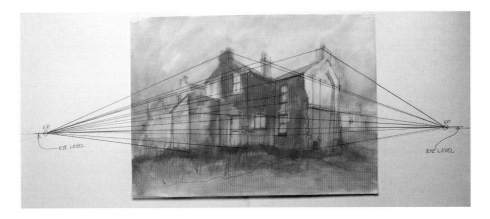

Apart from being a drawing tool, a pencil can be used to judge angles and to measure with. If you can accurately judge angles of perspective, or at least be able to check them like this, then you can correct the drawing as you go along.

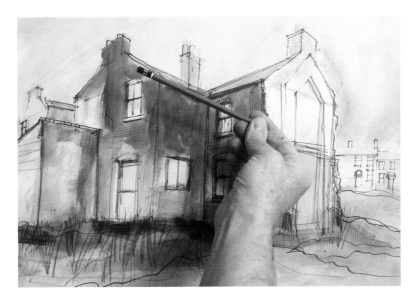

level and vanishing point(s) are, because there is then a destination for converging lines.

For example: Imagine you are standing at one end of a street looking down towards the other, and you are looking through a viewfinder that frames the end of the street. You will note that the rooflines, gutter and pavement lines, along with walls or hedge lines, all tend to converge towards the opposite end of the street. Wherever your eye rests, looking directly straight ahead, and at the point where the gutter lines intersect the rooflines will be the eye level (your eye level). This is one of the crucial main points of perspective, and needs to be established first.

Secondly, you need to establish the vanishing point. In this simple scenario there will be just one vanishing point. If you were standing on the corner of a building, you will have two vanishing points. This scenario assumes you are standing up. If you were sitting on the pavement, then your eye level changes to a low eye level, which immediately gives a more dramatic scene. Conversely, if you were standing on a ladder you would have a higher eye level.

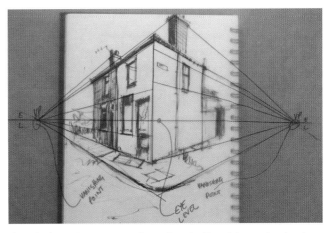

I have laid a tracing paper overlay and marked in red the eye level and two vanishing points to check the accuracy of this drawing. I can see that a couple of the lines are off – but mostly it's fairly accurate. I used my pencil to check the angles while I was making the drawing. Note the relatively high eye level because I am standing in the street on the same level as the house – so my eye level is on a par with where I would be if I were standing next to the front door. This is entirely logical, of course.

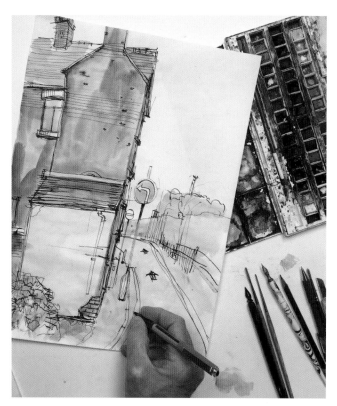

This A3 sketch on thin cartridge paper started off with some playful lines and exaggerated perspective in pen and ink. I liked the juxtaposition of all the road signs and markings in various colours: blue, red and yellow with the derelict house in brown. I also liked the composition – the way the picture was divided in half vertically, and the strong perspective.

All the converging lines above the eye level slope down towards the vanishing point: lines below eye level point upwards to meet at the same point. Everything on the eye level is horizontal.

Now, imagine you were in New York looking upwards towards some skyscrapers. You would need to apply perspective rules to what you see here as the vertical lines of the building taper towards a vanishing point somewhere above.

Aerial perspective

Naturally, other conventions come into play when creating the illusion of distance on a two-dimensional surface. Objects in the distance appear less clear, colours are less saturated, edges are more 'fuzzy'. In the outside world colour takes on a bluish tint in the distance, sometimes referred to as 'aerial' perspective, at the 'cool' end of the colour spectrum.

Adding drama

Once an understanding of perspective is gained, it can be used to add dramatic effect to make strong dynamic pictures, especially if it has an unusual viewpoint.

Natural landscape

It might be argued that the absence of buildings means that there is no need to be concerned with perspective, but a view looking down an avenue of trees is exactly the same scenario as the street scene. Similarly, in an interior, standing at one end of a room looking towards the opposite end, the same rules apply, as evidenced by the lines formed between floor and wall, and wall to ceiling. Very difficult to see and really hard to do accurately, it is nevertheless a perspective problem. Really, perspective crops up to a greater or lesser extent in most paintings.

See for yourself

Discover the rules of perspective by following converging lines in a photo or magazine image. Find a photo of a cityscape that shows strong perspective (converging lines) and draw over the top in biro to see where the vanishing point is (VP) and then the eye level (EL). This is a useful exercise that illustrates in a practical way how perspective works.

Scale and proportion

No matter how 'loose' or free a picture is made, it needs good foundations of perspective, proportion, composition and so on for it to work.

Scale

One of the first things to consider in picture-making is judging the size of the main subject or subjects in relation to the sheet of paper: how big does it need to be and how will other elements relate to it? Scale is important, firstly because the subject needs to be prominent if the picture is to have impact, and secondly because everything else in the picture needs to relate to it. If all the elements are too small and of similar size, there is no variety, but if the main subject is enlarged and cropped, it will add impact to the picture. So choosing the size of the main subject is crucial to the impact of the picture. Scale and proportion are intrinsically linked; large and small elements in a picture need to complement each other, each needing the other to work.

To illustrate scale I have positioned an overlay of a red figure by the nearest door to include in the picture plane, and a smaller figure by the door of a house in the distance. Each figure must be in proportion to the buildings themselves, but also the scale must reduce to compensate for the distance between them.

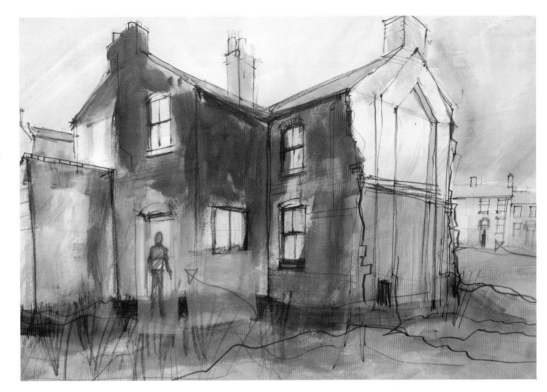

Proportion

Different elements within a picture need to work together. Having first established the size of the main subject, the dimensions of subsequent elements need to relate to that. If something looks out of proportion, it means that the relative size of one object next to another is either too small or too big. It will be noticeable. There has to be a starting point where the scale of the main subject looks correct; then other objects can be sized relative to it.

With people in a cityscape, for example, some might be in the foreground, some in the middle distance, some in the background. Firstly, the size and scale of the nearest figures needs to be established, so they work in the context of the picture. When this is judged to be satisfactory, the figures that are furthest away can be sized accordingly. This then gives two points of reference: foreground and background. Once this is established, figures that fall in between the two points can be sized more easily.

Common mistake

If all the figures are of similar size irrespective of where they are positioned within the picture plane, then there will be no real sense of distance. A picture needs variety of scale to create interest and drama and also a sense of the illusion of depth.

In still life, the proportions of objects arranged on a table top are important – for example, a selection of apples with a bottle of wine. The size of the apples needs to relate to the bottle of wine. The height of an apple can be measured against the height and width of the bottle.

Proportion is also important for elements within the same subject, for example a (standing) human figure. If the height of the head is measured, then the overall height of the figure can be determined by measuring how many 'heads' high the figure is (usually around seven or eight). Furthermore, the relationship of the features – eyes, nose, mouth and ears – can be determined within the shape of the face. For example, the eye line is often said to be halfway down the face. Some artists use the width of an eye to calculate the width of the face. It is a question of finding a unit of measurement and then using that unit to check the proportions of everything else.

Proportions within a building

Similarly, when drawing a building, the proportion of a door or window to the size of the building can be determined by measuring the height of the window to establish a unit of measurement and then seeing how many windows high the building is by how many windows wide. The same unit of measurement can be used to measure other elements within the building.

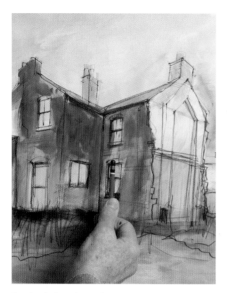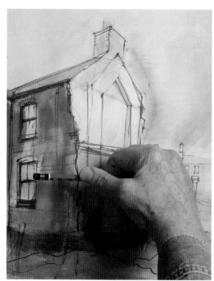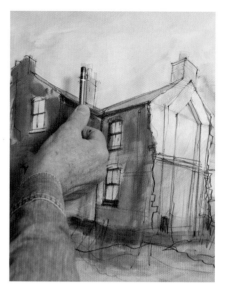

To check that I have the proportions reasonably correct within the building, I have used a pencil to take a measurement of the height of a window. Once I have determined that measurement – by using the top of the pencil and my thumb – I can then see that other elements are of similar size. The chimney and the distance from the edge of the wall to the window are the same measurement. I always use the pencil in this way to check dimensions – it is something of a habit.

Shape

Positive (and negative) shapes, rather than detail, can help a composition establish itself more quickly. A landscape may have large interlocking shapes: trees in a field, dynamic shapes that suggest movement. Negative shapes can be just as important as positive shapes, for example within a large silhouette of a group of trees where little pockets of daylight peep through between individual trees. A variety of different shapes within a composition will add interest, balance and asymmetry.

Colour

A lot of drawing, in traditional graphite or charcoal, is in monochrome, so tone needs to translate as colour. And certainly, in my view, a graphite or charcoal work is no less a work than a painting because of the absence of colour. A drawing can say many different things compared to a painting.

Colour is mentioned here because it is an important feature in a work to convey different meanings. Cool or warm colours evoke certain feelings in the viewer, for example, but they also make things advance or recede within the picture plane. For example, if something is painted red (a warm colour), it will advance; if it is painted blue (a cool colour), it will recede. Bold, bright colours can elevate moods and invoke optimism and confidence. Dark, sombre colours can create feelings of isolation and gloom.

Colour is a key feature in a work, so it is good to have an awareness of how it will affect the feel of a picture. Some artists are natural colourists; they see colour as the main point of a painting. Others see tone as more important.

Colour is very subjective, of course. Some artists strive to match the exact colours they see in a subject, others seeing it as a secondary consideration. Landscapes painted in bright primary and secondary colours are great mood elevators. The colours in a picture may not match reality – a painting can take on a different meaning other than a copy of what is in front of the artist. Such paintings can create feelings of great emotion.

Looking at this chapter's opening picture of the pit head gear, you will note that the colours are not 'realistic'; they were chosen, by way of experiment, to evoke a modern dynamic vision of a traditional subject. I had previously interpreted the same image using charcoal, graphite and pastel. The different versions say completely different things about the subject. The charcoal and graphite versions are a somewhat traditional response sympathetic to the subject, whereas the acrylic painting offers a completely different context and shifts the interpretation to a modern, contemporary take on the same subject.

EXPRESSIVE INTERPRETATION OF A TRADITIONAL SUBJECT

INTENTION

I wanted to produce an expressive painting based on a photo I had made years earlier. This image still has some resonance for me even today. I have used the same image to produce several works in graphite, charcoal, pastel and acrylic. It is a graphic image with strong perspective as well as emotional impact, and I never tire of trying to find another way to express how I feel about it. I wanted to produce something that reflected the power, solidity and monumental scale of the winding gear. I also saw it as a monument to the people who worked there.

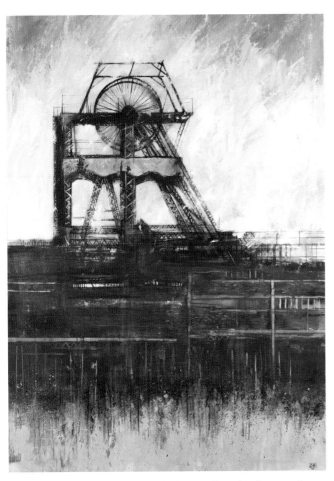

Potteries Monument: Chatterley Whitfield Pit Head Winding Gear, acrylic paint and acrylic inks on A1 paper. The exaggerated use of colour in this painting was something I wasn't sure of at the beginning, and I had doubts it would work. It was an experiment and I'm glad I continued down this path as it marked a change of direction in subsequent work. I could see that this expressive use of colour was equally as significant as the bold mark-making.

INSPIRATION

When I originally took the series of photos of the former coal mine, I shot the winding gear from many different angles. The original pale blue colour of the steel construction contrasted with the red and brown rust that had formed during decades of neglect. There was also a lot of red brickwork that filled in the vast spaces between the gigantic steel girder framework. There were broken windows of course, and the metal latticework reaching skywards to support the huge winding wheels was silhouetted against the pale featureless sky. There were pockets of light breaking through the dark shadows. A dramatic vision indeed.

It was monumental in both senses of the word: a) the sheer size, an almost impossibly huge structure for men to make; and b) because it seemed to be a memorial of remembrance to all the men who worked there, and the hard conditions they endured.

After I had made the photos it was a while before I did anything with them – the exploratory drawings I initially tried just didn't work. I struggled with the complexity of the structure and the perspective, despite being really inspired. But I did manipulate some images in Photoshop and tried effects that changed or accentuated certain colours, increasing contrast. I printed them out, put them in a folder and promptly forgot about them. I rediscovered the images years later and had the idea of producing an expressive colourful work that used a variety of techniques. I didn't want to make a 'conventional' painting with a brush.

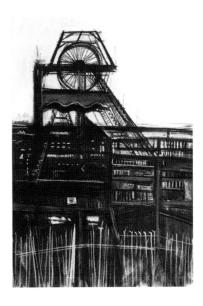

Potteries Monument, charcoal and pastel on A1 paper. An earlier version of the same subject displays a heavy covering of charcoal. Fixative was needed to enable subsequent layers to be applied. A soft white chalk was used to shape the structure and open up the solid dark areas with little dashes of light. A strong blue pastel was used to add highlights of colour to represent the painted steel structure.

MATERIALS

Sheet of A1 300gsm cartridge paper, acrylic paints, selection of brushes including a rigger (a specialist watercolour brush with long soft bristles), painting knife, acrylic inks, dipper pens, a few permanent pigmented drawing pens and markers, pencils.

METHOD

Step 1: I sketched out the drawing in pencil. It is such a complex arrangement of converging lines that the challenge was how to suggest all this complexity and create an impression of the heavy steelwork without putting all the detail in. This was a challenge throughout the picture; a lot of time was spent drawing detail, then knocking it back with washes of acrylic paint.

Step 2: Using a 25mm decorator's brush, I painted over the whole drawing with transparent white acrylic to unify everything and to lock down the drawing. The drawing was still visible. The paper was effectively primed now and ready for subsequent layers of drawing and painting.

Step 3: The drawing was strengthened first with pencil followed by black acrylic ink using a dipper pen. I also used black pigmented drawing pens for their free-flowing convenience. I painted in some of the large solid areas of colour, then alternated between working on an easel to paint and working flat to draw with the dipper pen. I painted the bottom of the picture yellow while it was upright on the easel and enjoyed the effect of colour and paint dribbling down off the bottom of the paper.

Step 4: I wanted to draw everything freehand even though it was a geometric structure with lots of straight lines and that's how I started the drawing. But I soon realized the lines needed to be straight to be effective because of all the strong perspective, so I grabbed a straightedge and started to build up the thickness of the lines where necessary. Because I was using only relatively thin drawing pens, I needed to keep going over the lines to make them thicker. I used a rigger to help this process.

Step 5: I chose coeruleum blue for the steel work as it is a bright blue that would contrast well with the rich burnt sienna I had in mind for the brickwork, and also the solid black shadow areas.

Step 6: Because the intention was to produce an expressive rather than realistic work, I searched for effects that would be sympathetic to the subject. I became looser with my paint handling, losing edges and then partially drawing them back

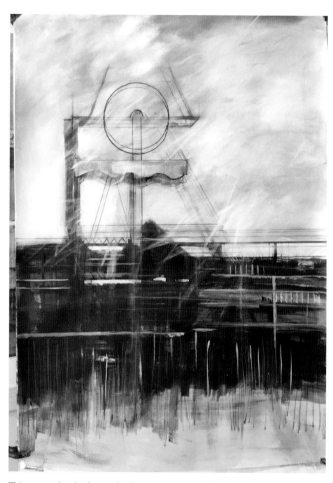

This stage clearly shows the layering process of drawing in and painting out. Everything is flexible at this stage and adjustments can still be made. The main pit head structure is starting to come together, and many layers of diluted semi-transparent paint have already been added. With a work such as this, I was experimenting and finding out things as I went along. There was no script to follow – I took each stage as it came and worked intuitively.

in. On reflection, I thought the surface of the picture was too smooth for the dramatic nature of the subject: it needed more texture and roughness. Using a painting knife, I worked over some of the painted areas, pushing the knife in various directions, and quite liked the rough feel this gave. I thought it fitted well with the subject matter and reflected the decaying, rusting structure and layers of peeling paint.

Step 7: I quite liked the balance of the abstract paint handling and the precision of the pen, and alternated between these contrasting methods to achieve what I thought was a balanced conclusion.

Step 8: There was no escaping the fact that there was a lot of drawing in this picture. I was constantly painting things in, then partially painting them out to get just the right balance.

When working with pen and ink or with the rigger, I take the picture from the easel to work flat on a table. I find I have more control this way. Here I have a selection of pens and pencils to hand so I have choice. When using the rigger it takes a while to get it working properly, so it is always an idea to practise a little first. I may dilute the ink more or switch brushes to get one that gives the right feel and control.

Here a synthetic flat brush is being used with opaque paint to adjust and soften some of the drawing. Everything in a picture must work with the rest – I like to maintain this balance throughout the making of a picture. Sometimes I will knock back a large area with a glaze, so that everything is still visible underneath, but less apparent.

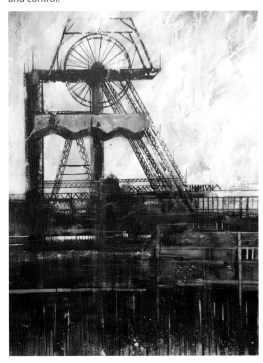

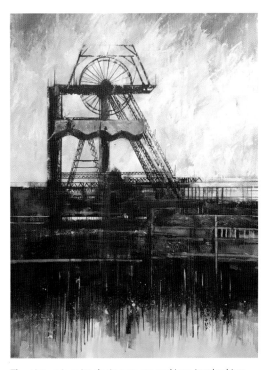

The picture is really starting to take shape now but there is still a lot to do. Initial stages can be tentative and slow while things are being tried out. Later, when there is a more definite path, there can be a more logical approach. I've been applying paint with a palette knife to give a different feel to the painted surface.

The picture is at its closing stages and I am just looking for things that need tweaking. I will rest the picture for a few days before having a fresh look at what is needed to finish it. It's important not to overdo it and take it too far. There is always a fine line between knowing when to stop and going past that point and spoiling all the hard work.

CONCLUSION

This painting was an experimental and intuitive journey, and I learned a lot by working on it. At many stages I thought it wouldn't work – the painting would show promise, then later it was the opposite. But I was determined to make it work. I frequently left it to settle before picking it up and working on it again, as I was often unsure how to continue.

Finally I had achieved what I set out to do, which was to create a contemporary take on an old subject. I hope I captured some of the power and emotive quality of the picture. For me the image still resonates today as a powerful reminder of our industrial past, and I was pleased to have created a modern interpretation of this huge structure.

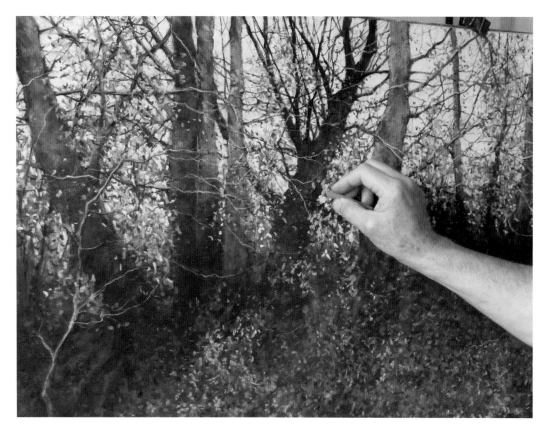

Woodland Walk, pastel and gesso on paper. This was an old pastel landscape that I had overworked and gone too thick and heavy with the smaller branches and twigs in the sky area.

There was not enough contrast in the picture, and because it was pastel on paper it was very difficult to change, so I took the drastic step of grabbing a tub of white gesso and completely painting out the sky area. The gesso messily dissolved and reacted with the pastel to make a dirty grey sky. So, initially it looked a lot worse, but got better with subsequent coats. I added white pastel over this newly painted sky, then re-drew the fine branches and leaves. The picture had acquired extra texture, which added interest. I reworked the rest of the picture to suit.

Texture

Texture can be expressed in two different ways: actual texture where the surface of the picture has had material applied to it to give thickness, and implied or perceived texture, where it is illusionary.

Actual texture

Although perhaps not as significant as composition or tone, appropriate use of texture can be a strong feature in a picture. How so? Imagine thick impasto layers applied by palette knife, and marks cut into it, or a picture made with paint that has sawdust or sand added to it. It will take on a completely different appearance from a painting with well-defined, hard edges, which has been made with a smooth synthetic brush. This is physical texture – it has a thickness and as a result will create shadows.

To a lesser extent texture will be apparent in brush-strokes, particularly with acrylics and oils, and also with techniques such as spatter or sponging. These effects will add a build-up of paint to the surface that will catch light, creating highlights and shadows.

Texture effects can be created simply by dragging charcoal, pastel, graphite and so on over a textured paper surface such as rough watercolour paper, or even heavy-weight cartridge paper that has a good 'tooth'. Texture is inherent on the surface in the same way as canvas or canvas board. Some artists like to create their own textured surface (ground) before starting to paint.

Perceived texture

Texture can be implied by creating illusionary effects by painting. The picture surface may be flat and smooth and can give the illusion of texture with painterly skill.

Mark-making

As discussed elsewhere in this book, everyone develops their own natural, particular (individual) way of making marks. In the same way that handwriting is unique, so too is a drawing or painting style. The way in which the pencil is held, the angle that it meets the paper, the grip of thumb and fingers will all influence the marks you make.

In this bold drawing I am using a soft Derwent XL graphite stick to add solidity in the trunk of the tree. These sticks are different in use to a normal graphite stick in that they lay down a matt, dusty layer that needs to be pushed into the paper to get a dark effect. Every picture is a challenge and I am always looking for something new with each drawing, whether it is complex textures of undergrowth or a busy, tangled group of trees. Sometimes I will select a picture because it is difficult to fathom, and if I can make something out of it then it becomes more satisfying.

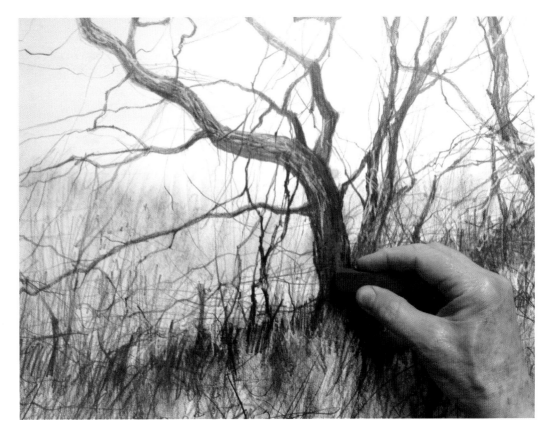

There is a unique way in which we all see things (our own personal vision of the world). We each have our own view, our own interests – we draw things in our own way. I think all these things are to be celebrated: why should we want to draw like someone else? Yes, we can admire artists, and certainly we can all learn something by copying from the masters. We are constantly being influenced by what we see, and we cannot close our eyes to external influences.

Vigorous, bold, directional marks to suggest movement will bring a dynamic quality to a drawing. Soft, flowing marks help create calm and tranquillity. This is something that can be fed into a drawing as skills develop, and the drawing is pushed further away from mere literal depiction.

Conclusion

This list of formal elements is really my own formulation. It is intended to provide a platform for discussion of your own work, that of your peers, and the work of others. It strives to give a framework through which to comment on and ask questions of your own work and as a result move it forward.

I have explained things without using jargon to give a user-friendly guide to some of the key components of a picture. There are many other things to consider when making a picture, but what I have presented here will give a good foundation on which to assess your own work. An awareness of what makes a good picture will help you achieve your own goals, and ultimately improve your work.

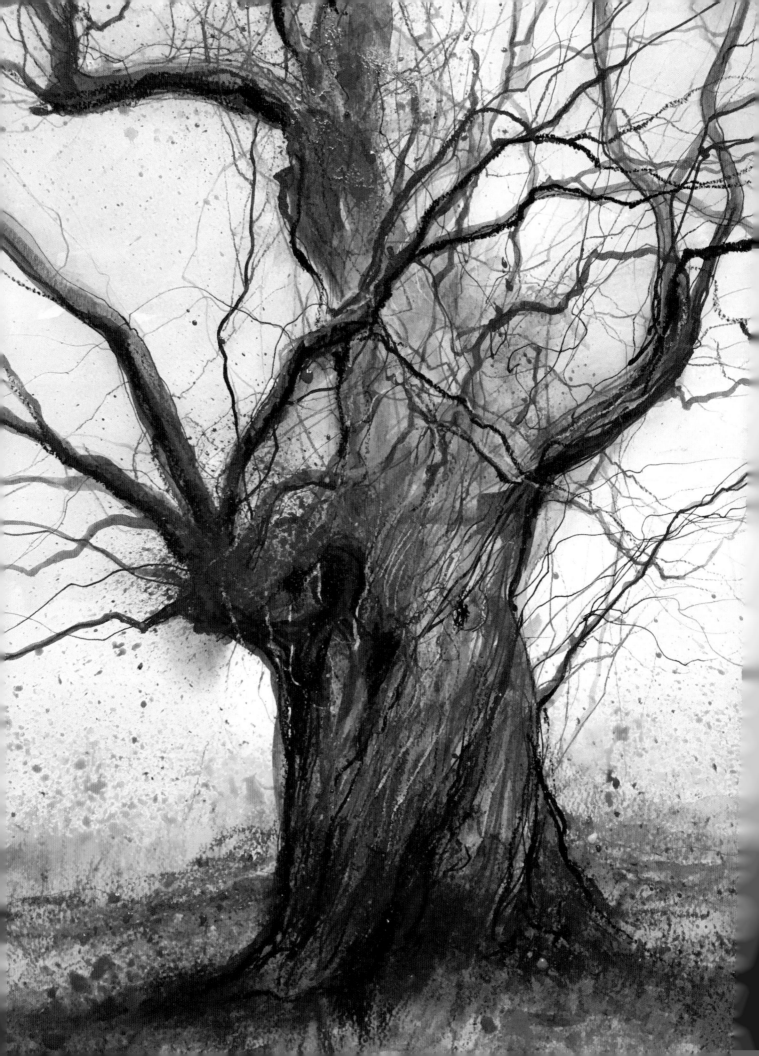

DEVELOPING YOUR STYLE AND IDEAS THROUGH SKETCHING

We have discussed at length the value of keeping a sketchbook, primarily as a resource to refer back to, to revisit themes and ideas, but also to discover what really interests you and motivates you as an artist. The more drawing and exploring you do, the more you will start to find out what works and what doesn't. By refining your interests you narrow your focus, start to specialize and begin to develop your own personal vision of the world around you. Your sketchbook is the ideal vehicle to chart this progression of your drawing skills.

Working drawings can have a certain freedom of expression, a dress rehearsal perhaps for what may or may not work in the future. There is no pressure to do a finished work; you can just explore compositional ideas, try out tonal variations and find different solutions.

Using thumbnail sketches, alternative ideas can be tested for possible paintings. Sometimes it becomes apparent that a painting may not work simply by drawing it out, but this realization at an early stage will save time and effort later, so you can go straight to the painting with more certainty that it will work.

Two pen studies of a derelict factory. I was fascinated by these chaotic scenes of abandonment – a once-busy factory now reduced to a skeleton. There was so much going on, it can seem overwhelming trying to get everything down. The main problem here was seeking a balance between the main structure of the building and the secondary nature of all the detritus. A very interesting, if not very attractive, subject to draw.

◀ *Old Oak Tree*, watercolour and mixed media on NOT watercolour paper.

Jewellery Quarter, Birmingham, pen and ink study. I enjoyed the sharp perspective and signage in this street view, close to the RBSA Gallery. I thought it would probably make a good subject for an acrylic painting. I liked the lamp post, which had quite a lean, and the shadows under the railway bridge.

A page from an A3 sketchbook: I enjoyed the perspective of the three-quarter view of the stone house and the fine wooden detailing on the oak-framed house equally. When you are sketching like this you are searching for the things that interest you personally. The more you get familiar with a subject, the better you become at drawing it.

Keep a sketchbook with you

If you get used to the idea of keeping a small pocket-sized sketchbook and mechanical pencil and taking them with you wherever you go, you will be able to make notes and quick sketches as soon as something interesting comes along.

When travelling by train or other public transport, for instance, there is a lot of activity, and many opportunities for pictures while waiting. Drawing everything that interests you will soon help you build up a library of various subjects to spark new ideas. There is value in even the quickest of sketches, especially when combined with written notes regarding colour, ambience, feeling, emotion, even sounds: you have an enhanced visual record. Later, when you flip through the pages, something will usually strike a chord and you will want to explore it further.

Enhancing a sketch

When sketching, the quickest and most direct way of describing a subject is with line: whether it is with a pencil, biro or pen. Some basic shading will help clarify things. Often when sketching on the spot, time is limited to explore all aspects of a subject, so it may be only a few scribbled lines.

Later in the studio, when time is not so pressing, I find it is useful to get out the watercolours and lay some loose washes over line drawings. The colours do not have to be exact; in fact it can be quite liberating to use colours differently. This can lead to a more creative and experimental interpretation, and allows one to explore different alternatives: for instance, sky colour. Even something as simple as changing the blue or grey of a sky will change the mood of a picture. Swap the blue for a grey and the picture will take on a completely different feel.

A couple of additions to my growing doorway collection. I have applied watercolour washes to these studies from a French sketchbook to enable me to see their potential for future paintings. The colours are only approximate but are a good visual reminder.

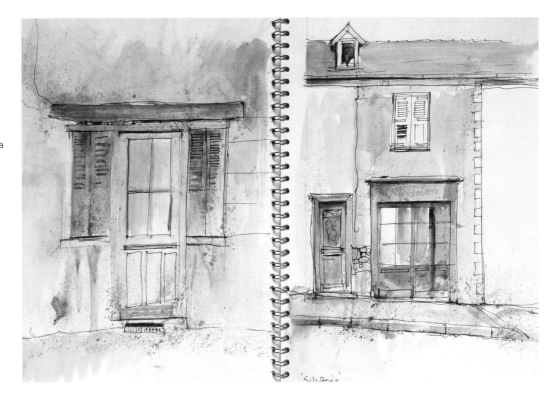

The development and progression of ideas for painting becomes logical. Having to consider alternatives for colour, composition, dramatic effect and so on drives a painting forward. Ideas can be picked up, examined and put down again, to be looked at and developed another day and viewed in a different light.

As a tool for artistic development and the formation of ideas, the sketchbook is unrivalled. Even if it is used only occasionally, it will be beneficial. Whenever I skip through the pages of an old sketchbook, there is always something there that could be developed into a painting, and naturally such development becomes fresher with the passage of time.

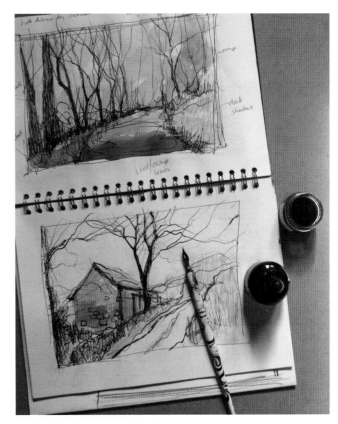

Occasionally when I am browsing some old sketchbooks and I see an interesting pencil sketch, I might draw over it in pen and ink or apply watercolour to develop it further. This exercise often leads to renewed interest in the subject and a subsequent painting might ensue. The landscape on top was later developed into a pastel; the barn with tree was started as an acrylic painting.

One of the most enjoyable things for me is inking over a pencil sketch. Sometimes I will intentionally not have the photo reference in front of me when I'm working like this, preferring to make the drawing work independently. I may pick up the photo later if I need some information or certain details. I find it quite relaxing sitting making sketches in the studio where I have the convenience of all my materials to hand.

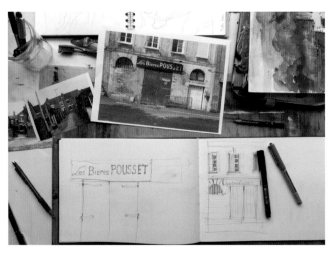

Here I am getting familiar with this abandoned building in Honfleur, Normandy for a future painting: I am sketching the signage to understand it better. Scattered around are other images and paintings awaiting attention. I sometimes enjoy switching quickly from one subject to another without much thinking time in between so I can respond visually in a direct way.

Photo reference material to inspire… My two main subject areas of natural landscape and abandoned industrial spaces are underpinned by a massive photo library. It's great to have a selection of images to browse and sketch from. I love the process of picking up a photo and exploring it through sketching until eventually a new idea starts to develop. Even though it may not reach a finished painting stage, it is still a worthwhile journey.

Using a camera to collect images

A camera gives an instant image and is capable of capturing many pictures in a short space of time. It is therefore an essential tool for the artist, especially when used alongside a sketch as back-up.

A camera can disappoint, though, when the results are later examined back at the studio. The image that initially caught your attention can often be lost in a host of background clutter. The camera lens has failed to select and isolate the thing that was of interest. If you were to draw the same scene, you would select and make judgements in a different way according to your personal view. The camera can be pointed in the same direction and capture a scene, but can never match your own unique selection process.

However, as a tool of convenience and speed it means that the artist can go on a field trip with camera in hand, shoot a load of pictures, return to the studio, download the images to a computer or tablet and start to work on the results immediately. A lot of people work directly from a computer screen nowadays, meaning there is no need to print out a photo.

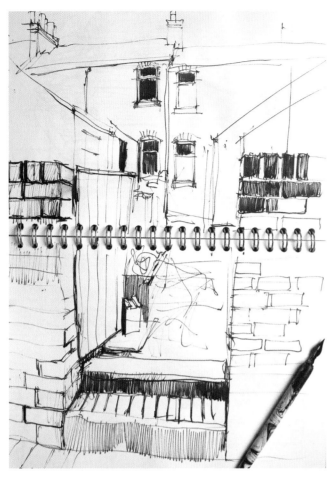

A sketchbook study across two pages in vertical format using pen and ink. Sketches like this can be loose and expressive. The line drawing has minimal shading because I am only interested in the architectural detail and compositional element. As the viewpoint is full on, there is no need to indicate three-dimensional solidity, but the steep perspective was challenging.

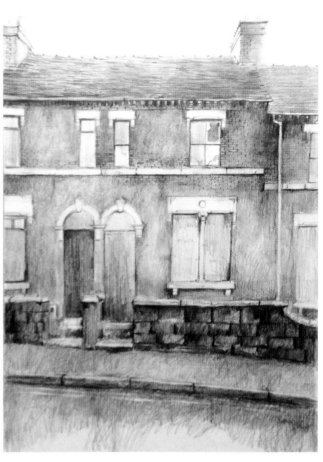

Terraces, pencil on A4 220gsm white cartridge. This unfinished drawing of a derelict terraced house has had a lot of preliminary work done. It is quite balanced in terms of background tones and a suggestion of detail. The next stage will be to continue to develop details, for example in the brickwork. Although there is a lot of work to do to make the brickwork more effective, it will create a stronger drawing, I think. The shadows will need to be strengthened to create more depth in the picture.

Developing and exploring a theme in the sketchbook: the urban landscape

Much of my urban sketchbook work has been centred around making exploratory journeys either on foot or by bike along industrial canal towpaths, stopping and drawing whatever takes my interest. This could be either a complete scene or just a small detail; both are equally satisfying to draw. Several different studies can be pieced together back in the studio to create different compositions. The sheer variety of subject matter that can be seen on a canal walk is a rich eclectic mix: from post-industrial dereliction and modern regeneration projects to conservation areas, woods, lakes and marinas. A beautifully painted narrowboat moored next to a broken building: beauty and ugliness side by side.

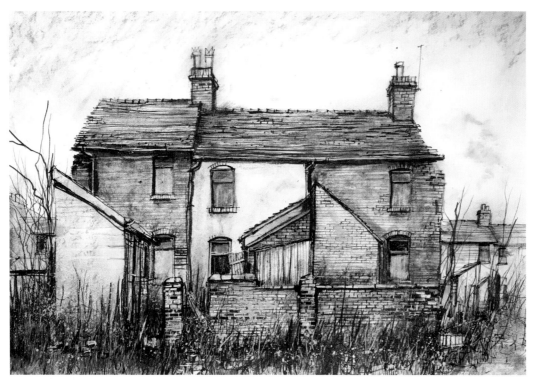

The Backs – Three Abandoned Terrace Houses, pen and Ink with charcoal on A2 paper. The finished picture has a good tonal range and interesting textures. The cartridge paper had maybe a little too much tooth to give a smooth tonal effect in the sky. The putty rubber wasn't that effective at smoothing it out. Perhaps I should have made some charcoal dust and applied it with a brush. There is often something that you wish you could have done better.

One of my favourite subjects is derelict or abandoned buildings. This particular subject is very familiar to me and I have produced a variety of work in different media: oil, acrylic, pastel, graphite, charcoal and mixed media. I think this subject will always remain important and relevant; it stimulates comment on social change, but through experimentation with different combinations of media I can say something new and explore different ideas.

For this particular piece, I knew I wanted to do a lot of detailed drawing: strong mark-making and intricate detail. I especially enjoyed the brickwork. I wanted to understand the structure of the buildings and to find ways to interpret the textures of old masonry. Nature is always trying to reclaim abandoned places, so there are often grass, weeds or even trees growing out of these man-made structures. Broken roof tiles, outbuildings and detritus are all fascinating material to draw.

MATERIALS
Daler Rowney FW black and white acrylic ink, dipper pen, 2B pencil for underdrawing, few sticks of willow charcoal, putty rubber, A2 220gsm cartridge paper.

METHOD
Step 1: The main structure (the parameters of the building) was sketched in lightly with a 2B pencil, followed by windows, chimneys, outbuildings and so on.

Step 2: The drawing was strengthened using pen and ink.

Step 3: When the ink was dry, I used the charcoal on its side to give the building some solidity. I decided to keep the sky mostly untouched with perhaps just a suggestion of tone at the top, to help frame the picture. The texture of the paper was showing through, which added to the feel of the old brickwork. I used a putty rubber to soften and add variety. Charcoal dust applied with a brush would have perhaps been more effective.

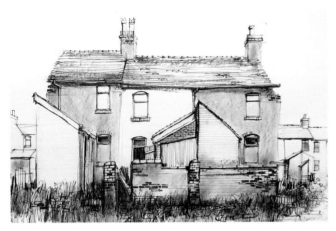

The initial pencil drawing has been inked, some charcoal tone has been applied and a little detail started. The main shapes are established now. There is no room for any big changes to be made, so it's a question of adding more detail and tone to create solidity and depth.

In this close-up, the detailed pen and ink work can be clearly seen with expressive vertical gestures for the grass and contrast with the brickwork and debris. Also clearly visible is the effect of the soft tonal qualities of the willow charcoal.

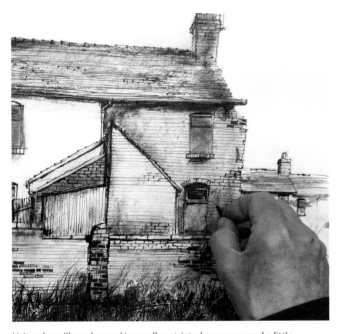

Using the willow charcoal in small, restricted areas seemed a little awkward after using the fine point of the nib. For this reason I always prefer to work A1 size to give more room to work (this drawing is A2).

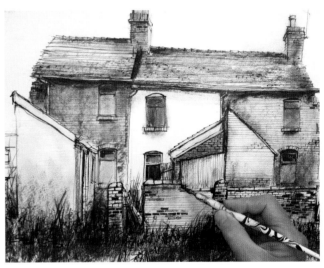

Alternating between pen and charcoal, I tried to maintain some balance. Little by little and in controlled stages, I applied charcoal tones to create more depth in the yard areas and to give more weight to the undergrowth. I worked under the eaves of the roof to pull the gutter forward and push the wall back.

Step 4: With the pen and ink I started to suggest details such as roof tiles and brickwork and so on. I also did some work on the windows, combining line with tone, and developed some looser textural work on the undergrowth. I enjoyed drawing detail with the pen; I tried to keep it balanced by moving around the picture. As soon as a few tones were established, it seemed less daunting to work on than white paper.

Step 5: The progression of the drawing followed the same pattern: working a little with the charcoal, followed by pen and ink. As the drawing developed, the shadow areas got darker and more bricks and details were drawn in.

Step 6: Towards the final stages, after resting the drawing, I decided to add even more detail.

Step 7: I used a fine mechanical eraser and lifted out some of the darker areas that had become too heavy and indistinct.

Step 8: The sky needed a little drama, so I applied more charcoal lightly at the top of the picture, softened with a putty rubber.

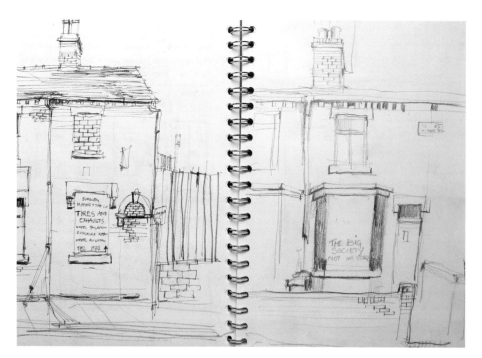

A double-page spread featuring the fronts of terraced properties. With the study on the left, I found it fascinating that what was once a normal terraced house had been transformed into a tyre business. The windows had been bricked up with concrete blocks and, along with the handwritten signage, were special points of interest. The abandoned house sketch on the right features a hand-painted message to make a political statement.

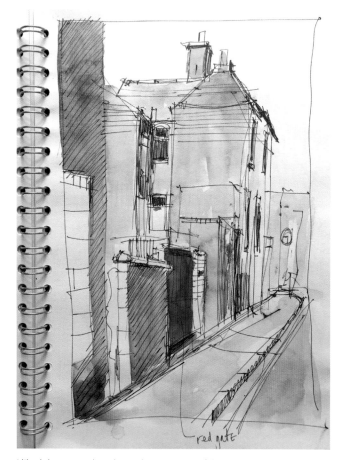

I liked the unusual angles and perspective of this picture, and also the interesting negative space of the sky. After making the pencil sketch, it appeared a little confusing, so I laid a few simple washes of colour to help identify the various elements. I'm not sure about the composition.

Capturing the post-industrial landscape

Over a period of time it became an obsession of mine to document the rapid changes taking place during the redevelopment of these old derelict industrial sites. When manufacturing industries decline – in this case pottery, coal mining and steel – factories become empty, then stripped of equipment and anything of value, including the roof, and subsequently fall rapidly into disrepair. The vernacular terraced housing that accommodated generations of workers gradually begins to be demolished and bulldozed.

This fascinating urban landscape is changing dramatically, forever. Sometimes even over the space of a couple of weeks there can be big changes, and it became a matter of urgency for me to revisit these places regularly, as they often exposed dramatic new vistas. Views that had been obscured for generations were now opened up to reveal new open spaces, albeit temporarily before new buildings were started.

There were many interesting compositional opportunities. Fine architectural details would be wrecked by bulldozers, terraced houses would be torn apart to expose their inside walls (now outside), decorated in garish coloured wallpapers and paint (yellows, purples, pinks, blues and reds), along with evidence of people's lives long gone. History was very much apparent in the dark shadows of an

unmodernized kitchen, an old fireplace or an exposed loft. Bright primary colours clashed with earth and brick colours and an extensive palette would be needed to capture the scene.

Dramatic winter or autumn skies created silhouettes of broken roofs and tall chimneys. Original, rotten sash windows in drab green would clash with modern white UPVC replacements. All this was tremendously rich subject matter to me. It was interesting to draw and to try to make sense of the broken shapes and structures. It sucked me into an imaginary world full of rich history, of imagined memories of the occupants and workers who inhabited these humble but honest buildings.

The process of drawing and investigating this charred broken landscape caused me to think profoundly about many different things. I was transported back in time. I reflected on what it was like to live and work in a different era. I think this is one of the many hidden beauties of drawing something: one is invited to think about and to try to understand the nature of the object of your attention, whether it be a tree, a portrait or a house. During this process many questions are raised, for example: how does it work – how is it made? What's its history? Or on a more practical level, how do I create a sense of form with this subject? What is the best angle to portray it? And so on.

Through this process I became more engaged with the world around me. I thought more deeply about the psychological effects of the environment on daily living, and the way in which industrial needs change the landscape.

This documentation and obsession was also driven by the desire to record for posterity a changing landscape that was fast disappearing forever. On one level it was a social commentary about the times in which we live, on a different level a reaction to our ever-changing environment.

Creating a series of work

When I referred back to my many studies, photographs and notes on the post-industrial landscape, I saw I had made many large-scale works in graphite, charcoal, pastel or paint. I also produced mixed media works, and small, more detailed acrylic paintings. Over time I amassed a huge ongoing body of work that I keep going back to at regular intervals to develop further.

Much of this work is produced in series: for example I might do a new group of four or six paintings, often using images used previously, but interpreted in a new way. *See* the project entitled 'The Pottery Workers Series'.

Pottery workers (part of an ongoing series), willow charcoal, pen and acrylic ink on paper.

This series was mostly about the workers doing their tasks. But the fabric of the nineteenth-century factory building was interesting in its own right. Often the interior walls were not plastered, merely white-washed, so many layers of flaking paint provided texture. The nine-paned windows with their curved top are a particularly recognizable feature of this type of building. Worn, bare wooden floorboards and functional shelving are key features also.

For this series I wanted to produce drawings with a different look.

PUTTING WET AND DRY MEDIA TOGETHER IN THE SAME PIECE

Normally I would not advise mixing wet and dry media in the same work, because of the potential for a muddy outcome that is often difficult or impossible to resolve. But, what I like about this combination is the contrast between the fine, hard-edged line work made by a pen nib against the broad soft tones of willow charcoal.

With the pottery workers, I waited for moments when they were totally immersed in their activity, each using their hands, demonstrating their particular skill in the production of fine dinnerware. I was quite pleased with the way the charcoal worked with the pen and ink to produce different effects.

Some time ago, I thought about doing a series of pottery workers performing their daily tasks in a traditional factory environment. I wanted a different approach: something other than pencil, something that could be strong and bold in execution but could also capture subtlety to suggest the busy work environment. A lot of my projects comprise works in series – a theme of works. A series can provide an opportunity to really get the best out of new approaches.

I had arranged a visit to an old traditional pottery factory, which dated from around 1888, and was able to see the various processes and stages in the production of plates, cups, teapots and jugs and so on and take photos and sketches. Interestingly, I was able to chat to production staff

This unfinished drawing is at an early stage where all the initial line drawing has been done. Starting with charcoal, then strengthened with ink, it awaits charcoal tone. I thought the loose drawing style suited the movement that this 'jollier' generated while producing plates made by throwing slabs of clay onto the plaster mould.

A close-up of the hands working. Here the four-part plaster moulds are being separated to release the jug formed by pouring slip into the assembled mould. Over time the plaster draws moisture from the drying slip to form a 'skin'. A delicate operation ensues to remove the jug as at this stage it is quite fragile.

and found all the related machinery and processes, whether by semi-automatic machine or by hand, incredibly fascinating. I was able to follow the whole process from the preparation of the raw materials – clay and slip – through to the finished stages of decoration and glazing.

Everywhere I looked there was an interesting corner or 'action shot' just waiting to be captured. It was difficult to focus on just one thing as there was so much going on. In this situation a camera comes into its own as it can process loads of different shots of anything and everything that interests you. It's not the same as sketching from life, of course, but when time is brief, for me it is essential. I was able to make a few notes in my sketchbook along with one or two supporting studies to get more of a feel for the place. I chose several subjects for this series of drawings, all at A2 size, working from a mixture of reference photos, notes and the sketchbook studies.

Back at the studio, after looking through all the material I had collected, I selected two or three images which I thought would work well and worked up a couple of sketches to get more familiar with the subject and to see how the idea would develop. I was reasonably confident everything would fall into place and the composition of man, woman and machine was interesting enough.

MATERIALS
Willow charcoal for the first underdrawing stage, then a dipper pen with a shaped nib to provide more flexibility, black Daler Rowney FW acrylic ink, a sheet of 'standard' – that is not too smooth or rough – 220gsm A2 white cartridge paper, a couple of pieces of putty rubber to help lift out areas if the tones got too heavy.

Tip: Whatever medium I work with, I always have a spare piece of the same paper handy on which to test things out.

This is the jollier again from behind the machine. He worked with speed and precision performing this repetitive task that required skill, strength and stamina, taking slices from a sausage-like supply of clay with a cheese cutter. It was a fascinating process to watch. I was allowed to have a go, but my attempt didn't really resemble a plate!

PREPARATION

I used the dropper from the bottle of ink to transfer enough ink to complete the drawing into a small glass or plastic container. I added a few drops of water to dilute it slightly for better flow through the nib. I tested the mixture by making some marks on a spare piece of paper.

Tip: I like the small screw-top jars of conserve you get at a B&B or café; for me these are ideal containers as the screw-top means you can keep the ink a while.

I also tried the charcoal on its side so I was sure I could make a good range of tones from light to dark. I applied different pressure, or gently cross-hatched then used a finger, piece of tissue or soft brush to see which worked best.

I didn't stretch the paper as the amount of ink used would be limited to line work. I didn't plan on laying any washes of ink. If I had planned to use the ink to create larger areas of solid black then I would expect some buckling of the paper. I think with this type of experimental drawing some slight distortion to the paper actually adds to the piece. I wasn't overly concerned if this happened.

METHOD FOR THE SERIES

Step 1: First I sketched out the composition lightly with willow charcoal, not worrying too much about exactness, as it was going to be an expressive direct drawing. I would use this as an underdrawing on which to do a stronger drawing in ink. Because the charcoal drawing was light, it didn't worry the pen nib too much in terms of picking up dust.

Step 2: Pen and ink was used to strengthen the lines of the drawing, then I let this dry before using charcoal to create the tonal areas. The drawing would be quite 'loose', and not merely a line drawing with 'filled in' precise areas of tone. As I worked into the drawing, adding detail and texture, I discovered that the beauty of using a 'dip' pen is that the quality of the line cannot be predicted because it depends on lots of different factors, for instance: how well loaded with ink the nib is; how freely the ink flows; the thickness of the nib and its quality.

Tip: I always have two or three pens at the ready, as invariably one will stop working as well as it should (ink dries on the nib and it can become clogged). It saves time to quickly grab a replacement. With this drawing the nib would also pick up charcoal dust and clog even more.

Step 3: A little planning and discipline is needed to leave some areas white, because the drawing will have more impact if it has a good tonal range, from the pure white of the paper to the black of the ink.

Step 4: Once dry, the finished drawing was fixed to keep it stable, then was overlaid with a sheet of smooth tracing paper to protect it until I was able to get a mount round it.

NOTES

Instead of using a heavyweight cartridge paper, I could have used a smooth heavyweight HP (smooth) watercolour paper, or a mixed-media paper that can handle wet and dry media equally and is quite robust in use. Make sure there is enough tooth for the charcoal to grip.

Alternatively, I could have used a conventional watercolour paper, which has a rougher texture that will give a different feel and appearance to the charcoal. The charcoal will need to be 'pushed' into the surface of the paper with either your fingers or a blender to neutralize some of the effects of the textured surface. Similarly, the pen and nib will have a more scratchy feel and will tend to pull at the surface of the paper even if a lot of care is exercised.

The 'dipper' pen will at some point, inevitably, blob a pool of ink exactly at the most inopportune moment, usually just when you are about to work on some delicate detail. You can often work with it to your advantage and the drawing can be saved, but if not, the drawing can be ruined or destined to become a practice piece. A certain amount of flexibility is needed when using this combination.

Tip: If things go wrong, don't worry too much and just put it down to experience. Save the 'ruined' drawing to try out new techniques.

Winter Trees, graphite on A2 220gsm white cartridge. I wanted to create an impressionistic drawing, meaning it would have less definition and more suggestion. I used a soft graphite stick and pushed it into the paper. I tried to build up the effect in stages, so regularly used a sharpened eraser to cut back into areas that were too solid. The most difficult but also most satisfying thing to achieve was the suggestion of a path to help pull the eye through the picture. It took great willpower to not overdo it and put in too much detail.

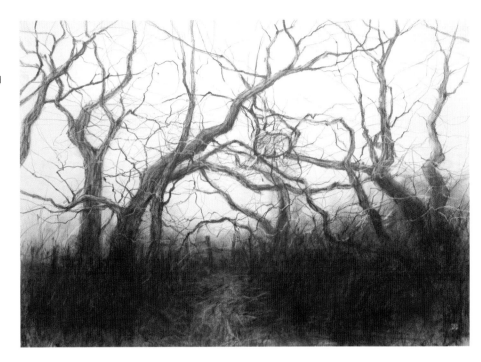

Moving forward

For me, drawing is a lifelong activity: something that is forever different, constantly challenging but always engaging. I am always discovering something new about the world and also about myself. It is a process that is in a constant state of flux, always evolving.

It is natural to keep moving forward, because along the journey, as your skills improve, you will look for more difficult subject matter to master, after which you will need new challenges. Certainly, the thought processes that occur when concentrating on a subject can continue long after the actual drawing session. The engagement with such thoughts is something that can be ticking over in the background, maintaining interest and stimulating new ideas. A good artist need never stagnate; there is always a new challenge to engage with.

Moving on from a simple sketch

Having gathered together some inspirational photos, I explore further by producing various rough sketches to find out exactly what interests me. The more studies I make, the more familiar I am with the subject and I can start to focus on particular aspects. I start to see things differently, moving things around to improve composition, altering scale to give more impact, even thinking about cropping a photo to a different format.

Choose a sketch to develop

After making a few small studies or thumbnails of my chosen photos, one or two might become favourites to develop further. I might try a larger drawing: a change of scale can make a lot of difference and can also highlight problems that at a smaller size weren't that noticeable.

Add tone

Make a tonal study by looking at a photo through half-closed eyes: everything will be out of focus, just lights and darks will be seen and no detail. Applying stronger shading to your sketch – just some simple hatching – will help you 'see' the picture better. The impact of the picture should become clearer now.

Remember: a good tonal range will add more impact to a drawing. Even when you are working in colour, there should be good tonal contrast in the colours you choose. All colours have a tonal quality.

Some artists choose to work from a colour palette that has a limited tonal range, perhaps with all the colours falling within a narrow mid-tonal range. This will create a certain ambience in a picture, suggesting serenity or calm; but if a painting lacks a good tonal range and nothing really stands out, it can lack depth.

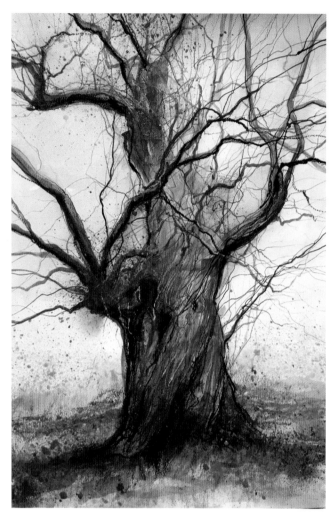

Old Oak Tree, watercolour and mixed media on NOT watercolour paper.

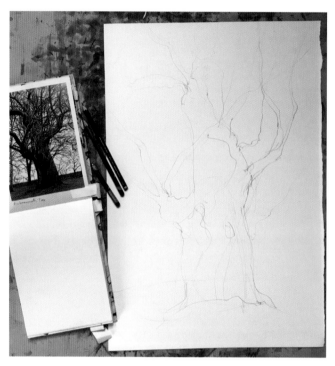

Using a small colour photo for reference, I started with a loose drawing on a roughly A3-sized sheet of watercolour paper.

The inspiration for this picture was a characterful old oak that had suffered storm damage. I particularly liked the twisting movement of the bark in the trunk of the tree. My intention was to produce a watercolour base and then draw over the top. I thought of it as a tree 'portrait'.

When working spontaneously with watercolour, I admit to being impatient when waiting for washes to dry. I tend to get carried away and continue laying wash after wash, meaning there is a tendency for things to get a little muddy at times.

MATERIALS
Watercolours, large flat brush and rigger (a specialist watercolour brush with long soft bristles), Daler Rowney FW sepia acrylic ink, dipper pen, bow pen for making thicker lines, old toothbrush for spatter, 6B pencil, pastel pencils, oil pastels, 300gsm watercolour paper.

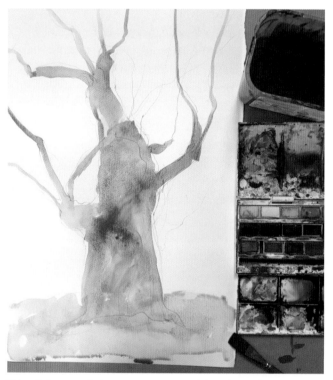

This painting wasn't about exactness or precision – it was about spontaneity and freshness. A couple of washes quickly established the format. Yes, I know the tree is in the centre of the picture, but I don't think it matters with this subject.

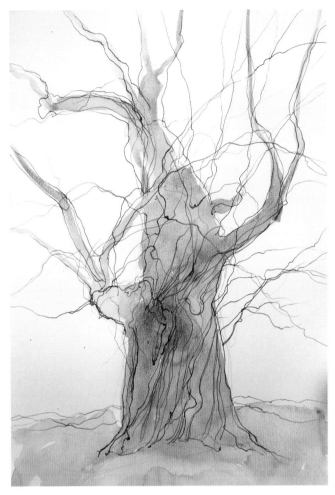

Knowing that I would be doing many layers, I drew with pencil then pen and ink to suggest the rhythm in the bark of the tree. The drawing will still show through the transparent watercolour washes.

METHOD

Step 1: Using a small photo for reference, I loosely sketched out the tree with the pencil on the watercolour paper. I didn't stretch the paper, but doing so keeps the paper nice and flat and stable while the painting is in progress. With the paper stretched there is more predictability when laying washes; unstretched paper will buckle to some degree.

Step 2: I mixed up some diluted washes: green for the grass, and brown for the tree, and loosely applied them with the large flat brush.

Step 3: Once this had dried, I used sepia ink with a few drops of water added and used the dipper pen to draw freely into the tree with lines suggesting bark. I added some small branches.

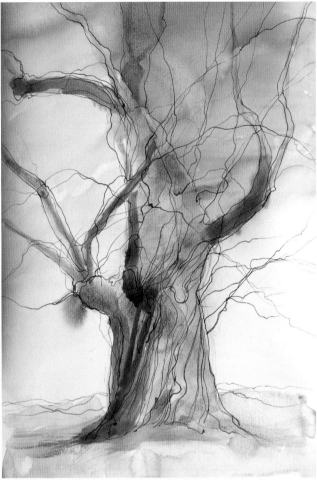

When mixing the blue wash for the sky, I miscalculated the strength and immediately realized it was too strong. I wasn't too worried at this stage – there was the option of lifting out some of the colour – or ignoring it for the moment, knowing that the rest of the picture would be more intense.

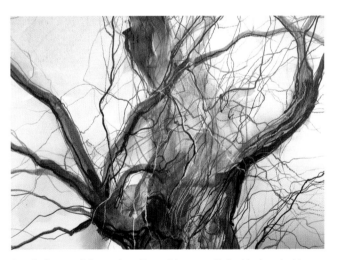

Detail of some of the mark-making with pen and ink – black and white – and also some brown pastel pencil work. Everything was looking more busy now and gave me confidence to continue.

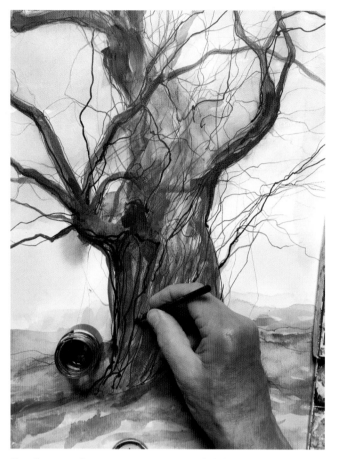

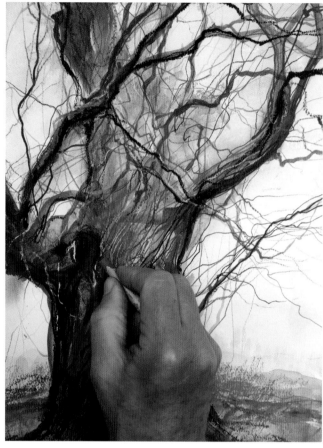

Here I'm using a bow pen or mapping pen, which has an adjustable nib that can vary the thickness of line. I am using slightly diluted ink to improve flow – to strengthen some of the line work on the thicker branches and in the shadows.

To add more variety and interest and also to exploit the texture of the paper, I decided to introduce some oil pastel. I've chosen a red brown to excite the surface a little – I thought it worked well with the flat brown wash.

Step 4: More washes suggested shadows within the tree, and blue washes were added to the sky. Once this had dried I could see that the blue was too strong, so I lifted out with clean water and a sponge to remove some of the intensity. This wasn't entirely successful but I thought that once the tree was strengthened it would balance out.

Step 5: After more work on the tree with pen and ink, I followed with some pastel pencil drawing, adding more small branches.

Step 6: On reflection, I felt the tree still wasn't solid enough, so I mixed some stronger washes of browns and yellow ochre, then added some greens around the base of the tree. The tree was strengthened with the bow pen, which created thicker lines.

Step 7: I thought the tree and undergrowth needed more texture, so I worked some oil pastels lightly over the watercolour, browns for the tree and green for the undergrowth. The texture of the paper really suited the effect I was looking for.

Step 8: I now felt the picture needed a bit of a lift, so I mixed bright yellows and greens and added them either side of the tree. For the finishing touches, I used an old toothbrush to add yellow and green spatter around the base of the tree, along with some fine pen lines for the small branches.

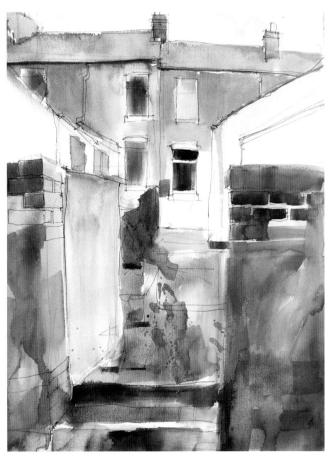

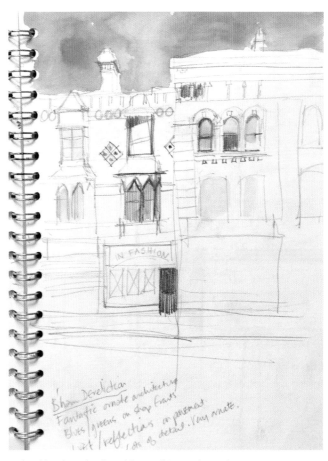

Loose watercolour washes are laid over a pen and ink drawing. I freely mixed random colour, accentuating the colours that I actually saw – so purples mix with red browns. It's 'resting' in a folder awaiting the next stage. I will enjoy re-discovering it later and will look at it with fresh eyes and make something of it. For me, it is often the stages before completion that hold a lot of excitement; there are so many interesting things happening throughout the making of a picture.

A sketchbook study of an old part of Birmingham. There were so many interesting features to this group of buildings – beautiful craftsman-built design elements that are missing from modern architecture. I have laid a blue wash in the negative shape of the sky to accentuate the roof shape.

Find your own interests

Regular sketchbook activity will help keep your ideas flowing as well as improve your drawing and observational skills.

When viewing an exhibition you may see a variety of works that might perhaps inform your own thoughts and reasons for making pictures. You may see something that sparks an idea: the way in which a colour has been used, the way paint has been applied, the quality of brushwork, or a fresh approach to a traditional subject matter, and so on. We are all influenced either directly or indirectly by what we see and experience, whether profoundly or subtly. Certain things have the power to challenge our perceptions. It is virtually impossible to work in isolation and without influence.

Through the practice of tackling different subjects you will find out what things you like – and these will naturally work out better. If you are receptive to new ideas and thoughts, your work will become more rounded, and there will be good progression and deeper understanding of what you do.

Ongoing urban landscape project

Having made lots of exploratory colour studies in my own sketchbook, based on documentary photos of a redevelopment area where terraced houses and old factories awaited their fate from the bulldozers, I wanted to explore how they might work as paintings or drawings. I had already thought about the subject and composition through the process of making the photos.

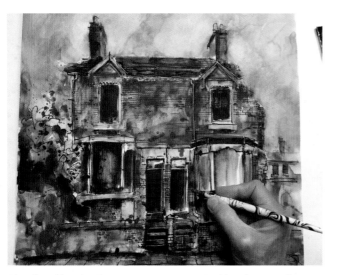

Abandoned houses: Continuing my regeneration/abandonment theme, this painting started with a basic pencil drawing on cartridge paper. I continued by laying various watercolour washes over the top, working light to dark. I dropped in some stronger washes wet-in-wet until it became unworkable; there were just too many wet areas. Once dry, I took some black acrylic ink and a dipper pen and started to strengthen the drawing. I wanted to suggest a lot of the brickwork without having to draw every single brick. It is always difficult to achieve a balance. I also did some drawing with white acrylic ink into the darker areas to suggest some highlights and the mortar between the bricks.

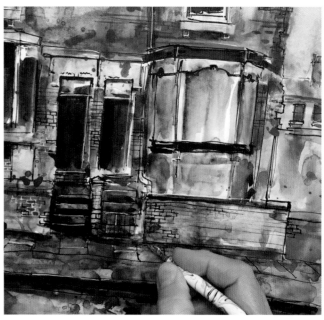

As the drawing developed I wiped out some of the stronger watercolour. On reflection, the colour would have looked better if I had worked on watercolour paper. Watercolour effects are not that successful on plain cartridge paper – the colour loses its intensity and the surface won't stand a lot of wiping out or wet-in-wet work. I was quite happy with the effect though, and enjoyed working over the layers with pen and ink.

I hadn't got a fixed idea of exactly how I wanted the pictures to look; I produced many sketches to get familiar with the subject and to explore textures and detail and so on. This was going to be an ongoing project that I could keep going back to. One painting alone couldn't possibly say all that I wanted to say about the enormous social and visual changes taking place. Whole streets and communities were being destroyed; there needed to be a body of work to best represent this.

I had witnessed dramatic transformations over short periods of time, and came to the conclusion that soon a whole slice of heritage would be lost forever. I felt a compelling urge to document these changes so that future generations might understand the history and significance of the area and put it into context.

What had started out as a photographic documentary project eventually became an ongoing artistic one where I could use the subject matter as a means to explore different drawing and painting media and discover new ways of working. It was through close observation, making many studies and much reflecting on the subject that I really got to know it well: drawing houses, shop fronts, factories, fascinating bits of detail, and then developing these studies into larger works.

Practical considerations

How might the series work? As small pen and ink drawings; as large graphite or charcoal works on paper; or perhaps small detailed acrylic paintings to draw the viewer in; maybe a variety of different media would give more scope and allow diverse ideas to be expressed?

Often, I follow a certain path instinctively and know it will work; at other times I dive straight in the deep end and discover too late that it doesn't work. At times I realize to my cost that I am too impatient to start a painting and have not thought the idea through enough, and as a result have hit snags. For this reason, it is good practice to do some preparatory work. It doesn't have to be in a sketchbook, although a sketchbook keeps everything in one place. I sometimes make working drawings on larger sheets of paper, which gives more scope, but then it's more difficult to keep them all together.

The process

I will make some pencil sketches so I can see what works best and then follow up with some watercolour to wash in some colour. I will then work into the sketch to strengthen it and make adjustments before deciding if there is any mileage in the idea.

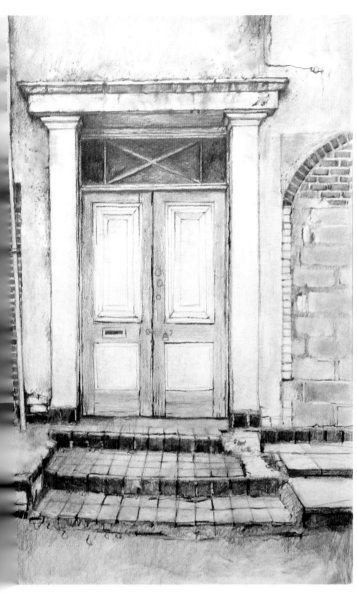

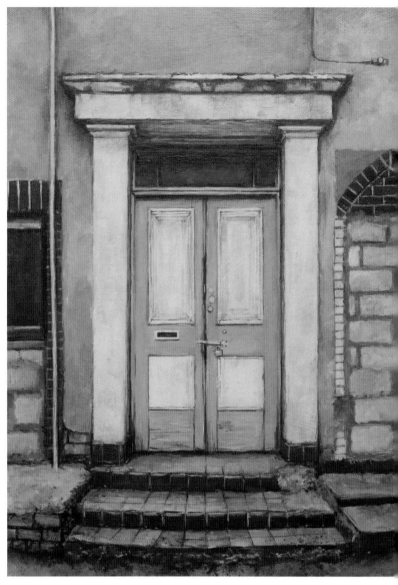

Tunstall Doorway, graphite on A2 220gsm cartridge. I think doorways make great subjects for drawings or paintings. This particular doorway has been the inspiration for large charcoal and graphite versions, and also a small acrylic painting. I have enjoyed working on them all. I chose this particular doorway because of the many different textures: brickwork, concrete blocks, tiles, rendering and so on. Because of the scale of the doorway there are some interesting perspective challenges. There is a lot of depth due to the long steps.

Tunstall Doorway, acrylics on board. This small painting in acrylics was very satisfying to do after getting to know the subject better through drawing.

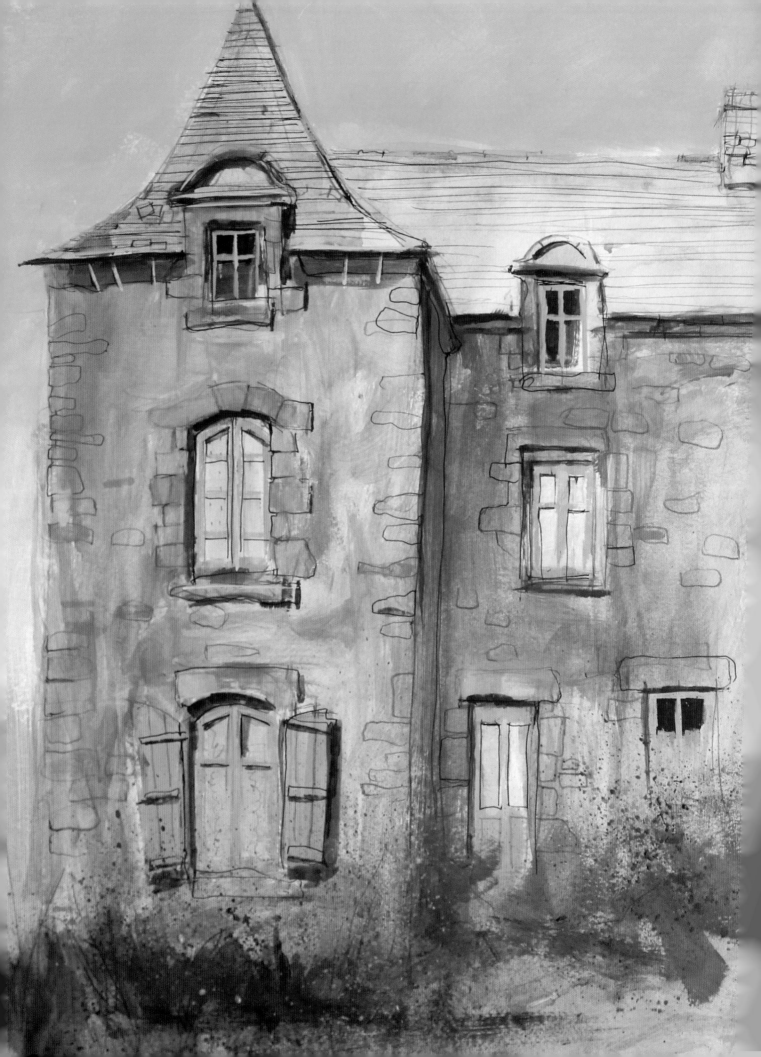

CHOOSING A SUBJECT

I n painting, there are traditional subject areas or genres, and your particular interests will probably fall into one or more of these categories. I have taken a traditional list, including portraiture, landscape, still life, narrative and so on, and given it my own update so that it fits contemporary practice and ideas. Tradition would normally place portraiture at the top, followed by landscape, then still life, etc.

My own take on this is to broaden the list as follows (in no particular order of hierarchy): portraiture, natural landscape, urban landscape, seascape, still life and narrative. I would include plein air painting as a separate genre, even though other subject areas come into it, for example natural and urban landscape, portraiture and so on.

It is interesting to know in which category your chosen subject falls, if only because you can see what the other possibilities are and how your own work fits into the bigger scheme of things. At this point I would advise against rating one genre over another – they are all valid. Furthermore, I would say that 'it's not what you paint – it's the way you paint it.' Meaning that some artists can make a great picture from a lowly everyday subject because of the way they have interpreted it. I am often pleasantly surprised when I see a painting of what I considered a really uninteresting subject in a gallery, and the artist has turned it into a thing of beauty.

Here I explore some of the genres and discuss their merits.

Choices for the plein air artist

Naturally, some subjects do not fall easily into a particular category, or may overlap into two or more different areas, for example a portrait in a landscape setting or a still life painted en plein air.

By way of explanation, I have classified plein air painting separately because the plein air painter's objective is, I think, quite different from that of the studio painter (we will discuss this later). The final drawing or painting will often have a different look or 'feel' to one produced from a photograph in the studio, though not always.

The plein air painter, by definition, is always battling against the clock or the elements, or both. So they have to work quickly, to get everything down before light fails, or a storm begins or any number of other constraints or external influences. And they have to find ways to overcome these things or use them to their advantage.

Such is the challenge of plein air painting – the work is about capturing a fleeting moment in time, responding to whatever is the other side of the easel. It could be argued that it is the most challenging genre of all – reacting to a scene by capturing anything and everything within a limited timeframe often under challenging and changing conditions.

A sort of shorthand develops, enabling a subject to be rendered with just a few strokes. A databank of images is formed within the artist's visual memory – a thousand different poses of people, a taxi or bus from any angle, a passing car, movement and drama. All these things are observed, often in the blink of an eye, and translated in paint or pencil without really thinking about it.

◀ *Old Green House*, Péaule, Brittany, acrylic on paper, 60 × 42cm.

While taking part in a plein air painting competition in Brittany, I set up my easel on the opposite side of the road from this fantastic old empty house. For me it was quite a find as it was completely original – it had some great features. Here I'm working against the clock to get some initial drawing done to get the proportions reasonably accurate so it fits onto the paper.

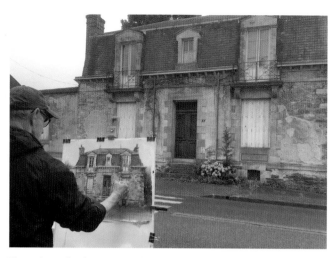

Throughout the day it was cool and drizzly, but not enough to put a dampener on the experience. Painting outdoors is different every day – the people you meet, the weather, your ability to get everything down in time. I'm at the closing stages here, painting in acrylics that still dried relatively quickly despite the damp conditions.

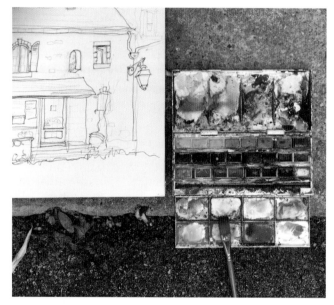

Here I've laid the paper flat on the ground so I can lay some watercolour washes without them running off the page. I started with a pencil sketch, then I inked over the drawing. The plan was to apply some colour, then go back over with the pen to strengthen. I found the resulting finished picture to be too weak. I was disappointed.

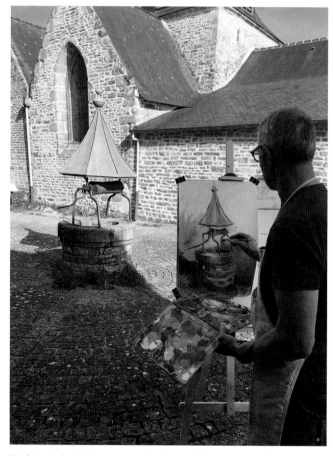

Working in the shade to escape the heat of the sun – one of the extremes of working outside. This viewpoint wasn't my preferred option, but it was just too hot to work on the other side of the well. The paint was drying out far too quickly for one thing. The shadows were too strong also. I didn't finish the picture.

Outdoor painters will often have their favourite places to paint, but many constantly seek new subject matter, relishing the challenge of capturing something different: always working against the clock, refining their skills and repertoire, building on their experience and creating their view of the world.

First-hand plein air experience

I am primarily a studio painter. It has always suited me to work whenever I had time – day or night – and I like to have all my materials to hand. I want the stability of a consistent environment so at least there is some control over what I do – no battling the elements or failing light. However, during a spell in France, I really got into plein air painting, partly because of the stable ambient weather and also the subject matter.

At first I found it very challenging – adopting studio techniques in an outside environment didn't work for me. I was also very tentative at first, unsure about the approach to take. However, I was pleased with my first attempt while it was in progress – it was basically a drawing with water-colour washes followed by pen and ink. But later when I looked at it again, it was incredibly weak. I rose to the challenge with subsequent efforts, switching to acrylics, which I felt more comfortable with.

After several painting excursions, however, I am a convert. I absolutely love everything about the experience – apart from strong winds! It really focuses the mind when you have to produce a painting within a given timeframe.

Using just a couple of coloured pastels with white, this expressive portrait done during a life class has no reference to true colours, so that all the concerns about colour matching are non-existent, meaning that I was free to focus on other elements such as form, proportion and expression. I used the white towards the end for detail work and highlights.

Portraiture

Portraiture is considered by many to be the most difficult subject to master, and when done well one can see the justification. Drawing the human head is a very challenging but ultimately very rewarding experience. A lot of artists are afraid to tackle such a difficult subject for fear that the outcome bears no resemblance to the sitter. But it is certainly worth attempting to see what you can learn.

Portraiture tests many skills: proportion, perspective, form, composition, colour mixing and matching, as well as using close observation of detail to create a likeness. When attempting a portrait, it is one thing to get down the general form of the head, but a big step further to get a recognizable likeness. Often students will ask, why doesn't my picture look like the sitter? The shape and position of the eyes and their relationship with other features, the line of a nose, a slight upturn at the corner of the mouth: if these individual, unique characteristics are not present, then the portrait misses out on being a likeness.

Sometimes, though, it is possible to capture the essence of a person with just a quick sketch. In tourist hotspots, the quick sketch artists are able to get the likeness of a complete stranger in a few minutes. They have trained and honed their analysis of a person's essential characteristics and are able to exaggerate these to good effect.

If you haven't as yet tried portraiture, then I recommend you do. The process of trying to make it work is a valuable experience. Of course it is a challenge to get correct proportion and form and so on, but the process you go through trying to figure out what is wrong when it doesn't work is very useful.

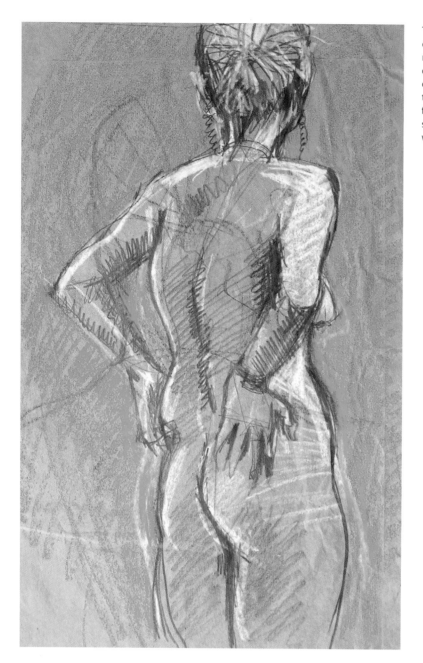

This small study uses pencil with Caran d'Ache watercolour sticks (used dry) on a recycled brown envelope. The paper has degraded over time to reveal a drawing on the other side. The mid-tone brown of the paper is a good tonal representation for the model. The bright blue used to separate the figure from the background worked well, I thought.

The human figure

Under this portraiture section, by extension I have included the human figure. People in different poses – family and friends groupings, people working and at play, doing sport and everyday activities – will always generate interest in the viewer as it is who we are. People are interested in people – we are all interested in human activity, it broadens our experience and it is something we can relate to.

Animal portraits

Similarly, animal portraits and wildlife studies offer a more specialized but equally popular choice of subject matter. It is interesting and challenging to try to capture the essence of the character of an animal. This area is more specialized but offers tremendous possibilities for expression in different media.

I thought it would be challenging to do an animal drawing when I saw this sheep. I worked from a photograph as sheep are rarely still and as soon as you get close they naturally run away. After doing a few pencil studies I tried pen, which I thought worked so much better. I used a roller ball pen, which glided easily over the paper surface.

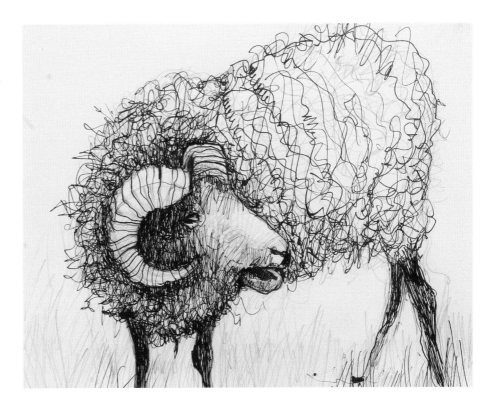

Here I'm trying out the possibility of producing a painting of these windswept trees on a Welsh hillside. Applying some green acrylic to the grass helped me see the picture better. I remained unconvinced though, as although the trees had a lot of character and energy, their movement was all one way.

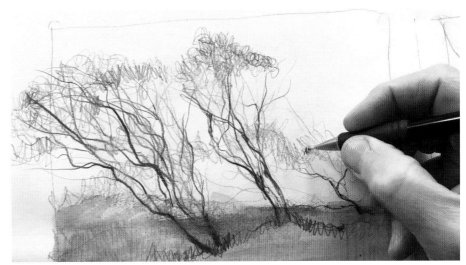

Often it is the things that don't work that give us the best learning experience; we remember them because we have to work out solutions to the problems. If we adopt the approach that each drawing is a new step on a journey, a process to learn more about something and improve skills, then good progress will be made. We need to keep learning new things, new techniques and new skills to move forward with our art.

The natural landscape

Landscapes are always popular with artists. Certainly with today's focus on environmental issues and the need to protect the natural landscape, this genre will always be important.

Of course it has long been a traditional role of the artist to capture beauty wherever it may lie: in the natural world, the human form, the animal kingdom or even man-made objects. Many artists focus on and specialize in certain aspects of the natural environment: water, woodland, mountains, the coast and so on.

Plein air or studio?

On a good day, painting the landscape while being immersed in it is a most pleasurable experience. The more you do it, the more you get used to preparing for a sudden shower or gust of wind or working in intense heat. Obviously, plein air painting suits certain media better than others. In my experience, one of the most challenging materials to work with outside is pastels, in particular pastels on paper. For me it's just too precarious. Many artists choose watercolour or oil. I like working with acrylics outdoors even though it's a struggle to stop the paints drying out, particularly in hot weather.

My own preference is to take a camera and sketchbook to record as many different aspects as possible to develop later in the studio. This allows me to work on many different pictures at the same time.

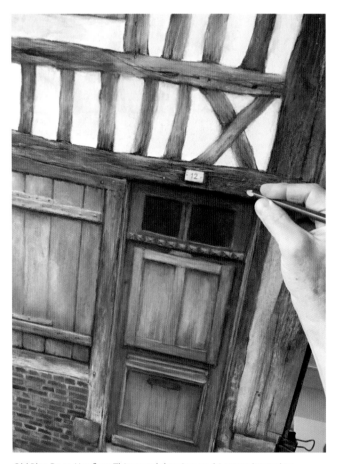

Old Blue Door, Honfleur. This pastel drawing on A1 paper is nearing completion, having had many layers applied. The whole point of choosing this subject was all the wonderful detail and texture in every square centimetre. So I spent a lot of effort trying to build and maintain detail, such as the grain of the oak frame and the mouldings on the door. I achieved this by using pastel pencils, backed up by carefully sharpened pastel sticks. Very enjoyable, if time-consuming.

Exploring the urban landscape/ cityscape

Urban sketching is a worldwide phenomenon, and many manufacturers have built and expanded whole product ranges around it. It promotes drawing within a group as a social event, with people often meeting at a pre-arranged destination determined through social media.

If you want to try this activity, minimize set-up time and maximize drawing opportunities by grabbing a handful of pigmented ink drawing pens in a range of nib thicknesses and either some coloured markers or even a set of grey markers if you prefer working in mono. Or simply take a couple of mechanical pencils and maybe four or five coloured pencils to block in basic colours. A spiral-bound sketchbook is easier to hold one-handed than the bound version, which you have to hold open. Many people take a small folding seat for comfort.

The urban environment has provided countless subjects for me over the years. It is forever changing, always different and therefore never boring. Whether, like me, you live in a post-industrial landscape (of which there are many) or somewhere more rural, nature reclaims neglected buildings and over years dramatic changes can take place. It is these dramatic changes that hold a lot of fascination for my own work.

Work can take on different meanings: social commentary, hidden stories, the passage of time, strange juxtapositions of old and new. Different textures, colours, interesting architectural features, busy street scenes, old churches and factories, signs, and so on – there is so much to explore.

Seascapes and water

Such is the ever-changing fascination of the sea that it deserves to be a genre all of its own. Colour, texture, movement and the constantly shifting effects of light on its surface are difficult but incredible things to get down.

Painting water holds many challenges: reflections, transparency, movement are all difficult things to capture.

In a broader context, the marine environment holds even more fascination: the activity around a busy harbour with all the interest surrounding fishing and boats; a typical beach with all its colourful human activity – windsurfing, swimming and families playing games; rock pools with varied marine life. Boats of various sizes and shapes bobbing up and down in the water or resting upturned along with brightly coloured buoys, coloured fishing nets and so on, all offer exciting opportunities.

Skyscapes

Skies are such a fascinating subject to paint that they deserve their own category, in my view. Fast-moving clouds are very difficult to capture; they can feature every colour imaginable – occasionally (fantastically) all at the same time. When the conditions are right – often in early spring or late autumn (and usually when you haven't got your camera to hand) – you may be presented with a stunning vista of such drama and intensity that it seems as though there is a huge fire beyond the horizon. In these conditions, the urge to record this immensely bright inferno of colours often ends in disappointment as the camera is unable to capture the contrast and intensity of light. Similarly with paint, creating the intensity of light is a real challenge.

That great observer of skies, John Constable (1776–1837), was so keen to get his skies looking as natural as possible that he would go out in all weathers with his sketchbook or canvas and make studies of cloud formations to be used as reference material for his paintings. If you have ever tried this, you will realize how difficult it is to capture fast-moving clouds. Try it yourself when there is a particularly interesting sky; it is a great exercise to do. Of course Norfolk and Suffolk (Constable country) are well known for their big skies. The flat topography means that when working in the landscape, the sky naturally occupies a large proportion of the view and so becomes a dominant element of the picture. I recommend taking a closer look at Constable's skies, and also the work of Edward Seago (1910–74), another British painter from Norfolk who painted dramatic skies in oil and watercolour.

Still life

Symbolism plays a big part in still life, going back to the Dutch golden age of the 1600s, where each object had a specific meaning enabling a subtle or bold statement to be expressed. Objects such as a lemon half-peeled, a human skull, a wine goblet lying on its side, books, meat and flowers all had hidden meanings, which formed a narrative when used in different contexts.

Still life objects can be a way of exploring the things that have special meaning to you – personal memorabilia of particular significance. When viewed in this context, still life offers huge potential for expressing themes and ideas.

Narrative painting

In simple terms, narrative painting tells a story or weaves a plot – but within a single painting. It requires technical skill as well as imagination. It also relies on the artist having an individual style.

I have suggested some subject areas above for your consideration, because I think this overview will help you see where your own preferences fit in the greater scheme of things. Some subjects do not classify easily, or are a combination of one or more different genres, or have elements of different genres within one work. Labels are not important.

DRAWING FROM LIFE OR FROM PHOTOGRAPHS

This chapter considers the advantages or disadvantages of drawing from life compared to working from photographs. It is not the intention to suggest one approach over the other, simply to present the merits of both ways of working and allow you to form your own opinion. If you work exclusively from photos, I would certainly advise making some drawings from life, and vice versa. It is worth discussing these different options, as sometimes a new approach, subject or using new materials can stimulate new ideas.

The two ways are quite different. Drawing from life involves making decisions about form, scale, composition and so on when there is no fixed image in front of you that has been 'translated' and cropped, and where a lot of decisions have already been made for you. On the other hand, drawing from photographs doesn't necessarily mean that the painting has to adopt a photorealistic approach or be too calculated; it too can be interpretive in approach.

Photographs as inspiration

Selecting a photo that inspires you, then positioning it next to your paper, board or canvas and setting to work is convenient and practical. You can keep going back to the painting whenever time permits, as the photo doesn't change – it is constant. There is a certain consistency with this method. You can set up the painting somewhere else and continue – it is readily transportable and transferable.

Nowadays, taking a photograph is so easy; nearly everyone has a device for making photographs, whether it's a camera or mobile phone, and it is not always necessary to print out an actual physical photo. A lot of people paint from an image viewed through a computer screen, tablet or mobile phone. The image is much brighter and clearer in this format as it is backlit. A few minutes after capturing an image on a device you could be using it to draw or paint from. Such is the convenience of this technology that it can be used to capture a permanent record of a still life set-up or plein air session, so the painting can be continued at a more convenient time or back at the studio.

When painting still life in the studio, the set-up must ideally remain in position until the painting is completed, occupying valuable space. There is also the issue of lighting to consider: if you prefer natural light, then depending on the time of day or the weather it could be constantly changing. Studio lighting can give a consistent light source. Natural lighting is the best, but is unpredictable, meaning the painting remains in a constant state of flux until the end. A camera will make a record of your still life set-up, enabling the painting to be worked on if the light changes too much or the fruit or flowers fade.

If you are working from a photograph, there are two main choices when translating the image into a drawing or painting. A grid can be drawn or overlaid on the photo, then the image recreated square by square onto your surface; or you simply place the photo in front of you and draw directly from it. Experience often tells us when it may be more effective to choose one method over the other. Of course there are many artists who will have never used and have no interest in using the gridding-up method. On the

Tangled Branches with Dry Stone Wall (detail), pastel on A1 cartridge paper.

other hand, some prefer the reassurance of a grid so that everything is in the right place.

There is a selection of grid apps available for tablet or laptop to use on a selected image. If the image and grid are saved to the device, the process can be made without the cost of printing out a photograph or drawing a grid by hand.

Gridding up or working directly?

In this section we will discuss two quite different approaches: gridding or squaring up and drawing directly from a photograph. Using a grid ensures an accurate starting point, even though the work can later take a more expressive route. The key elements of the picture are anchored in a precise underdrawing. Just because a picture has been started in this way doesn't mean that it has to continue like this to be an exact copy of the photograph – it doesn't have to be a 'tight' painting. The drawing may start off being an accurate representation of the photo, but depending on what follows, there may only be a suggestion of those original marks remaining at the end.

Portraiture is a genre where accuracy is usually essential. If the picture is going to be recognizably of the person, taking a good photo and using a grid makes a lot of sense. Many professional portraitists work in this way. Of course, producing a good portrait involves much more than just getting the features in the right place; something of the character or spirit of the person must come through, and many artists prefer to work directly from the sitter to capture the aura of the person.

In the case of a complex cityscape, where it is difficult to make sense of the composition because there is too much going on, using a grid will help to organize and get the information down.

For the gridding-up process to work, the proportion of the photo must match that of the drawing or painting. This is where the process can very quickly go awry. Both photo and drawing must be the same proportion.

GRIDDING UP A PHOTO

The process involves choosing a photo, ideally getting an enlargement of it, then drawing vertical and horizontal lines on it to create squares (a grid). The next step is to reference the squares on the photo to replicate the information into the squares on your paper or other painting surface. The grid lines can be easily removed once the drawing is completed.

MATERIALS
Photocopy enlargement of photo, pencil, black biro, T-square, ruler, masking tape, A3 cartridge paper.

METHOD
Step 1: Choose a good photo. If you have any doubts about whether it will work as a drawing or painting, use your sketchbook to try some studies to test the composition.

Step 2: I usually like to print out an enlarged A4 version, or get an enlarged photocopy. The detail is much clearer and the grid will work better at a larger size. Use masking tape to fix it to a piece of board or card that is bigger than the photo.

Step 3: Measure the width and height and decide how many squares are needed. Smaller squares mean more accuracy or a more complex picture, for example, a cityscape. Use bigger, therefore fewer, squares when the subject is more simple, for example this doorway.

Step 4: This picture measures 24 × 18cm, so I chose 3cm squares. This gave me six squares wide (18cm divided by 3cm equals six squares), and eight squares high (24cm divided by 3cm equals eight squares). Marks were made on the photocopy to indicate the 3cm increments.

Step 5: Use a T-square to line up the marks and draw vertical and horizontal lines. You will have now created a grid of squares. Number the squares 1–6 and 1–8; this is the ratio or proportion of the photo.

Tip: Use a pencil to mark off the 8 × 6 measurements, double check they are correct, then use a black biro to draw the grid on the photocopy.

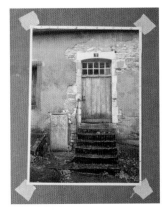

The enlarged (A4) photocopy is taped squarely to a board or stiff card. It is measured (H24cm × W18cm) and a unit of measure is calculated – in this case 3cm squares would give 8 squares deep by 6 squares wide – which is a perfect size.

The width was measured then marked and numbered with increments at 3cm intervals.

Measuring then marking and numbering the increments at 3cm intervals on the height.

Using a T-square and black biro, carefully draw vertical and horizontal lines to form the squares.

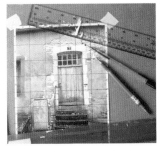

The photo is squared up ready to be transferred onto the paper. Ruler, pencil, black biro and T-square are the equipment needed.

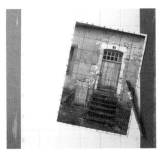

Using the A3 sheet of paper, we know that the proportions of photo and paper match. So measure the width and divide by 6, the same with the height and divide by 8. This should give you 5cm increments.

Check that the squares on the photocopy match those on the paper. Use the T-square to draw horizontal and vertical lines to make squares. Number the squares to correspond to the photo.

If everything is correct, start the drawing by going for the big shapes first, in this case the actual doorway. Move from square to square slowly. Draw in all the main elements first. Keep checking for accuracy.

Follow the squares either row by row or by main shapes, depending on the complexity of the subject.

The completed drawing is ready for the next stage, which might be to strengthen the drawing or overlay pale washes of paint, depending on your original idea.

Step 6: Once the photo has a grid, it can then be translated onto your piece of paper, board or canvas.

Note: Because the photocopy is A4, you can choose A3, A2 or A1 paper and it will be the same proportion. I am using A3 cartridge paper (approx. 42 × 30cm).

Step 7: Now take the paper and measure the height and divide by eight. This will give the dimension of your squares – in this case 5cm. Mark the 5cm increments on the width. This should give six squares (30 divided by 5 equals 6). Don't worry if there is a bit over or under, this can be 'lost' in the drawing. The important thing is that the squares are accurate. In this case it was close enough; there is just 2cm extra on the height (5cm × 8 squares equals 40cm with 2cm over).

Step 8: Using the T-square draw the vertical and horizontal lines lightly in pencil to give squares. Number the squares to match those on the photo (8 × 6). That's the paper gridded.

Step 9: The next step is to make the drawing by following the outlines of the main shapes – in this case the doorway itself. Some people start top left and work their way through. Others select distinctive shapes and draw these first. Draw lightly at first until you are sure the drawing is accurate.

Step 10: Check the drawing and make any amendments, but keep the grid intact in case it is needed at a later stage. When the drawing is well established the grid can be erased.

Step 11: Develop the drawing according to your original idea.

MATCHING THE PROPORTIONS

If the original photo is, for example, a square format or a 'letterbox' shape, the paper will need to be cut to match this proportion. To match the proportion of the photo to the paper, position the photo in the bottom left corner, so the vertical and horizontal edges line up. Using a long ruler or other straight edge, place it diagonally on the bottom left and top right corners, and draw a line through the two points until it meets the right-hand side of the paper, then draw either a horizontal or vertical line till it meets the opposite edge of the paper. You have now matched the proportions. Cut the paper to size, if necessary.

To check that the photo and paper are the same proportions, position the photo bottom left on your paper so it sits exactly in the corner. Then take a long straight edge and position it diagonally from the bottom left corner and top right corner of the photo, then follow the diagonal until it reaches one edge of the paper – in this case the right edge.

Draw a horizontal line from where the diagonal meets the vertical side. Use a T-square to complete the rectangle. Cut the paper accordingly. Once cut, the paper will be the same proportion as the photo.

Producing a partial grid

If an image is reasonably straightforward and doesn't warrant a full grid – perhaps it is a landscape where there are just a few main shapes, but their position and relationship are crucial – then a partial grid might be all that is needed. In this case, so long as the proportion of the photo matches that of the drawing, the paper can be divided into four, six or eight so the main elements such as horizon line or tree shapes are roughly in the right place.

Applying a grid to a sketch

If you have produced a detailed sketch that works really well and you want to develop it further, grid it in the same way as a photo. A lot of artists do this; in effect, the sketch acts like a photo.

Working directly from a photograph

Just because a photograph is used as the primary source material for a work doesn't mean that the end result needs to be a faithful copy of the photograph. A photo can be used as a starting point, or as a loose reference, to guide a work in progress. I think this is a point worth emphasizing. The finished work can still be interpretive.

If you position the photo some distance away so that just the basic elements are apparent, you will avoid the temptation to focus on sharp detail.

Less focus on absolute accuracy

Some of my own favourite pieces are when I have focused less on the photo and more on what's happening with the drawing or painting surface. It allows for more creative input. Rather than becoming preoccupied with getting an exact likeness and total accuracy, I can concern myself with what's happening on the surface of the paper, and enjoy it for its own sake.

The discipline of life drawing

Life drawing is, in my opinion, one of *the* most valuable activities for an artist. Even if it is not your primary subject, as a discipline it is one of the best things you can do to train your eye. It can be difficult and challenging, but it is ultimately very rewarding. If you do it regularly, you will begin to notice improvements in hand/eye coordination, leading to better judgements regarding proportion and

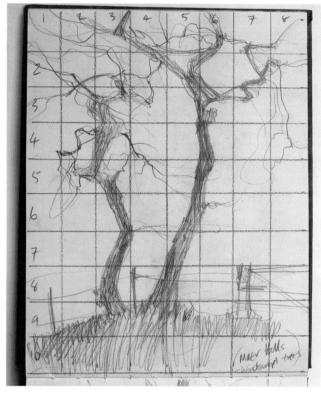

An example of a grid applied to a sketch. If you have produced a drawing that you like, provided there is enough information there you can apply a grid and scale up in the same way as a photo. It won't have the detail but it will have all the interesting elements that you have found. Scaling up a drawing is a good way of not getting too focused on detail.

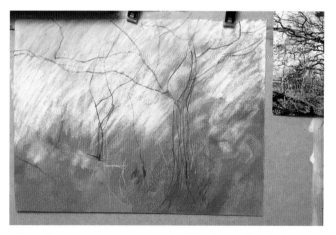

This small pastel on pastel card started with background 'washes' for the sky and grass. Then the trees were roughly positioned over this first layer with pastel pencil. The basic picture is now established. Care will be needed when placing more branches in the sky area, because it will be difficult to change later.

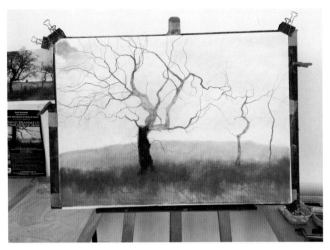

Working on a pastel landscape on A1 paper for a demo/workshop. The 6 × 4in reference photo is clipped to the board and I am looking at it just occasionally. There are some background washes in a variety of colours, softened and blended, and I have started to establish the main tree over the top.

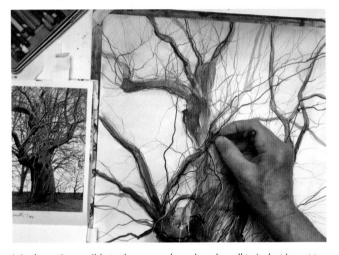

It is almost impossible to draw every branch and small twig, but I want to capture something of the vitality and strength of this old damaged tree. The drawing needs to give an impression of the photo – it's my job to translate and respond to the image to create something new.

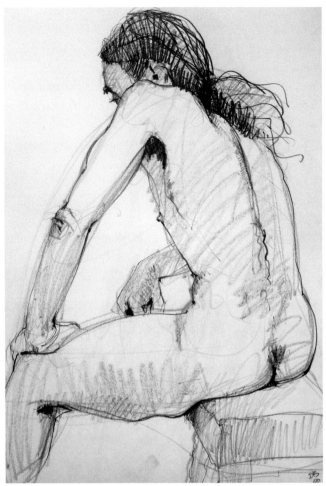

The discipline of life drawing is invaluable as a way of engaging with a subject to try and understand it. The amount of looking and analyzing that is constantly going on really hones your skills. The more you do, the more you are training your eye to look hard, the better you get at seeing essential shapes and forms. You are learning and improving all the time, even without realizing it – making judgements on angles, proportions and so on. This is a simple study using pencil and an orange water-soluble stick on A2 paper.

scale and so on. Even just being able to place the figure within the confines of a sheet of paper is something that becomes easier after a while.

Life drawing sharpens skills, trains the eye to 'look' more closely and is great training. I always find that my drawing is sharper and more confident after a life drawing session. It also allows you the freedom to experiment with expressive mark-making.

You need to stay with it for a while as it takes time to get used to working in such a direct way, but you will start to see shapes and angles more readily. It can be intimidating drawing within a group where peers can see your progress, but your drawing and painting will certainly benefit from the activity.

It's a good idea to date your life drawings and keep them in order, so that when you look back over them you can see how your work has progressed.

More control in the studio

There will be times when outdoor conditions are perfect and there's nothing finer than to be painting outside immersed in the landscape, responding to nature directly. At other times, when it is cold, dark, wet and windy, it is easier and more practical to work in the studio.

When people view my large treescapes on paper, I am often asked if I have made them in situ. I find working

outside with pastel or graphite on a large sheet of paper impractical, both in terms of the changeable weather (cue wind and rain) and also the time element. Treescapes are very labour-intensive and my way of working means that after starting a picture I may rest it before continuing; it therefore comes together over a relatively long period of time. I also like to work on many pictures at the same time, alternating between different subjects.

On the other hand, my plein air paintings look very different to those produced in the studio, which is not a bad thing. Sometimes it's good to have a time constraint on a painting because you have to work under pressure to finish it.

The camera lens sees things differently

When working from a photograph, a lot of preliminary decision-making such as selecting, composing and cropping has already been done and the camera has conveniently converted the image into a two-dimensional format that has been selected through the viewfinder.

It is very easy, convenient and quick to use a camera to capture a scene for a potential drawing or painting. Twenty different pictures can be taken while even the briefest of quick studies is made. But the singular camera lens cannot 'see' things in the same way as our own binocular vision. As good as the camera is with regard to functionality, exposure control, focus and zoom and so on, it cannot capture a scene as we see it.

Personal view
A view can sometimes create emotions that affect our interpretation; it might generate an emotional response that we try to capture digitally. Here, there can be disappointment, as a photo can only record a scene coldly and technically. Looking at the photo later can trigger a memory of the moment and still give much satisfaction, but it cannot match what we see.

During countless country walks, I have developed a love of trees in all their different forms and find them fascinating subjects. It is a lifelong preoccupation. I can be very annoying to be with at these times, as I keep stopping to take photos of trees.

My time is often limited and time for sketching on such trips is short, so I take loads of photos instead. But invariably I am disappointed when I find the photo of a tree I

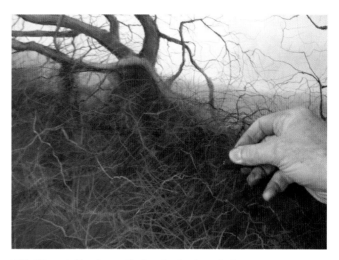

With this pastel landscape the layering has been built up over many sessions, so is very much a studio-produced picture. It needs the stability of a studio environment partly because it's a large (A1) work on paper and partly because of the range of pastels and pastel pencils needed. Subsequent layers will be adjusted to try to get more depth in the shadow areas. Later, more undergrowth will be added, and the process repeated until it reaches a satisfactory conclusion.

particularly liked has become lost in a background of foliage and 'clutter'. My eye had picked out an interesting tree, but unfortunately the camera was not able to distinguish it from the background. If I had sketchbook and pencil to hand, I would see so much more: I would be able to focus on the subject and extract the information I wanted.

This is not to criticize the technical virtuosity of the camera (exposure, focus and so on), rather that my human response and personal way of seeing meant that I had zoomed in on the thing that caught my attention, but the camera had merely recorded (albeit very ably) all the information I pointed it at.

Working en plein air

Some artists want to draw and paint the world around them. Their objective is to position themselves in front of a subject and to respond to it through paint: it is their experience, viewpoint, interest or just simply the making of a record of a particular time and place. That is the objective. There is a certain freedom about starting and finishing a painting in a day, or less, then next day moving to a new place, setting up and doing the same again. In this way a visual diary of the artist's life is created.

The plein air painter doesn't use second-hand imagery – that is a photograph. This fact ensures every picture is a unique piece, because even if they painted from the same spot the next day, it would be different

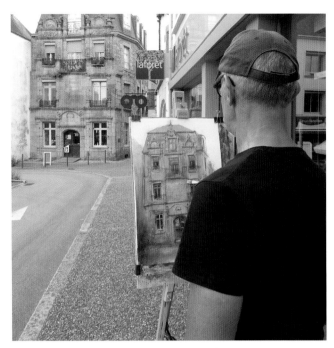

Outdoor painting in Brittany: I've chosen an interesting but detailed subject to paint. There was too much information to get down in the allotted time, so I had to find ways to quickly and effectively suggest detail to achieve balance. I used washes of acrylic to build up layers of colour to give solidity, and the combination of a drawing pen and rigger to describe the architectural features. I alternated between working broadly with a flat brush and acrylic paint and drawing detail with a pen.

soon after we arrived and set up it started to rain. Later it just got heavier and heavier until finally, when we packed up to leave, the rain magically stopped.

I was painting in acrylics on paper and had done several studies, which I had laid on the grass under the shelter of a huge tree behind me to keep dry. Eventually the volume of rain was such that when I turned round, water was dripping heavily through the tree onto my freshly painted work. Some of the paint had dried but the torrent of water had washed off the not-quite-dried areas to create a very interesting 'distressed' effect, which in a perverse way suited the picture and summed up the experience.

I think each plein air experience is memorable in some way and helps to explain the growing popularity of various local, national and international urban sketching groups. It is also useful to have feedback from your peers and the public alike.

The test of urban sketching is to be able to capture the essence of a scene very quickly – buildings, shops, people and traffic always on the move – and if the sketch doesn't work, simply move on to the next thing that catches the eye. It is also useful, time permitting and while the experience is fresh, to apply some colour, either with watercolour, coloured pencil or marker, to add more interest.

Later, it is interesting to use such studies to compose a completely new picture, and to have the freedom to change things, or move things around to get the optimum balance.

in some way because of changes in weather, levels of daylight, or activity. Constantly rising to the challenge of working against the clock, the weather or location is part of the attraction: each day means a new picture and a new challenge.

The best exponents of painting outdoors work year-round and on most days, pitching themselves against the clock and nature. They develop skills to quickly judge perspective, composition, scale and so on, because their eyes become trained to see and analyze with great accuracy.

To set up your easel and to have your work viewed and commented on by passers-by is all part of the experience, but it can be daunting. Some artists like to work with a group of like-minded people for more confidence. Most people are genuinely interested in what you are doing and will stop to chat and offer supportive remarks, or offer insights into the subject you are painting, which adds to the experience.

Whenever I look at the pictures of a plein air session at Trentham Gardens (see opposite page), I smile, because the weather was so perverse that day. It was a typically changeable British summer's day in July, and I had agreed to meet a group of students for some outdoor painting, but

Working from life

Drawing from life is the most natural thing, indoors or outside. Whether it is portraiture, still life, a room interior, plants in a garden, tools in a shed, fruit on a table, toys, and so on, the choice of subject matter is limited only by your imagination.

Sitting in front of a three-dimensional subject and translating what you see onto a two-dimensional surface is challenging for sure. Everything has to be worked out – what to include and what not. Some artists use a simple viewfinder or their hands to frame the subject, in order to have a starting point of reference.

As soon as you have a few reference points marked out, it is important to work out the scale and proportion of the objects within the frame. This is where the pencil doubles up as a measuring device for relative sizes and angles.

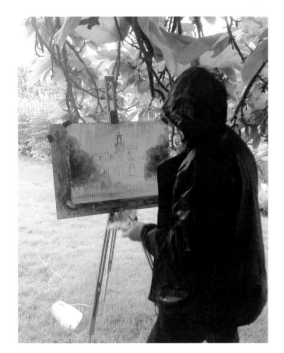

The joys of plein air painting…

Plein air painting at the height of a British summer: one of the things that the outside painter has to contend with is the weather. On this occasion the rain started the moment I set up the easel and started to paint, then got progressively heavier until it became torrential. Here I've retreated under a tree for shelter, but the rain found its way through and washed off the paint.

I retreated further and further under the shelter of a tree. The downpour eventually found its way through the tree and dripped onto the paintings I had managed to make, which were lying on the grass to 'dry' behind me. When I turned round I was amazed to find most of the rain had washed the acrylic paint off the paper.

The umbrella was ineffectual in keeping the rain off the picture – by then the damage was done. As soon as I had packed up and started to leave, however, the rain stopped as if by magic.

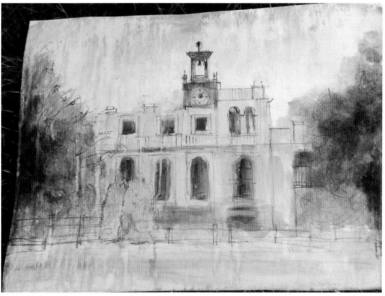

In a perverse way, I found the effect quite interesting as it was sympathetic to the derelict building I was painting. Having resigned myself to the situation, I continued painting and produced four pictures. Everyone else in the group had packed up and gone home after suffering around ten minutes of the deluge, leaving me to 'enjoy' the rest of the session.

Walnut Split in Two, charcoal on A3 paper.

With this drawing the intention was to work within a time constraint (in this case, an hour), to reduce thinking time and maximize a direct approach. I had the idea of taking a small organic subject and drawing it larger (A3 size). So I used this walnut and split it in two to reveal the nut and inner shell. The organic shapes and forms on the inside of a walnut are fascinating to draw, I find, with the soft rounded forms of the nut contrasting with the hard edges of the shell.

With charcoal, I always find it best to work larger because of the imprecise nature of a stick of willow when drawing and blending. Charcoal is so flexible to work with it almost feels like one is 'sculpting', using fingers to model the form. Pale tones can be easily softened with the finger and stronger darks can be built up and worked into. Layers can be fixed so that more drawing can be added.

MATERIALS
A couple of sticks of willow charcoal, a charcoal pencil, a putty rubber, fixative, sheet of A3 220gsm cartridge paper.

METHOD
Step 1: I carefully split the walnut (it took a few goes to get a good result), separated the two halves, and laid them side by side. Then I took a photo for reference in case I wanted to work on the drawing later.

Step 2: I spent time looking and analyzing the two halves of the nut as I positioned them in front of me before committing charcoal to paper. I tried to visualize the scale and proportion of the two halves and how they would fit onto the sheet of paper, allowing for some shadow at the bottom. Then, holding the charcoal lightly, I sketched out the outline of the two halves, followed by the nut inside.

Step 3: I followed the line of the internal shell, and suggested the shape of the nut. I find it fascinating drawing small organic subjects on a much larger scale as it enables you to explore fascinating natural forms and to appreciate how nature produces so many beautiful, interesting designs. Working to a larger scale gives the subject an abstract feel.

Step 4: To help clarify the shapes, I added some shading to certain areas to help me understand the form, and also started to develop a mid-toned shadow underneath the nut to suggest the nut was resting on a flat surface.

Step 5: The idea was to make an intuitive response to the subject rather than an accurate depiction, so no measuring was done – just direct drawing. The drawing will have an energy because it is freer and more direct. Total accuracy was not the primary objective here: you can see I have made exploratory marks here and there, which all adds to a looser feel to the drawing. If this way of working is new to you and you feel awkward or under too much pressure, try different timings; for example, give yourself more time. In the back of your mind think about how much information you can get down in an allotted time. You begin to focus on what is important.

Step 6: Finally, I took a long look at the drawing and decided to strengthen it by going darker with the shadows surrounding the two halves. The intention of this project was not to produce a finished piece, so I didn't want to overdraw it. After around an hour's drawing I felt I had explored all I wanted to explore, so left it there (*see* image above).

I wanted to draw something larger than life size and organic in nature. So I found this walnut and split it in two and immediately found a lot of interesting shapes and forms to draw.

The hard shell encases the fascinating form of the softer nut. Whenever I draw natural forms I am amazed at the complex beauty of nature.

I held the stick of willow charcoal loosely while lightly positioning the two shapes on the sheet of A3 paper. I drew outlines for the outer and inner shell.

Happy with the positioning, I strengthened the drawing and established some shadow on the bottom to indicate the nut was resting on a solid flat surface.

I used a charcoal pencil to make more definite lines – charcoal in pencil form is harder and darker than a stick of willow. I then added some light tones to suggest forms.

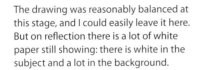

The drawing was reasonably balanced at this stage, and I could easily leave it here. But on reflection there is a lot of white paper still showing: there is white in the subject and a lot in the background.

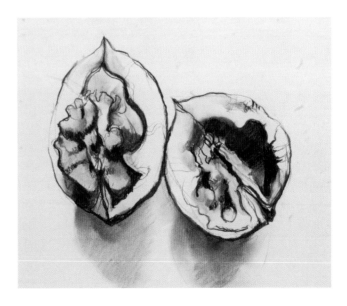

DEVELOPING A DRAWING

A drawing can be 'tight' even if it hasn't been gridded up for accuracy. Without the constraints of a guide, artists are free to interpret things more and allow their personal style to come through. A drawing needs character and a certain personal approach if it is to be distinctive; it can have many qualities other than exactness or precision. Good pencil handling or unusual and expressive mark-making, for example, create interest for the viewer and help the drawing to stand out from others.

Towards a more individual style

The more drawing you do, the more confident you become: your pencil handling improves, you find you are able to position things on the paper better, you find you become more accurate in measuring, and so on.

When teaching, I am often asked by a pupil: 'Is it finished yet?' or more frequently: 'Where do I go from here?' There is often a fine line between finishing a drawing at the right time and overdrawing it – going too far. It is something that becomes clearer the more experience you have. Often people continue drawing or painting way past the point where they should have left it, and the whole thing suffers as a result. We have all been guilty of this. Sometimes we are so consumed with the drawing that we don't stop to reflect regularly enough.

It can be easy to start a drawing and get everything blocked in, but then reach a point where it is not clear what to do next. The picture needs to maintain balance, but at the same time prominence needs to be given to the main subject or subjects. Sometimes the focus can shift to inconsequential things, for example if there is too much detail too soon.

As the drawing progresses, a decision on tonal range has to be made. Ask yourself this question: how dark and light does the drawing need to be to create impact? If all the drawing is in light to mid tones then no matter how accurate the drawing is, it will probably lack impact and focus. On the other hand, of course, impact may not be what is wanted from the drawing – it might be a very quiet, calm subject. The tonal parameters need to be set at some point, and these can be used to gauge the rest of the drawing.

Does the style suit the subject?

Different subjects need to treated appropriately: a delicate flower requires different handling to a derelict building. Sometimes creating soft tonal contrasts comes more naturally than rough textures when drawing broken buildings. Students often show a certain timidity or lack of confidence that prevents them from making bold statements.

By drawing a lot of different subject matter, it will become apparent that certain things work better than others. This discovery sometimes steers us in a certain direction with regard to subject choice. I see nothing wrong in this as drawing what comes naturally can lead to greater understanding and confidence in other areas. Pursuing this avenue means that skills can develop at a good pace because you are comfortable with what you are drawing; subjects become more familiar – the drawing works better.

◄ *Moorland Tree*, pastel on A1 paper.

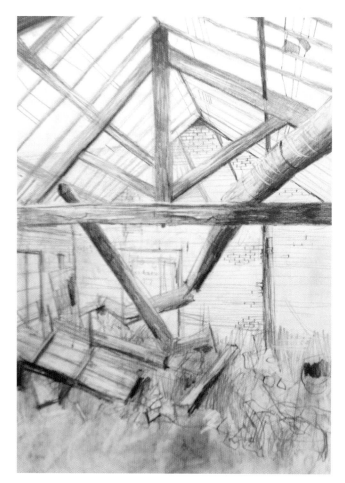

The challenges of tackling this derelict factory interior were many – the low viewpoint gave it a busy, distorted perspective, exposing the jumble of broken equipment and debris everywhere. There was too much information to take in. Where does the eye go to next? How could I make sense of it all, even though I couldn't figure out a lot of what I was drawing?

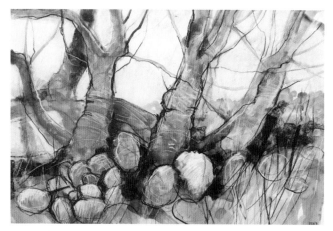

A semi-abstract landscape using charcoal and white chalk on top of gouache. I wanted to capture something of the energy of the windswept trees as they burst out through the drystone wall. Matching the exact colours wasn't important. I used yellow paint to add another layer of interest and represent tonal changes that underpin the drawing. Detail was added using white chalk and a charcoal pencil. Another example of trying a new approach.

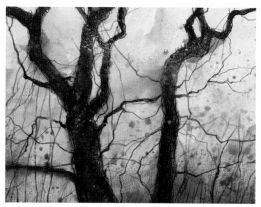

An experimental drawing with no clear plan to follow. It was a question of reaching a certain stage, pausing, before deciding on the next step, and so on. The decision to splash the vibrant yellow along with the green spatter on the background was taken near the final stages of the picture.

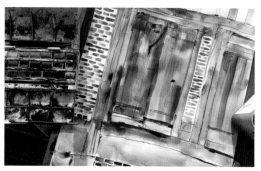

This is a watercolour of an oak-framed building in Honfleur. After a day's sketching and photographing in and around this fascinating coastal town, it was still a blisteringly hot Normandy day into late evening: a fine opportunity to work through some of the images while they were still fresh in my mind. Here I am working flat on the floor, producing picture after picture – they were drying very quickly.

Realizing your personal vision

The more you become familiar with a subject and are able to relax with the drawing, the more you are free to explore other avenues and experiment with new techniques. Your personal vision will begin to develop.

We all have a unique way of drawing and seeing. It is important to recognize this, but it takes a lot of drawing and experimentation for your style to fully develop. As an experienced artist, I have been aware of this fact for a long time, and it can be difficult sometimes to break out from your usual 'style' and try something new. At these times I find it helpful to switch to a different medium, or to change subject and try to interpret it in a different way.

Your style is something that should always be evolving, of course. By 'your style' I mean something either tangible or intangible that makes your work recognizably yours.

IDEA AND INSPIRATION

The bottle ovens of the Potteries (the Stoke-on-Trent area in the Midlands, England, that once produced world-famous tableware and sanitaryware) are fascinating subjects to paint. I have many photos of these iconic structures in various stages of decline. I find it incomprehensible that these important buildings – part of our industrial heritage and often decorated with beautiful details – are allowed to decay into a sad and neglected state to be lost forever.

This painting was to form part of a series with an industrial theme. It is an ongoing project that I keep adding to from time to time.

Bottle ovens are difficult shapes to draw: apart from the challenge of symmetry, the proportions are awkward to get right. At first they seem quite simple and straightforward, but perspective and scale need to work together if the drawing is going to work. Other buildings are often attached to them. Naturally, where the adjoining roof meets the circular bottle there is an unusual juxtaposition where the pitched roof rises up the tapering bottle shape. There are also all the signs of neglect and abandonment that on the one hand are sad to witness, but at the same time very interesting to draw. Many of these buildings display scars of alterations and damage accrued over the years; some of the exposed walls are painted white as they would have been internal walls at some point.

Nature plays a powerful role in trying to reclaim neglected buildings, so when mortar gets dislodged from in between brickwork, soil accumulates and airborne seeds sow themselves. Grass, flowers, weeds and trees start to grow in abundance, in turn trying to force the bricks apart with their thickening root systems. All of this helps hasten the decline.

I have drawn this particular subject many times, and find something new every time. Every bottle oven has a different shape and size. Many were part of pottery factories built adjacent to canals, which were originally used to bring raw materials in and transport finished ware out by commercial barge. They remain potent symbols of our past heritage, existing in an era when manufacturing industries were prominent.

In my own artistic practice, I feel it is important to acknowledge this history as it has helped shape the character of the area as well as the people. At the same time I want to place it into today's context. For me it is a lifelong influence and inspiration, something to keep going back to again and again. As my work moves in different directions, it is

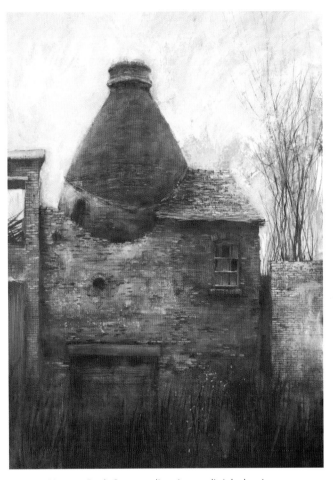

Potteries Memory: Bottle Oven, acrylic paint, acrylic ink, drawing pens on A1 heavyweight cartridge paper.

interesting to see how my interpretation of the same subject has changed and developed over time.

With this particular image, I had previously explored different approaches using a variety of media, for example by producing a small series of A3 studies, in watercolour, charcoal and pencil. Certain subjects have such an appeal that there is always something different to say about them, and for me this is one. I think I will always find something new to say about this image, such is the fascination it holds.

With *Potteries Memory* I liked the flexibility of working with mixed media: applying paint in different ways, drawing with various pencils and pens. It is about finding the best qualities of a particular medium and using them in combination with the best qualities of a different medium to create something new. At least, that was the intention.

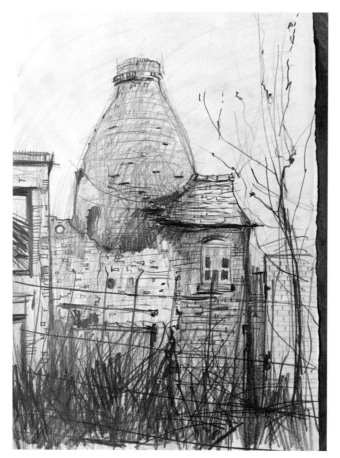

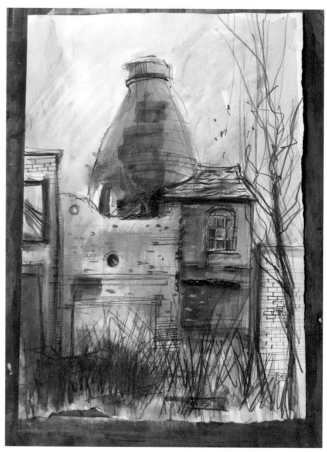

This is an early pencil study of the same subject, and clearly shows vigorous mark-making. At this time there was no intention to produce a painting – I was just experimenting and exploring the subject through different drawing media to see what worked and what didn't. I didn't intend to produce a 'finished' drawing. Pencil on A3 cartridge paper.

I have never considered myself a watercolour specialist – I use it as a means to enhance drawings or as an essential ingredient in mixed media. Therefore, I don't take much notice of matching exact colours – it's just not important for such experiments. Here there are watercolour washes over a pencil drawing, with some white pastel to knock back the sky colour. Watercolour and pencil on A3 paper.

MATERIALS
Acrylic paint, selection of brushes including a rigger (a specialist watercolour brush with long soft bristles), painting knife, acrylic inks, dipper pen, drawing pens, A1 sheet heavyweight cartridge paper.

METHOD
Step 1: Working from a small photograph, I used a 6B pencil to sketch the image onto the paper.

Step 2: I mixed some diluted white acrylic paint and washed this over the whole sheet of paper to seal the drawing, ensuring it remained visible under this transparent layer. I could have put the paint on first and then drawn over this, but I prefer the feel of pencil on paper rather than on top of a painted surface. The mark-making is quite different and making adjustments with an eraser is more difficult.

Step 3: I strengthened the drawing, still using the pencil. Then I started to add more paint, blocking in the main building

with varied mixes of reds, browns, yellows and pale blues for the sky and some darker shadow colours – greys with hints of green at the base of the picture.

Step 4: As I built up the paint layers, things were starting to appear more solid but the drawing was getting lost, so I introduced some pen and ink to bring back some definition. Painting is all about losing and then finding the drawing, but for me, all this extra corrective drawing adds more interest to the picture.

Step 5: The pen and ink work now looked too strong and prominent, so I scrubbed some paint over it with an old bristle brush to soften things off.

Step 6: The beauty of working with acrylic paint is that you can switch between transparency and opacity quickly and easily. As soon as there are one or two layers of paint on the surface it becomes easier to manipulate subsequent layers. The painting was looking much more balanced now.

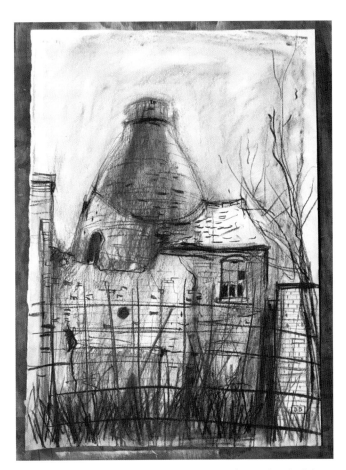

Close-up of the brickwork, which shows the way the drawing reacted with the painted surface. Also clearly visible is the texture of the paint, which made the pen drawing more difficult when trying to draw straight lines. I was looking for different ways to apply paint so that it didn't look like a conventional painting made with a brush.

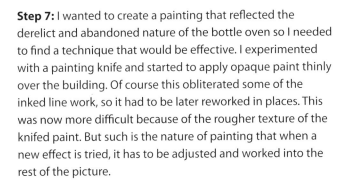

Another version – this time in charcoal – gave me ideas on how I might proceed. Each version was enjoyable. The shape of the bottle oven is quite simple on the face of it, but it is really difficult to get the balance of perspective and scale, let alone the symmetry. Charcoal on A3 paper.

Step 7: I wanted to create a painting that reflected the derelict and abandoned nature of the bottle oven so I needed to find a technique that would be effective. I experimented with a painting knife and started to apply opaque paint thinly over the building. Of course this obliterated some of the inked line work, so it had to be later reworked in places. This was now more difficult because of the rougher texture of the knifed paint. But such is the nature of painting that when a new effect is tried, it has to be adjusted and worked into the rest of the picture.

Step 8: I was pleased with the way textures were being created. I thought they were sympathetic to the subject. I decided to use the palette knife to add some colour into the roof and brickwork and was surprised at how controllable it was, up to a point.

Step 9: Some white and light blue paint was added to the sky.

Step 10: A lot of detailed brickwork was added to the oven and walls. The pen was perfect to draw the fine branches of the trees coming out of the top of the wall and also the undergrowth at the bottom. The rigger helped to thicken up some of these lines.

Step 11: A small, flat, synthetic brush was used on its side to apply browns mixed with burnt sienna and yellow ochre to create a varied surface.

Step 12: Finishing touches involved a lot more pen work for the brickwork. I had to exercise some restraint here as I was in danger of carrying on until all the bricks were drawn.

CONCLUSION

I thought this work sat well with the pit head winding gear painting, as it used the same materials and equipment. But the challenges posed by each painting were quite different.

I think my earlier series of A3 studies helped create a better outcome. I hoped that by reworking the image I could create a different emotion. It was all about finding another way of expressing a new idea about the same subject.

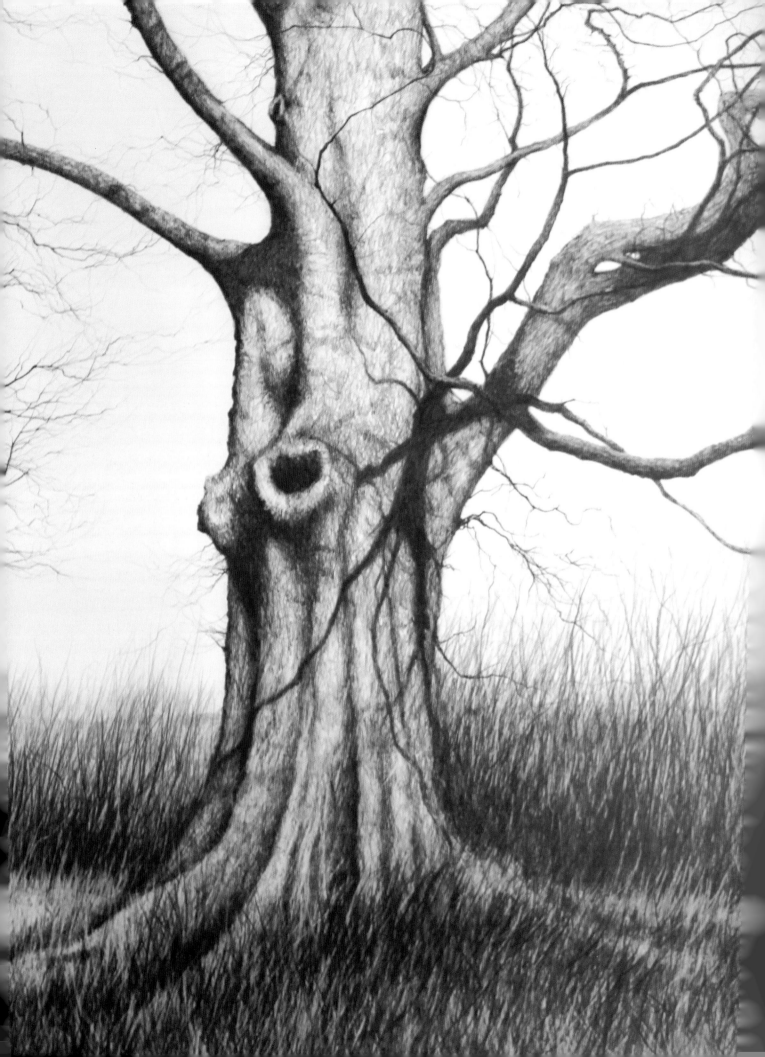

EXPLORING THE POTENTIAL OF DRY DRAWING MEDIA

Here we focus in more depth on different drawing media and how to use them to make more informed choices to suit your style and subject. You will find a collection of materials along with practical examples and projects that thoroughly test each medium, showing what it can and can't do, which materials work well with others, and so on. It is intended to be an objective, yet personalized review of working methods.

The chapter explains different dry media in a logical progression; Chapter 8 will do the same for wet media. The guidance given here (and indeed in the whole book) is based on many years' experience of experimenting with and exploring a range of different media. Sometimes (often) there have been disasters: paint hasn't dried properly or has reacted badly with another medium, or a perfectly good drawing has been ruined by trying to take it too far. I once applied impasto acrylic paint over a freshly glued collage. The collage was still wet with PVA glue, and the mixture took days to dry. The surface cracked and crazed – the work was ruined; I had to admit defeat and abandon it. This is sometimes the price you pay for experimenting. I certainly learned from the experience, and it didn't stop me from continuing to experiment as it is this that moves your work forward.

Nothing ventured, nothing gained, as the saying goes. So don't be afraid to try something new or take a risk: there is the chance that it could turn out better than you thought, and you might learn something new.

◀ *Lonely Tree,* pencil on A1 300gsm cartridge.

Expanding the materials list

We have explored some of the techniques and effects that can be created just by using pencils, erasers and paper. We have seen how pressure on the pencil makes darker line and tone, and we have discovered how texture is created and how to make adjustments to a drawing using erasers. We have seen how to apply graphite to paper but also, and equally importantly, how to remove it.

Throughout this book you have seen many different drawing 'tools' and media used. Some of my pens, for example, have been handmade or improvised; some have been lovingly used for many years. Some have been bought, used once, instantly discarded, only to resurface later to become firm favourites. So don't be overly keen to throw anything away too soon; it may not be the right time in your development to fully appreciate what a new medium has to offer.

I have often been full of anticipation when going to an art materials store (like a child in a sweet shop), wondering what I might find: pens, pencils, erasers, a new tube of colour, perhaps, that I can't resist buying. Sometimes I have been a little too keen to snap up a new product because it looked attractive in the shop, only to find I already have one of those back at the studio, also unopened. I call that an occupational hazard!

In my formative years I remember going into my local well-stocked art shop and seeing hundreds of different-coloured tubes of oil paint. It's a delightful memory: the smells of the oil paints and mediums, colours and the mystery of new materials. I still think one of the joys of being an artist is walking into an art shop and looking around and discovering something new to play with.

My tin of graphite materials that I take along to demos. There is much more in here than I actually need – I always take a bundle of ready sharpened 6B pencils to save downtime during the demo and a lot of bits of eraser and graphite sticks. The little jars contain powdered graphite ready to use on broad tonal areas. My drawings are nearly always on A1 cartridge paper, clipped to a board that is fixed to an easel where I stand to work.

I started this A2 sketchbook drawing as a workshop project focusing on buildings. It was intended to be a fairly controlled drawing. At first it appeared as though little attention needed to be paid to the scale of the door and window, but of course it is crucial to get this relationship established at an early stage so that the detail of the stonework can be enjoyed. The stonework is more difficult than it looks – definitely a lesson in how to control line and tone.

Sometimes just seeing a new product sparks off an idea and you start thinking of the potential of adding a new colour to your palette, or discovering a new set of drawing pens or pastels.

As your knowledge, skills and experience grow, so will the selection of your materials begin to make more sense. With this in mind, I have compiled a list of materials with a brief explanation of what they can do and what applications they might be suitable for. It is by no means exhaustive, and the possibilities for using a particular medium in many different ways are limited only by your creative enthusiasm.

This selection provides a good, sound base and reference point for many diverse drawing activities. Enjoy experimenting!

Graphite

Pencils – hard and soft

Graphite is a traditional and natural drawing medium that has first been made into powdered form, then mixed with clay and water to form a paste that is extruded into rods, which are inserted into a wooden sleeve to make pencils. The ratio of graphite to clay determines how hard or soft the resulting pencil is: more clay means the graphite will be harder.

Generally, pencils are graded according to how soft or hard they are. At the softest end of the scale there is 9B (Derwent), 8B (Faber-Castell) down to B (less soft); next there is HB, which is the 'standard' grade found universally in offices and schools; then F, followed by hard grades H to 6H. Popular brands such as Derwent, Faber-Castell and Staedtler all offer quality products and are widely available from your favourite art shop or online.

For general sketching work, a 2B is a good choice. It will maintain its sharpness well and be able to suggest a good range of tones. Anything harder and the lines will be faint and darker tones difficult or impossible to achieve. With a pencil that's too soft, dark and light tones can be achieved easily but the point will wear down quickly, making the drawing appear 'woolly' if not checked; it will need regular sharpening to maintain a crispness of line.

Graphite sticks come in many different sizes and grades. On the left is a very soft stick, which is very smudgy, matt and black; then a chunkier stick and block for laying down more expressive marks and tones. On the right is a more conventional pencil-shaped stick, which is solid graphite wrapped in a thin plastic sleeve.

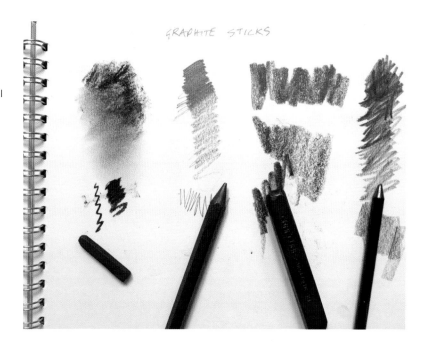

In this graphite landscape featuring a row of trees, I am using a soft stick, which is making solid, matt areas. I am then carefully combining this with conventional pencil for the trees, which of course has a sheen. The shiny pencil marks catch the light and the matt surface doesn't, so where the two meet decisions must be made as to how to blend them together.

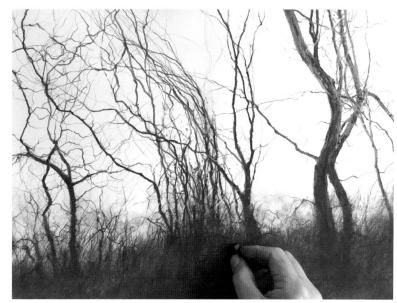

Graphite sticks

A wide range of graphite materials is available from quality manufacturers. Some graphite sticks are the shape of normal pencils, but instead of the usual wooden sleeve the whole stick is solid graphite with a thin plastic covering to help keep it in one piece and keep fingers clean. The advantage of this type of graphite stick over a conventional pencil is that you can use the side of the point to make a broader mark, making them ideal for shading larger areas. They are available in a more limited range of soft and hard grades.

Graphite sticks or blocks range from small pastel-sized pieces to thicker, chunky sticks that are very robust and great for making bold, gestural marks when working large scale. Some are hexagonal-shaped, others are square-edged sticks. They generally come in a more limited range of grades.

It is always worthwhile to try before you buy if possible, as the properties of graphite sticks vary from manufacturer to manufacturer.

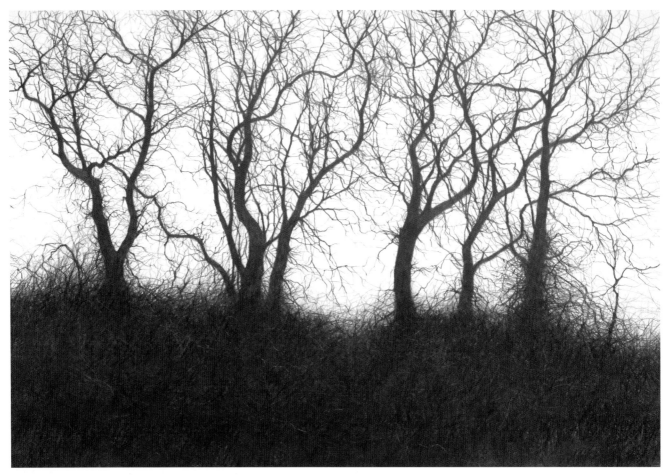

Tangled Hedgerow, graphite, tinted graphite and coloured pencil on A1 cartridge paper. It is a very busy picture and I was quite addicted to the mark-making. I introduced the coloured pencils gradually as I worked downwards, so there is a lot of subtle colour in the undergrowth, less in the trees.

This subject was a tremendous challenge: I chose it because it was difficult, and without knowing how it would work. It was so busy, so full of life and energy, and I wanted to respond to that. I thought about a large-scale drawing using mostly pencil, meaning lots of busy mark-making – a real test of stamina. The pencil would work fine, but it would be very laborious because of the busy branchwork of the trees and the abundant undergrowth. I would need to work more broadly, but still create a lot of textures.

The drawing began as a two-hour demo in a gallery. I decided very early on to introduce some colour, albeit subtly, to pull the eye through the picture into the distance beyond, and also to add interest to the dense foreground. After the initial positional drawing in pencil, I introduced some coloured pencil. The foreground in a picture such as this

needs to have depth and strong darks, especially around the base of the trees in order to anchor them in the ground.

It is impossible to draw everything accurately, there's far too much going on: it's too complex. So it is a question of keeping the marks lively to capture the movement and energy, while at the same time creating the relationships between the trees themselves and the undergrowth.

MATERIALS
2B, 4B and 6B pencils, hard and soft erasers, soft graphite stick, dark brown Derwent XL tinted graphite stick, selection of coloured pencils: yellows, greens and browns, A1 sheet 260gsm cartridge paper.

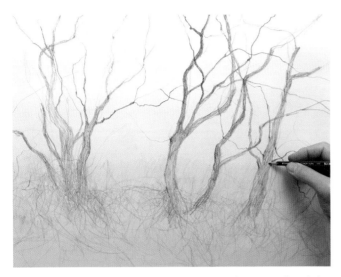

I started with the line of trees and the horizon line. I kept everything light so adjustments could be made. The coloured pencil work is similarly quite open – I am just getting a feel for how the drawing might work. At this stage I thought the whole drawing would be in a much lighter key, without going too dark in the shadows.

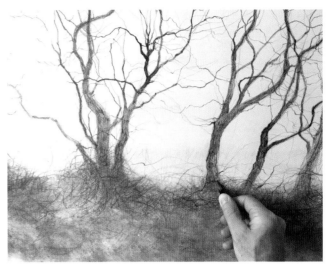

Everything is still balanced, just more developed. The trees are a bit more defined and the undergrowth has had some red brown tinted graphite applied then blended with soft graphite into the paper with fingers to start building up the layering process. The trees are starting to become more connected with the ground with the addition of shadows around their bases. Some detail work has begun on the branches, helping the trees to start to develop their character.

METHOD

Step 1: With the 2B pencil, I suggested the shape of the foreground and also the distant horizon line. This gave me a guide for the position of the trees. I looked for negative shapes – the gaps – between the trees.

Step 2: When drawing the main trees, I first of all drew a single line, then drew a second 'tramline' to suit. I always start by drawing the tree thinner than I think it is, as it's easier to thicken it later, rather than the other way round where an eraser would be needed to cut it back.

Step 3: When I was happy with the shapes of the trees, I used various brown-coloured pencils to make scribble marks to suggest the undergrowth, followed by greens and yellows for the distant plain.

Step 4: I roughly 'filled in' the main tree shapes with a 4B pencil, making directional marks. I freely and intuitively drew in some of the smaller branches.

Step 5: I continued to work on the trees, giving them more solidity and presence, then moved to the bottom of the drawing to develop shadows in the undergrowth. For this I used a soft graphite stick on its side and smoothed it and blended it with fingers. I used a putty rubber to make

adjustments and to vary the tones, then applied some of the brown tinted graphite in the same way, merging and blending the two together. I did some drawing over the top with a pencil to suggest some undergrowth.

Step 6: Then it was back to the trees with a 6B pencil to develop some of the busy branch work.

Step 7: I did more drawing on the trees and the undergrowth, using the putty rubber to soften things off.

Step 8: I used a slice of hard eraser to cut into the undergrowth to remove graphite, then went back in with the coloured pencils to add more texture. Undergrowth has form and shape: it is solid ground with grass and brambles and so on growing over the top; it catches light to change colour and creates dark shadows beneath. So the white of the paper needs a good dense layering of graphite to give it solidity. This dark tone needs to be established before light areas can be lifted out to suggest textures of grass, branches and so on.

Step 9: With this particular drawing I wanted it to be very busy to give the impression of a hedgerow that was full of life, so the more marks I could make the better. Tonal contrast was supplied by the sky, which remained unworked as the white of the paper.

Powdered graphite

Some manufacturers offer powdered graphite as an 'off the shelf' product to apply with a brush, finger, tissue or cloth and so on, but of course you can create your own by simply scraping a craft knife blade along a graphite stick and collecting the residual powder on a sheet of paper, which can then be stored in a jar for future use. Alternatively, rub a graphite block/stick along a strip of fine/medium sandpaper for similar results.

Tip: Experiment by covering a whole sheet of paper with a 'flat' tone first by shaking some powdered graphite onto the paper. Use a brush or tissue to rub it gently into the surface, then start off by 'lifting out' areas with a putty rubber before starting the drawing. Effectively the drawing has a different starting point: highlights as well as shadows have to be created.

Tinted graphite

Derwent produce a range of very chunky tinted graphite sticks called XL Graphite. The colours are very limited and very subtle and low key. They work well with normal 'grey' graphite and can enhance the subject if used appropriately.

When tinted graphite first appeared, I admit I was sceptical and considered it something of a gimmick – another new product that promised great things. I initially resisted trying it as I considered graphite a pure, natural and traditional drawing medium that should always be used in a conventional way. When I finally got around to buying

A fairly recent addition to the graphite arena – these chunky 'Derwent XL Graphite' blocks came out a few years ago. For some time I couldn't see the point of coloured graphite; surely it was just the same stuff as coloured pencils? But after buying a tin and experimenting with different techniques, the blocks are now a firm favourite for my graphite landscapes: the colours are really subtle and low-key and suit heavily worked, dense areas, or if in powdered form, can produce soft tones.

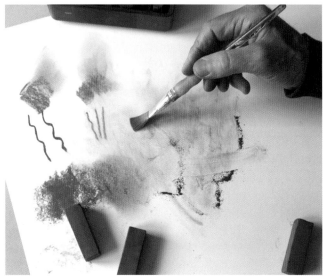

If you want a more subtle tonal covering, make some powder by scraping a blade along the stick, then use a brush (or tissue or your finger) to apply it to the paper. It's like painting with powder. I keep a soft brush for this purpose.

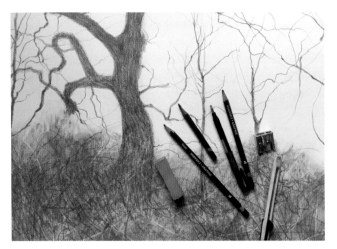

Treescape in graphite and tinted graphite. I love this stage in a drawing where the composition is established and I am reasonably happy with the position of everything. I have tried to keep the drawing 'open' – not too solid or dark – so the various layers of textural marks can be seen. I have introduced some green tinted graphite to add subtle colour. It's not meant to be coloured realistically; the green is just an approximate suggestion of foliage.

and trying it, I initially didn't take to it and found it quite limiting, but over time and after a lot of perseverance and experimentation it is now an essential part of my graphite toolbox. I'm really glad that I got over my initial scepticism because it is now a big part of my practice.

Used straight out of the tin, the colours can be strong and difficult to manipulate, even though they are quite muted. Used directly, the strong pigment stains paper easily, making it difficult to remove and manipulate with an eraser, but by making powder with a knife blade or sandpaper and applying it with fingers, brush or a tissue, it can create some really subtle washes of colour that can be used as a background layer to a drawing.

The tinted graphite creates a lot of interest when I do a demo or workshop – people are intrigued by its subtle qualities. I use the tinted colours with conventional natural graphite and sometimes the subtle effects are only discernible in certain light conditions. I think this adds to the allure of the drawing and gives it a fascinating extra dimension, especially when the work is framed and behind glass.

Liquid graphite

Technically this is wet media of course, but I have included it here within this graphite section. In practice it is both wet and dry: initially applied as a liquid, and once dry it has similar properties to conventional graphite. Liquid graphite which can be painted on as a wash sounds a little strange at first, and I guess the rationale behind developing it was to create a product that could give an even tone applied with a brush, which once dry can be manipulated with an eraser or pencil like conventional graphite.

It has a slight metallic sheen when dry, which for me is at odds with conventional pencils, powdered graphite or graphite blocks; I feel its physical properties are too different. If the process or technique is too evident in a picture, I think it detracts from its feel. You begin to notice the 'effect' above anything else. However, if used on its own or in a mixed media work, it could be satisfactory.

Mechanical pencils

There is a vast range of technical or mechanical pencils available on the market. They use refills that come in small dispensers, usually HB or 2B grades, and in different thicknesses from 0.5 to 1.2mm. The leads are approximately 6cm long.

The advantage of this type of pencil is that because the leads are so fine they don't need regular sharpening like a normal pencil. Clicking the button on the end with your thumb will pump the 'lead' through as it wears down. The mechanical pencil will give precise drawing because the point retains the same thickness throughout its length. They are great to take sketching as there isn't the need to keep stopping to sharpen the point. For sketching I find the 2B refills give a good balance between darker tones and precise line work.

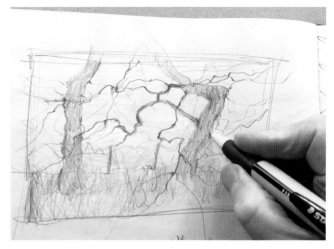

This mechanical pencil is a favourite. It's great to use, with a thicker, more grippy feel, and is very light. It takes 0.9mm refills, which means the drawing has a different appearance to one produced by conventional pencil. It can give a more textured look, encouraging directional mark-making.

Naturally, the leads are more brittle than a conventional pencil, so more care is needed if working vigorously as the leads can break and create marks on the paper. It's something you adapt to quite quickly. In the same way, you need to be aware of how quickly the lead is wearing down or you will soon be scratching into the paper with the metal tip of the holder.

Clutch pencils

I have classed these differently to mechanical pencils, although their function is very similar. The main difference is that while a mechanical pencil pushes the 'lead' down through the pencil when the button on the end is repeatedly pressed, a clutch pencil does not pump the refill through the body. Instead, the button on top releases the grip and the refill is pulled through by hand, or a new lead inserted.

A pencil-shaped clutch pencil like the blue Staedtler takes longer, thicker refills that are virtually the same length as the holder itself, approximately 12cm. I have a selection of old Staedtler pencils that have different grades of refill, 4B, 2B and HB. I also have one that has a sharpened matchstick for use as a pen with ink. The Staedtler has a built-in sharpener in the button on top: a very well thought-out design, and very practical and versatile.

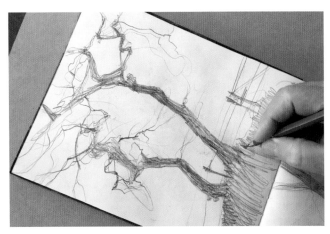

Exploring the fantastic structures of exposed, windswept trees using a clutch pencil. These dramatic trees sit on an exposed edge, so they are shaped by the wind. I have used them many times in my pictures, they are favourites – always different, a bit more weathered, a bit more twisted each time I see them. I enjoy the dialogue going on between the two forms.

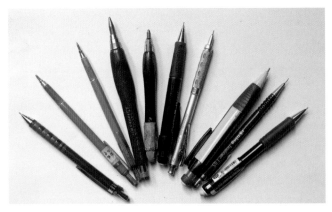

Here are some of my mechanical pencils, clutch pencils and holders. They take various refills in a choice of grades. For me, each offers a different drawing experience: some are light to hold, some are thicker, some are better balanced. I enjoy the variety.

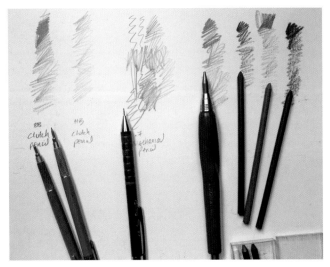

Clutch pencils take 2mm refills that are 12cm long; mechanical pencils take various thicknesses such as 0.5mm, 0.7mm (which is a popular size), 0.9mm and so on. The holder on the right takes 6mm refills in graphite, compressed charcoal, sanguine, white and dark brown. They are versatile drawing tools.

Various-sized clutch pencils

Available in many different designs, some of these are really good to hold and are a pleasure to use, offering good ergonomics. Some I find are a little too heavy to hold comfortably for long periods; some are really light. Some offer a convenient sharpener built into the end. It's all down to personal preference.

Cretacolor produce a range of holders along with different refills of 5.6mm diameter, including compressed charcoal, sepia, sanguine, black and white, and 2B, 4B, 6B graphite. I find this is a great system.

Charcoal

Willow charcoal is one of the most traditional and natural mediums to draw with. It can take a little getting used to, especially straight after using a pencil or graphite stick, as it breaks and crumbles very easily. Even a thick stick will crumble if too much pressure is applied, but this is also part of its charm and attraction. Using charcoal means dirty fingers of course, so alternatively try using charcoal pencils. Natural willow charcoal offers beautiful and varied mark-making.

Charcoal is capable of a great tonal range and strong or delicate mark-making; some artists exploit these qualities very well. There are many artisan charcoal makers around today, or have a go at creating your own. It is very satisfying to use something so traditional, simple and basic that has been used by artists for centuries.

Charcoal is available in thicknesses from thin wispy sticks of 1mm thickness through to chunky scene painters' sticks for large-scale work. Great for producing delicate tones and lines, it is very intuitive and easy to manipulate with either your finger or a putty rubber. These same qualities can also mean that it is very easy to lose the drawing completely as careless handling of finished work can spoil the drawing. When the drawing is complete, ideally fix the work and use an overlay of smooth tracing paper when storing.

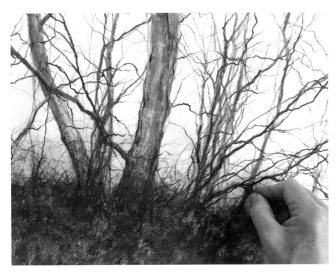

Here I'm working on a charcoal treescape with a stick of willow charcoal. I've used the stick on its side to block in the trees and create solidity in the undergrowth. Because of the lovely soft quality of the material I was able to create depth as well as solidity in the foreground.

A drawing can be started by covering the whole sheet of paper with charcoal, then lifting out areas before drawing back into it, so in effect starting with a mid-tone. The next stage can be using a putty rubber to 'draw in white' (or negative), before continuing with the charcoal. This process is almost like sculpting form but in two dimensions.

Someone once handed me several chunky pieces of charred wood from a tree that had been struck by lightning. It makes great marks. I'm saving it to use on a large-scale, expressive tree drawing.

Tip: Don't fix the drawing if you intend to do any lifting out with an eraser or any further blending, as this will be difficult or impossible after fixing.

Charcoal pencils

Charcoal in pencil form is harder and darker than natural willow charcoal; the marks are stronger and therefore more difficult to manipulate. The effect of charcoal pencils can at times look similar to graphite, only blacker and more matt.

The material is coarser in texture and it doesn't glide over the paper surface like graphite. Charcoal pencils from different manufacturers vary in strength and quality. Derwent, for example, offer light, medium and dark tones; Conté offer grades such as B and 2B. Try using them in combination with willow charcoal, so you have the advantages of both: lovely soft tonal qualities with willow and stronger line work with charcoal pencils.

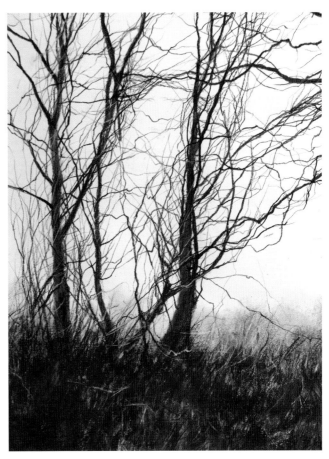

Using charcoal pencils created a bolder, stronger drawing – the undergrowth has more texture because of the ability to overlay marks more effectively than a stick of willow. An eraser has been used to cut back into the charcoal to create highlights where one branch crosses in front of another.

Tip 1: Because of the resistance presented by pushing a charcoal pencil over paper, the resulting drawing will be different when compared to working with a graphite pencil. You can experience the qualities of both by producing a drawing in graphite, followed by a drawing in charcoal pencil of a similar subject and compare the two. Charcoal is blacker than the grey of graphite.

Tip 2: Charcoal and pastel pencils are slightly thicker in diameter than normal graphite pencils, so a conventional pencil sharpener will be too small. If you prefer a sharpener, ask for one for pastel or charcoal pencils. I find that a sharpener puts too blunt a point on a pencil. I prefer to use a craft knife to create a longer, more visible point. Then use a piece of sandpaper to keep the point sharp.

Compressed charcoal sticks

Manufactured in stick form, compressed charcoal is excellent for strong, confident drawing and for making very solid black marks. It is available in grades, and some manufacturers offer shades of grey and even white. Purists will shun the ready-made greys and whites over the challenge of creating their own tones naturally using skill and technique. The sticks are typically harder, solid but economical in use. Dark shadow areas can be quickly established, but care needs to be taken if lighter areas are to be preserved or when lifting out. Compressed charcoal is more difficult to remove or manipulate with an eraser, so it favours a bolder, more direct approach.

It is also available as a refill for certain mechanical 'clutch' pencils. This refill form has many advantages as you could have a selection of different refills – for example, compressed charcoal, graphite and Conté – and then have a whole range of different drawing media to work with.

Tinted charcoal pencils

Tinted charcoal pencils are available from Derwent, among others, offering an excellent range of very subtle colours that are ideal for landscape work. Used in isolation, it is sometimes difficult to see their true colour, but when put next to black the colour is distinguishable and gives interest and variety in a landscape.

Tinted charcoal blocks

Also available are chunky charcoal blocks made by Derwent called XL Charcoal (same idea as the graphite blocks), in a very limited range of colours including white. I always think of white charcoal as something of an anomaly, as charred wood is black, but it is strongly pigmented and works well. These blocks can be used to make bold solid marks or very subtle areas of tone when used as a powder (made by scraping a blade or piece of sandpaper on the block). Apply the powder to the paper surface with either a brush, finger or tissue. These blocks are very versatile and economical. They are heavily pigmented and go a long way.

Tip: The colours can be strong if used straight out of the tin and can easily overpower the drawing and then be difficult to manipulate. Practise with them first to get used to them.

Liquid charcoal

Charcoal, or 'fusain' to use the French term, is available in liquid form from specialist manufacturer Nitram. Liquid and powdered charcoal can be applied by brush. I haven't as yet tried liquid charcoal, preferring to use it in dry form. It is on my list to buy one day, as it seems a useful addition to the materials cupboard.

Note: Simply applying water to a drawing made with willow charcoal will dissolve it to give a wash effect.

Powdered charcoal

Create your own charcoal powder by rubbing it on a strip of fine sandpaper, or scrape with a craft knife. If you want to work on larger areas, powdered charcoal can give great smooth coverage. Alternatively it can be conveniently bought off the shelf. Apply the powder with a brush or tissue to create lovely soft tonal effects.

Pastels (sometimes referred to as dry, soft or chalk pastels)

Pastels are arguably the purest of all pigmented media. With little or no binder to hold the powdered pigment together, effectively you are pushing pure colour into the painting surface. Pastels rely on a surface that is a little absorbent and has some 'tooth' or texture with which to 'grab' and hold the powdered pigment.

The quality of pastels varies considerably, and the choice is down to personal preference. Each manufacturer's products will have different properties. Some are relatively hard, so will hold their point for longer, are less crumbly and therefore good for drawing. Others are softer and less robust in use, and will crumble or break readily. If you buy too cheaply you will not get the best experience and you will be disappointed: there will be too much binder and inferior pigment, making it difficult to get decent coverage and effects. The beauty about using a good art shop is that often you are able to get sound advice on a product and perhaps even test it before buying.

When working with pastels, a wide range of colours is needed, particularly when working on landscapes. However many greens one has to choose from, it is never enough; there is always an elusive green or brown that is not in the box. Pastellists often spend a lot of time choosing their palette of colours before starting on a particular picture and keep them separate.

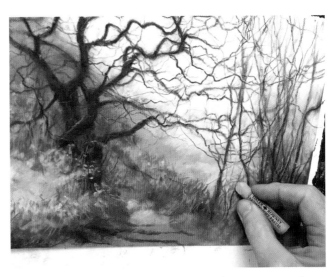

Building up texture on a small pastel landscape. This one is on pastel card, which has a good tooth to grab and hold the soft pastel. I have only recently started to work at this small scale as I've always found it difficult to work less than A1 size in pastel. It was one of the hardest things I've done – I had to persevere and find new ways of making it work.

When using pastels from different manufacturers, apply them with care. Harder pastels will not work well over soft ones as they will cut into the softer pigment and remove it. Professional pastellists will have discovered from experience which brand of pastel can be used in which particular order. There are many manufacturers of dry pastels, including Pastels Girault, Schmincke, Sennelier, Unison, Rembrandt, Terry Ludwig, Daler Rowney, Faber Castell and so on. There are many artisan pastel-makers too, and many artists actually make their own. All these products will have different properties and their own colour ranges. As with oil paint, some artists buy according to colour, as long as it's from a reputable manufacturer.

Pastels are instant and direct. The medium suits artists who like to work quickly and spontaneously or equally those who take a more considered and deliberate approach. Many contemporary pastellists use pastels over a previously painted surface such as watercolour or acrylics, so there is a texture underneath.

Pastels are a versatile medium, with beautiful, potent colours. However, they can take time to master, as it takes practice and experience to apply layers successfully.

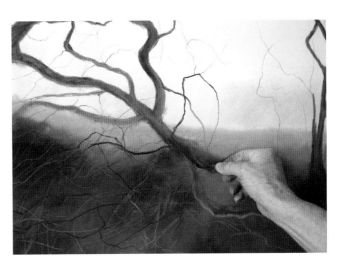

Winter Hedgerow, pastel on paper: the early stages of a large pastel treescape. I have laid some background 'washes' of greens, greys and browns and am trying some exploratory drawing with different colours to get the feel of the picture. It is very exciting to make sweeping gestural marks; they set the direction the picture will take. Tones are established in a general way; shadows and highlights on the windswept tree help suggest form.

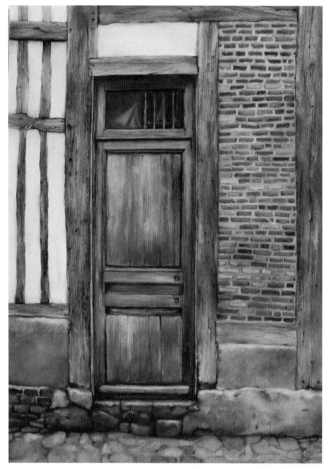

La Vieille Porte (The Old Oak Door), pastel on A1 paper. Continuing my interest in old doorways, I was really taken with this one I found in Honfleur. When I saw all the fascinating detail, I knew I wanted the challenge of putting it all in and making it work. It would have to be a large pastel work because the inherent texture of the medium would work so well for the brickwork and worn woodwork.

MATERIALS
Pastels, pastel pencils, A1 sheet 260gsm cartridge paper.

THE MAKING OF THE PICTURE
This picture is based on a photo of an old oak doorway in Honfleur, Normandy, that I found of particular interest. It displayed all the evidence of its age – hundreds of years of weathering and alterations. To my eyes it was a thing of beauty and I wanted desperately to capture something of its history.

Using a mid-toned brown pastel pencil, I sketched out the main structure of the doorway. It's actually based on vertical and horizontal lines. I positioned the door off-centre to create a little asymmetry. Enough space was left below the doorway for the stone floor.

For this rather 'tight' drawing, care was taken to start the pastel underpainting by blending colours softly. It was important to get the feel of the aged, weathered appearance of the woodwork and masonry. Where, for example, the oak frame meets the infill plasterwork, I tried to push the colours as close as possible together so as not to create gaps where the white of the paper could show through. This is more difficult with pastels as the colour you are using will pick up some of the colour next to it and contaminate it.

In between layers, I applied fixative lightly to help prevent the current layer from blending too much with the layer underneath. When the detail was in danger of getting lost, pastel pencils were used to correct the drawing and bring it back on track.

For the red brick infill panel: firstly, layers of warm greys, yellow and white were blended to give a background 'wash' of colour over which the individual bricks would be drawn. This process is a little tedious but ultimately very rewarding. I drew guidelines to keep the rows of bricks 'straight'. The individual bricks are all slightly different in colour: some darker, some lighter, some redder, some yellowy and so on, and there is a shadow underneath each brick and highlight on the top edge.

Creating the aged feel of the oak door required similar detailed observation, with directional marks drawn into the panels using different coloured pastel pencils: black, browns and white.

Before final detail could begin, highlights and shadows were built up, particularly to push the door inside the frame. Similarly, the front of the step needed to come forward, and highlights on the raised mouldings on the door frame and the door itself needed to stand out more.

A picture such as this needed to work on two levels: on the one hand, as a solid piece of architecture, so from a distance it worked as a door. On the other hand, the detail work needed to be convincing – for example, the thin line of shadow under each brick, and the solid lumps of stone that rested on the floor where it met the building.

The brickwork was the most satisfying aspect to work on.

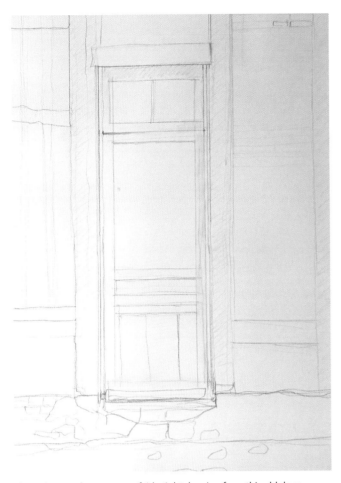

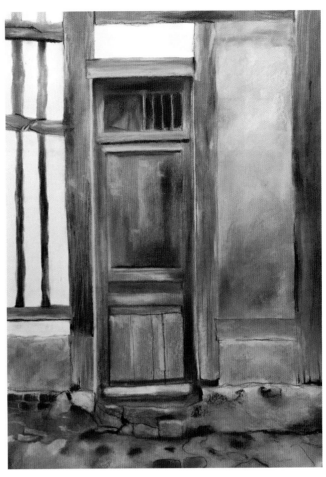

I knew I wanted an accurate, fairly tight drawing from this old door. There was a lot of beautiful detail to work out, so the drawing needed to be spot on. I worked from an enlarged photocopy of the photo, but I didn't grid the picture; I just took care and tried to judge the proportions correctly. I didn't want photorealism; I wanted it to look like a freehand drawing with all the foibles and wobbles that entailed. The drawing essentially started out as a series of verticals and horizontals to create panels containing brickwork, door and so on.

The next stage was to get background 'washes' of approximate colour, on top of which the detail can be developed – you need to see beyond the detail. The difficulty is where one colour butts up to the next. It needs a delicate touch to work right up to the guideline with one colour, then apply a different colour in the next panel. Where the two colours meet is tricky to resolve as each needs to be blended and pushed into the paper – which in turn disturbs the adjacent colour. You just have to keep working at it until it starts to look right.

CONCLUSION

When I start a new work, the reference photo often suggests the approach I take. For this example, I was interested in the texture of the old oak and the brickwork, so the intention was to draw with reasonable care and accuracy so that each different element could work to best effect.

I tell students to always bring a black and a white pastel pencil to sessions, as they are always useful for making corrections to paintings. I often use them for initial underdrawing for a pastel or acrylic work and for making adjustments as the picture progresses. They are great for detail work, but it can be difficult or even impossible to work over really soft pastels.

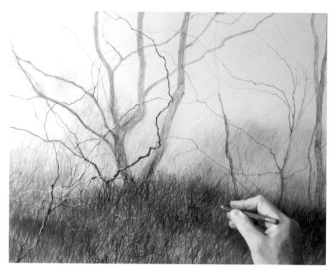

Autumn tree in graphite and coloured pencil on A1 paper: this large treescape started out as a graphite drawing. The trees were established, but instead of continuing with the graphite in the undergrowth and background, I thought I would introduce some subtle colour with coloured pencils to see if it would add to the picture. It is difficult working the two things together: if there is too much graphite on the surface, the coloured pencils will pick up the graphite and become dirty – it's hard to get the right balance. The next stage will be cutting back with hard and soft erasers, before proceeding.

Pastel pencils

As with charcoal pencils, pastel in pencil form is harder and more brittle than a stick of pastel. They are great for detail work either on their own or they can be used in conjunction with soft pastels. However, you will find they don't always work well on top of some pastels, especially artists' quality soft pastels, because putting hard pastels over soft tends to remove the pastel underneath. Some artists use them to make the initial drawing; some shun them altogether. Some produce a complete picture with them, as they offer a lot of control.

With my own pastel work, because I don't use very soft pastels I am able to combine them reasonably well by carefully drawing over the surface. I use them often in landscapes and architectural work. Making some light hatching marks, then using a finger or blender, will produce a lovely soft area of colour.

Pastel pencils work well over watercolour paintings where the texture of the watercolour paper will give interesting broken colour, or if you want some instant colour over a watercolour or pen and ink study.

Coloured pencils

I categorize coloured pencils into three main groups: firstly, the 'conventional' coloured pencils/crayons available from many manufacturers and sold in attractive and functional sets or individually; secondly, water-soluble coloured pencils which can be used either wet or dry; and finally, Derwent drawing pencils. I class the latter separately as I find them very different from conventional coloured pencils. They are highly pigmented with a waxy feel and are therefore difficult to manipulate with an eraser, so a different working method needs to be adopted to get the best out of them. They make a really strong mark, and are great for confident drawing.

Ideally, it is always best to test pencils before you buy, as each brand has different qualities. A set of pencils is a big investment and you need to be sure how they blend, how strong the pigment is, and so on. This is where buying from an art shop has advantages over the internet as you can get good advice and more often than not be able to test a product. Try to buy a few loose pencils first, so you can assess them thoroughly. When testing a product, take the quality of the paper you are using into account, as this will affect the end result.

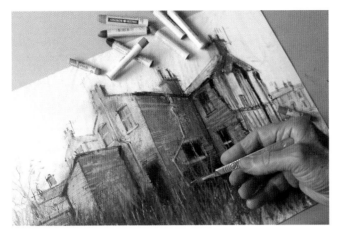

Oil pastel sticks are highly pigmented. It takes a bit of practice to get them to blend, as they tend to slip and slide easily over existing layers. Care is needed as the picture can very easily get out of control, and then difficult to resolve. On this urban landscape there is a good build-up of colour, and I am using a scalpel blade to scrape away layers to reveal some of the paper surface.

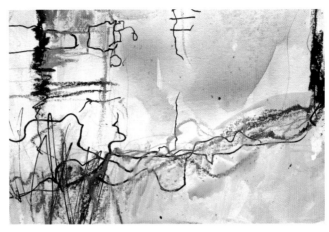

In this quite abstract-looking detail of an old French barn (see the project in Chapter 9), the marks made by different media are clearly visible. There is pen and ink, wax crayon and oil pastel, with watercolour washes over the top. You can see the way in which the freshly applied yellow watercolour is resisting the grey and green oil pastel underneath.

Coloured pencils are a great, quick way to apply colour to a sketch and are useful for mixed media work too. They have become quite a specialized medium, where artists produce some amazingly detailed work. Many artists use them to adopt a hyperrealistic approach to subject matter. Technical virtuosos, they utilize specialist solvents and blending tools to achieve their goal.

Oil pastels

Completely different from dry pastels and not to be confused with them, oil pastels are highly pigmented sticks of colour that take practice to work well. Often mistaken for their chalky dry cousins, they have caused frustration and confusion at (dry) pastel workshops, when, even after giving out a specific materials list, people have brought along oil pastels instead.

Their 'waxy' nature means it is quite difficult to work in layers, or to blend accurately with any consistency, as they tend to skid or glide over the surface underneath, making it difficult to predict outcomes. Having said that, many artists have developed techniques to get the best out of them and produce fantastic work.

They work very well over a dry watercolour wash, for example on watercolour paper that has a more accommodating texture compared to cartridge paper or smooth card. The dimpled texture of the surface captures and holds the pastel as it passes over the recesses of the paper, creating unexpected flecks of colour. Subsequent layers can then pick up further colour on the raised areas of the surface.

It is worthwhile persevering with this medium, as it is capable of creating strong, unexpected and unusual effects.

Because they are oil based, the pastels will dissolve with low-odour thinners to make washes that can be applied with a brush or rag. Once these washes have dried, they can be worked over the top with the pastels, or can be worked into the still-wet wash, which causes the pastel to dissolve and give a really strongly pigmented mark.

In my own experience, oil pastels really come into their own when working with mixed media. This is their strong point: adding highlights of strong colour over a watercolour or acrylic painting, for example. In this situation you can draw into certain elements of your painting, strengthening lines or adding texture.

Wax crayons

Creating similar effects to oil pastels, wax crayons are widely available and cheap to buy. They are popular as children's drawing media. As with oil pastels, it is challenging to work in layers for the same reason that they tend to skid over the surface very easily, and are therefore difficult to work into to make changes and adjustments.

Economical to use, they are a quick and easy way to apply colour to a sketch. They will naturally work well as part of a wax resist technique (see Chapter 9).

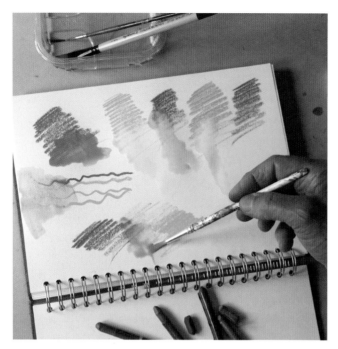

I've been a big fan of water-soluble crayons for many years. I have always preferred to use them dry, often over the top of a pencil drawing. Only occasionally have I applied water to wash and soften the colour. Here you can see the strong pigmentation and the way the colours can be blended with water. Water-soluble crayons are very versatile, offering a quick and convenient way to apply colour to sketches.

Water-soluble sticks

Similar in use and feel to wax crayons or oil pastels, these highly pigmented sticks are water-soluble and can be used wet or dry, which makes them highly versatile and flexible. Available from a number of manufacturers, they are effectively (like watercolour pencils) two products in one. I've included them here in the dry media section because they can be used quite successfully dry. The addition of water can be a secondary consideration.

They are a great choice for on-the-spot rapid colour sketching. The sketch can later be developed by brushing clean water over it to create washes and soften edges and then subsequently be worked over wet or dry. The best thing about water-soluble sticks is that because they are dual purpose, they can be used both wet and dry in the same picture.

Used in combination with watercolour, they can enhance or highlight certain passages when drawing over the top of a dry or wet watercolour. Water can be worked into the marks to further soften and blend the painting.

They can be used dry to create a complete picture; then clean water can be washed over the top to dissolve the drawing so it has a similar appearance to a watercolour. Once dry, the process can be repeated to build up layers.

Caran d'Ache is an experienced and long-term manufacturer of water-soluble crayons, and has been a personal favourite for many years. I have used their crayons on their own or with mixed media and found them highly pigmented for making bold, expressive marks. They combine well with strong pencil drawings, over which the coloured sticks can be applied in various hatching or shading techniques; then water can be washed into the surface to create instant washes. Using the sticks to draw back into wet or damp paper produces strongly pigmented marks as the water dissolves the tip to release intense pure pigment.

Derwent, along with other manufacturers, also offer a range of water-soluble drawing sticks.

Try producing a drawing 'dry' – covering the whole surface with colour – then selectively wet certain areas with a brush and clean water to soften edges as appropriate, to give interest and variety to your work.

As with oil pastels, the colour palette is limited: you can only work with the colours you have in your tin – but they will blend up to a point. Mixing new colours will perhaps not match an exact colour. You need to work within the limitations of the colour range.

Conclusion: Great for sketching wet or dry and for mixed media, water-soluble sticks are a very versatile addition to your mixed media box, and well worth exploring.

Water-soluble coloured pencils

With a similar application to the water-soluble sticks described above, these pencils can be used alongside the bigger sticks when more detailed work is called for. Because they are in pencil form, they suit small-scale works best.

They can be used wet or dry. They are effective when used with watercolour to draw over a dry picture to define edges and provide detail. If used on a wet surface, the pigment will dissolve to give a much stronger mark.

Erasers

Hard erasers

In this book, I have stressed the importance of being able to manipulate a graphite, charcoal or pastel drawing by using an eraser to adjust, make negative marks or make corrections. The eraser is as important as the pencil in this context.

Over time, I have bought many erasers and have discovered that some are more effective than others. They have many different qualities: some would feel quite 'gritty' and leave too much residue; some would just glide over a layer of solid graphite to polish and burnish it, making it very shiny and therefore even more difficult to remove; some were very hard and would damage the paper. It is worthwhile trying and buying a selection to suit different circumstances.

I keep a box of mixed erasers and if one is ineffective in an application I reach for another. They come in different sizes, shapes and colours. Try a few different brands and discover the ones that work best for you.

In practice, when I get a new eraser, I take a craft knife and cut a slice off to use. This is for two reasons: first to keep the unused part clean; and second to create a more manageable, customized tool with which to cut into a drawing. So I end up with a tub of small bits of black eraser. I try to keep them separate from graphite sticks as they look very similar; there have been times when I have picked up a piece of rubber mistaking it for graphite. In use the eraser obviously gets black very quickly, so care is needed if you later use it on a lighter area or you will transfer marks onto the paper.

When I work on an expressive, large work, I will use hard pieces of eraser as aggressively as a piece of graphite to make textural marks. If I am working on a more con-trolled drawing using only pencils, I will try and keep the drawing clean using a soft eraser very gently, so as not to damage or mark the paper. Inevitably, sometimes a drawing will be ruined because of an unwanted mark that cannot be removed.

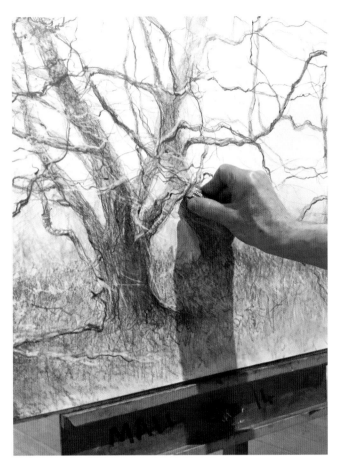

Here I'm halfway through a graphite demo in the Mall Galleries, London during an RBA (Royal Society of British Artists) group show. I'm using a hard eraser to cut in the branches where they pass in front of the trees; in effect I'm drawing with the eraser. It's important to try to maintain a balance within the picture.

Putty rubbers

Very versatile and effective, a putty rubber is useful for graphite, charcoal or pastel work. For very gentle lifting out, a clean piece of this soft, malleable rubber can be pulled off the whole and gently rolled or dabbed onto the paper surface to make very subtle adjustments. Great for lifting out cloud shapes from a flat toned sky by gently stroking the rubber across the surface. It is easy to pull off a piece of rubber and shape it into a point for precision spots by dabbing the point gently onto the paper.

When I am working on a treescape I will use a putty rubber to soften off and knock back the small branches of a tree, or to open up more solid areas and make them less dense.

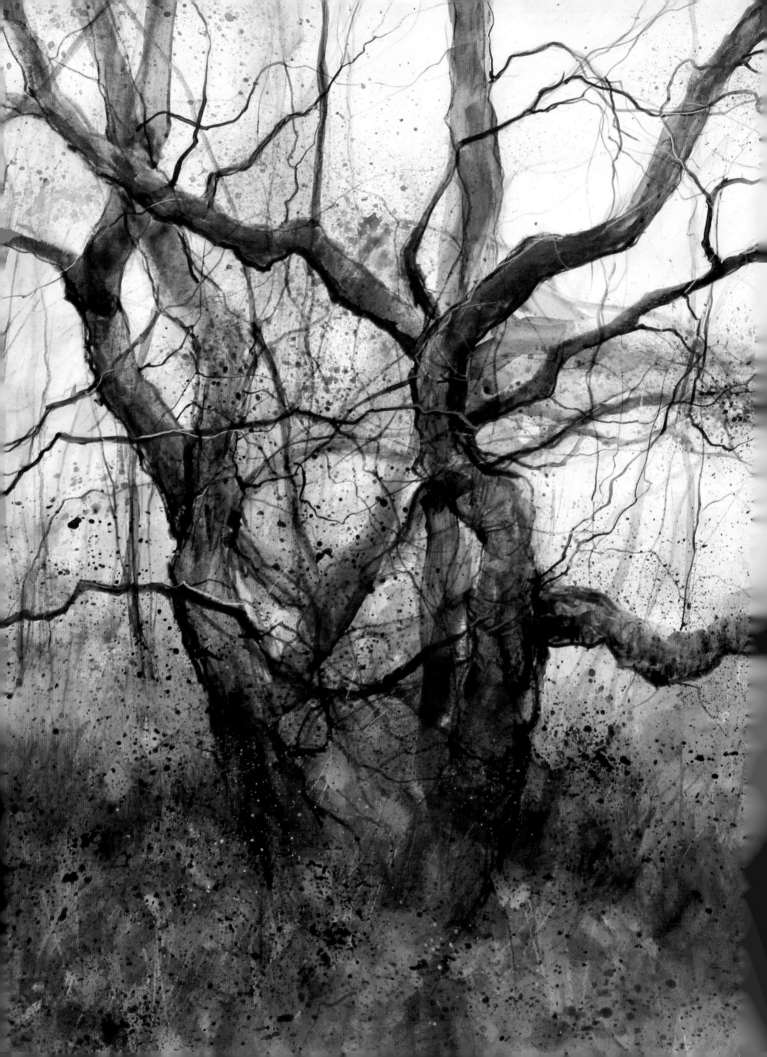

WORKING WITH WET DRAWING MEDIA

n the last chapter I focused on dry drawing media, which despite being fairly straightforward is often challenging to manipulate and adjust. The use of an eraser is a key part in this process.

When drawing with wet media (inks and paint), the marks are more permanent and need a more confident and considered approach. With watercolour and water-soluble inks, adjustments can be made by 'lifting out' using clean water with a brush or sponge. With acrylic inks and acrylic paint, once dry they are fixed and waterproof. If changes are needed they need to be worked on over the top, in effect by adding extra layers of lighter colour or white.

Pen and ink

This very traditional method of drawing and writing is very satisfying. Working in pen and Indian ink requires simple equipment and is a permanent drawing medium. Allow time to experiment and make mistakes by practising in your sketchbook. It is through this process that skills develop and learning takes place. If an ink drawing goes wrong, it can't be erased, so a certain confidence is needed when using it. You have to learn to work with mistakes and turn them to your advantage. A light underdrawing in pencil will help you achieve a good outcome.

◀ *Autumn Treescape (Tangled Trees)*, pen and ink and acrylics on A1 heavyweight cartridge.

This direct pen and ink sketch is one of many made of a derelict pottery factory. There were so many interesting things to draw: juxtapositions of rusting machinery next to an old whitewashed brick wall, and dark, decaying floor timbers with bright vivid green vegetation. For me it was endlessly fascinating. Although this was an interior wall, it was bare brick and had a window. It had been an exterior wall at some point.

Equipment

To draw with pen and ink, you simply need a pen holder, a few nibs of different thicknesses, a bottle of ink, some water in a small jar and some paper, and you're all set.

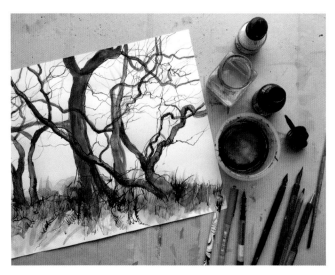

All the equipment I used for this study are here – pens, pencils, Payne's Grey and white acrylic inks, a small container in which to pour some ink along with a few spots of water, and a rigger. I have drawn with the rigger using diluted ink to give variety in the undergrowth and also as an underpainting for the trees. I can then draw over the top with the pen and full strength ink.

Paper

Choose a smooth paper to ensure the point of the nib will remain intact. I use a good heavyweight cartridge paper of 220gsm to 300gsm, depending on the supplier, which I find is suitable for most of my work. It is robust enough to take pen and ink with light washes and won't buckle too much if kept fairly dry. A hot-pressed (HP) watercolour paper is particularly good as it will be smoother and take washes more easily, yet will withstand working wet-in-wet better than cartridge paper. That's not to say a conventional textured NOT (that is NOT hot-pressed) watercolour paper cannot be used – it's just that the nib will tend to scratch away at the surface and hamper a free-flowing drawing style. There are also good mixed media papers that enable wet or dry working.

Pen holder

I suggest using a couple of nib holders as you then have the option of putting a medium nib in one and a thicker nib in the other for more variety. There are many designs available; it's down to personal preference.

Nibs

There is a lot of choice, but ask for steel drawing nibs rather than the writing nibs used for calligraphy or poster work. Some nibs are fine for highly detailed work, but they will give a completely different drawing experience. It's best to get a selection, as there are many shapes and sizes available, all with different qualities: some have a rigid firm feel, while others (the heart-shaped ones) have a more flexible feel with a bit of 'give'. I like these. Some firm nibs can be quite scratchy.

Inks

Calligraphic inks are available in many colours, but in the main these are not waterproof, which means that if you are going to apply a wash over your drawing at a later stage, the inked drawing will 'bleed'. Of course this might be the desired effect, but if you want a stable drawing, choose acrylic inks as they are waterproof once dry. A popular brand is the FW Acrylic Ink range by Daler Rowney. These are available in an ever-expanding range of colours, including metallics and pearlescents. They come in small bottles with a handy dropper top to decant ink safely into a separate container, which is essential.

Tip: Try not to use ink directly from the bottle because with regular use the ink will evaporate and dry out, becoming thicker in consistency. Use the dropper top (or pour carefully if your bottle doesn't have a dropper top) to decant ink into a separate small glass or stout plastic container, then add a couple of drops of water to enable the ink to flow more freely through the nib. This small amount of water doesn't dilute the ink to any great degree but it makes it easier to use. There is always a lot of settlement with the pigment, so shake the bottle vigorously for a few minutes before every use.

Colours

Essential, traditional colours are black and sepia, but it is worth considering the more subtle Payne's Grey. Both sepia and Payne's Grey offer softer qualities compared to black. In certain circumstances black can be a little harsh and something a little warmer is preferable. At other times, of course, the boldness of strong black and white drawing is perfect. Experimentation is the key; naturally your ink drawing can be in any number of colours.

Whatever your choice of ink, make sure you understand the difference between using a waterproof versus non-waterproof ink. Always read the label or ask advice, even though the small label often carries instructions in very small print.

If you are feeling confident and spontaneous, you can work on a pen and ink drawing in a direct way without any underdrawing. If, however, you prefer working in a more controlled way, you can produce a light underdrawing in

pencil first, then carefully 'ink' over it. You can continue to develop the drawing in this way with a fine nib first, then work over it again with a thicker nib to strengthen the drawing. The drawing doesn't have to end there: there is the option to add washes of diluted ink to add tone and give more solidity and form to your subject. It is possible to develop a simple pen and ink drawing into a full-colour painting using inks, instead of the more traditional water-colour wash.

Learning from the Masters – Vincent van Gogh

We can all learn from other artists by understanding how they have used a particular medium successfully. Arguably one of the best exponents of expressive pen and ink techniques was Vincent van Gogh (1853–90). He created a huge range of mark-making to suggest movement and texture, using a reed pen, quill and pen with ink, often over a graphite underdrawing. The sheer variety of marks in his graphic work created interesting surfaces full of life, perfectly capturing the movement of a stormy sea, busy landscape, or portrait. The directional drawing in his trees gave them much life and character. He produced expressive portraits where every bit of the paper is covered in beautiful marks.

If you need any inspiration for ideas on how to add more variety to your own pen and ink work, look at his drawing, *Boats at Sea, Saintes-Maries-de-la-Mer*, 1888. Here you will see how various pens have created marks of different thick-nesses as well as more diluted marks. There is stippling in the sky and sea, giving depth to the picture. It is pure line work with no tonal washes, but it works wonderfully.

Study the huge variety of 'scribble' marks he made to describe a busy allotment-style garden in his drawing, *Cottage Garden*, 1888. There is interest everywhere you look.

A more progressive van Gogh picture is *Harvest in Provence*, 1888, which uses quite a 'modern' mix of media: reed and quill pens with ink, watercolour, gouache, wax crayon and charcoal. So, in effect he was a pioneer of mixed media techniques: a truly modern Master whose influence still strikes a chord with contemporary artists.

Working with pen, ink and wash

Use the dropper on the ink bottle to transfer a little ink into a clean jar or small container. I like to add a few drops of water to this, as it helps the ink to flow through the nib more easily. You will also need a jar of clean water to dip the nib into and clean the drying ink off regularly, other-wise it will clog the channel.

Grab a few sheets of scrap paper and make some ran-dom hatching and drawing marks. Try to make as many different marks as you can. Think about van Gogh's draw-ings and his endlessly inventive mark-making.

It is inevitable that you will have 'accidents', such as ink uncontrollably blobbing from the nib onto your drawing in the most inconvenient place, but don't let this put you off. Sometimes, as with watercolour painting, it is possible to rescue the drawing or adapt it to use the mistake to good effect.

The pen needs to be used a little before it starts to work properly, so give it a chance to get going. Be willing to sacrifice a few sheets of paper to explore the medium and its unique drawing qualities. Doodle, scribble, dot, dash, hatch, scratch, cross-hatch, draw circles, wavy lines, stipple and invent and discover your own unique mark-making capabilities.

Mixing and applying the wash

A diluted inky wash can be combined with pen line work to give subtle or dark tones to enhance the drawing. Good preparation is everything and I suggest as a starting point using three strengths (tones) for simplicity: light, medium and dark. To mix these you will need three containers, either plastic or glass. For the palest wash, pour a little water into your container first, then, using the dropper top, transfer ink into the water, testing it every so often to determine the strength. When you are happy with the strength, move on to the medium wash and add more ink, again testing it at regular intervals, before moving on and doing the same with the dark wash.

Use a watercolour brush to apply washes to the draw-ing, keeping a separate brush for each wash. Everything will quickly become contaminated if you have just the one brush; the washes will get progressively darker and you will end up with three washes of similar strength. A certain method and discipline is needed to apply washes successfully. But once you have done it a few times, you will get used to it. If you choose small screw-top jars, you can label and keep your washes for next time.

Washes can be applied quite loosely over your drawing, or sit quite tightly within the parameters of the lines, depending on your style. Start off with paler washes, then build up to darker washes as your drawing develops to create more depth.

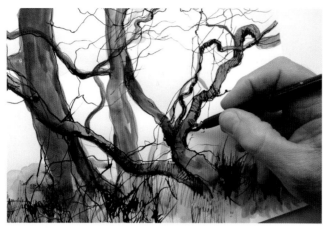

In this close-up, undiluted ink is being used to draw over different strengths of washes. Washes can be laid down first or last – there are no hard and fast rules. Sometimes it's fun to start with some unstructured washes, then draw over the top, sometimes the other way round. I'm using a pen with a flexible nib that gives a great drawing feel.

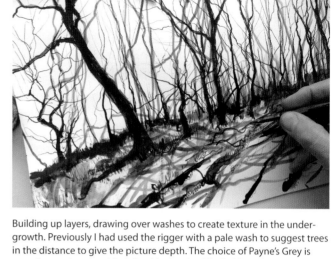

Building up layers, drawing over washes to create texture in the undergrowth. Previously I had used the rigger with a pale wash to suggest trees in the distance to give the picture depth. The choice of Payne's Grey is more interesting than black for this drawing I feel, although sepia might work just as well.

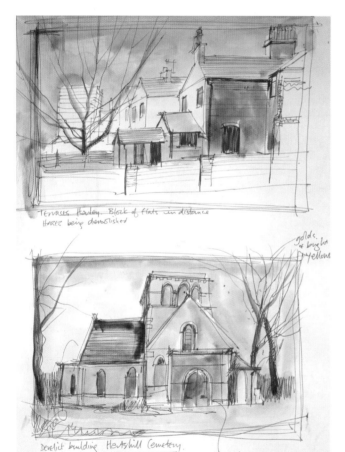

With these two sketchbook studies I have used an artist's drawing pen, then laid some watercolour washes on top to remind me of approximate colour and shadows. Interestingly, the rather unusual building in the bottom picture, found in a cemetery, had this purply-blue brickwork that contrasted well with the green foliage.

Choose sepia ink (over black) if you want your drawing to have a more traditional and softer feel. Choose black ink for more general use and also if you intend to apply colour washes to your drawing at a later stage, whether it be with coloured pencils or watercolour. There are no rules; the aim of this book is to encourage you to try new things, and explore different combinations of media.

One of the great things about working in black pen on white paper is that white ink can be used to work back into the drawing. This means that you can continue the black ink drawing past the point where it is overworked and detail is lost, then use white acrylic ink to draw into the black areas to open it up again.

In my view, a drawing becomes more interesting when 'corrections' and adjustments are visible. Continuous corrective marks add texture, as well as giving a certain history or chronology to the work. I think using white ink in this way is akin to using an eraser on a pencil drawing when opening up shadow areas.

Drawing pens

Practically speaking, working with pen, ink and wash is primarily a studio activity, although not exclusively so, of course. When you are out and about sketching and you want the qualities of a pen without having the inconvenience of taking bottles of ink and washes with you, as well as brushes and clean water, the portability and practicality of a handful of drawing pens is obvious. They are convenient and instant.

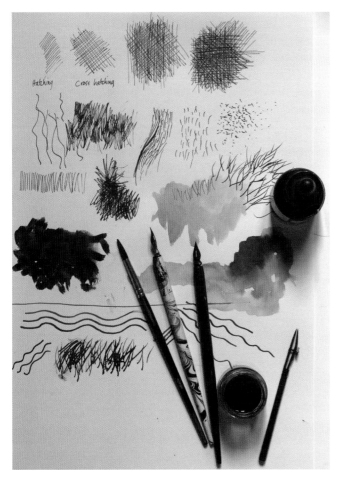

A lovely medium to work with… If you are new to pen and ink, give yourself time to practise. On this sheet I have used a dip pen and acrylic ink. Because you can't rub out the drawing, some people are afraid to use ink, but you soon get used to finding ways to work with your mistakes, and confidence grows. The pen bottom right is a mapping pen, which has an adjustable nib for making thicker marks.

Fibre tip, rollerball, brush-style pens

Available in different nib thicknesses and with a choice of fibre, rollerball, brush or conventional fountain pen-style nibs, the advantages and convenience of these are obvious. Make sure you are aware of exactly what you are buying, as some pens use pigmented ink, which will be more lightfast and therefore more permanent. Some will be waterproof, which means that once dry they will hold their line if you later decide to lay a wash over your sketch; others will bleed or change colour if later washed over. Always make sure that the pen has permanent, waterproof, pigmented ink if you want to continue with ink or watercolour and you want the drawing to remain fixed and stable.

I appreciate you may not be overly concerned about whether inks are lightfast or waterproof, but it will remove some of the guesswork over how to progress the drawing

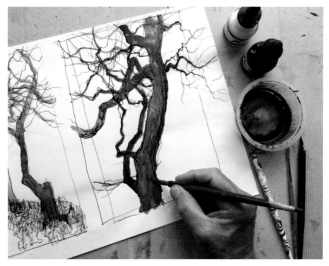

I've probably overdone the strength of the wash on these trees, so the pen marks are not that prominent – hard to rectify as once it's down, acrylic ink can't be lifted out. It's always best to test your washes first as it's impossible to tell how strong they are when they are in a container. Just visible bottom left is where I have tried making some scribble marks to suggest grass.

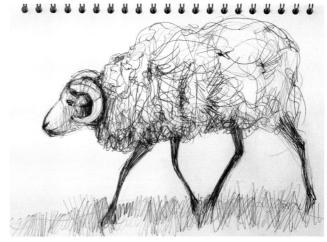

As I sketched this black sheep in black biro, it brought to mind the series of sheep drawings and prints that Henry Moore had done. Biro seemed the perfect tool to capture the woolly texture – I used a scribble technique. It started out as a pencil sketch, then I drew over it in biro. I did a series of these to see if I could capture the characteristics of the animal. It's one of the few sheep drawings I've made.

if further work is needed later. Non-permanent inks will discolour over time, even if they are not exposed to light regularly. Also, if you are looking through an old pen study in a sketchbook and decide later to add a watercolour wash, you may have a shock to discover that the ink was not waterproof and bleeds to the extent that the drawing is ruined. I know this from experience.

A pocketful of drawing pens and coloured markers is really useful for plein air artists who often need to respond quickly to a scene. There is a vast selection of coloured

marker pens in many colours and tip thicknesses – some acrylic based, some spirit based.

The popular urban sketching movement has created a growing demand for manufacturers to produce a good range of suitable pens offering instant colour specifically for this purpose, so that it is possible to complete a full-colour sketch rapidly and without the need to carry brushes, water or a box of watercolours. A box of watercolours, however, will always be a firm favourite as the colour is instantly accessible, especially when using water brushes (a clever brush with a water reservoir in the handle) that can be squeezed to release water as needed – so the equipment is very minimal.

Fountain pens

The traditional fountain pen makes a great drawing tool. Compared to a fibre tip, rollerball or biro, the nib offers more resistance, similar to a dip pen. Some artists prefer this more natural drawing feel, but care must be taken in practice as the nibs are designed to follow a certain direction and can be damaged if used too vigorously. A standard fountain pen designed for writing will only use specific writing inks, which tend to be blue or black. They are generally not waterproof or particularly lightfast, so are not really suitable for longevity as drawings will fade and washes will bleed. Drawing inks are thicker than writing inks and can clog or ruin a conventional fountain pen designed for writing.

Artists' drawing fountain pens

These take thicker, waterproof, Indian or permanent drawing inks. Some take ink cartridges; some have plunger or lever fillers. They are designed specifically to take drawing inks, but they require more maintenance: the ink will still dry and clog the internals if left for long periods, requiring complete dismantling and cleaning before they can be reused (they are designed to be taken apart easily). In use, though, they are very satisfying as they offer a similar drawing experience to a dipper pen, with the practical advantage that they will keep on working for longer periods. They are more reliable than a dipper pen and won't be quite as prone to 'blobbing'. A wide range of nibs is available.

Bamboo and stick pens

Pens made from a piece of sharpened bamboo can be bought off the shelf, but there is something very satisfying about making your own drawing implement, whether it is a piece of charcoal or a sharpened stick to dip into a pot of ink. A piece of bamboo, a twig, a long matchstick, or even balsa wood can be sharpened and shaped at one end with a craft knife to make a point or nib. You can make a selection of different sizes and shapes.

Take a suitable piece of bamboo or twig and whittle the end to form your desired shape, pretty much like sharpening a pencil with a craft knife. Naturally, it is experimental and can be hit or miss, but give yourself a little time and make one or two. Large matchsticks are easy and very effective; the wood is a little soft and porous so they will make smudgy, soft-toned marks as the ink is absorbed.

Whatever you use, it will take a few goes to start working properly, as the tip may be absorbent at first as the ink soaks into the wood; but with use it will start to work better. As soon as ink has dried on the tip, the wood is sealed. In use, the tip may need some fettling, so keep a craft blade to hand.

Tip: A clutch pencil makes a great holder for a long sharpened matchstick, allowing better grip.

If you are working large-scale and expressively, something with a larger and more robust tip than a pen nib would be more effective. A sharpened bamboo or twig will be capable of multi-directional mark-making, with the potential to express movement and energy using thicker, bolder lines.

I have experimented with different sticks of wood. I found some bits of balsa wood of different shapes, some dowel-shaped and some flat, and tried dipping these in ink. I discovered that the balsa wood was (naturally) very absorbent, so I didn't think it would work well. However, I was delighted by the softer marks it made. Looking back on subsequent drawings, I was amazed to find that they resembled charcoal drawings, because the sticks could still make marks even when the ink had dried out, but the marks were greyer and softer, very much like charcoal when used on its side. It was a great discovery and learning experience and goes to show the value of experimentation.

Try making a pen by splitting a thin cane – the sort that are sold as supports for plants – and then carving a point at one end. This thinner stick has more flexibility and 'give' and is very satisfying to hold and to draw with.

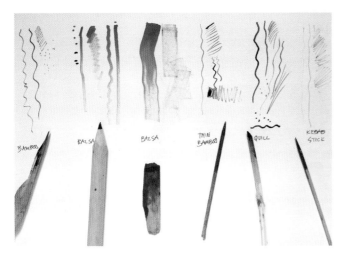

A while ago, while browsing in an art materials shop, I came across a thick double-ended bamboo drawing pen (shown on the left of the picture). Having bought and tested it, it opened up a lot of possibilities to create different, more varied drawing marks. I then set about making my own pens – finding sticks and cutting nibs into the ends – and was delighted by the effects of the different woods and shapes. The absorbent balsa wood carried on making marks after the ink was used, which was interesting.

These home-made drawing pens are great fun to make and use. They are more unpredictable than a commercially made version, but are capable of unique mark-making.

Biros

I find the humble biro to be a very versatile pen: equally at home as a writing or drawing tool. I buy black biros by the pack, so there is always a well-placed biro in every room to make notes, scribble an idea down, or make a quick sketch. It is a great instant drawing pen, provided you draw with the pen upright; using it in a horizontal position when drawing upright at an easel means it will stop working after a short while.

Biros are great for working in sketchbooks. It didn't occur to me for a long time to try them on larger scale drawings as I thought it would be too labour-intensive: the larger the picture, the more drawing is needed to create thicker lines or solid areas. In fact solid areas are virtually impossible, and continued repeated intense pressure will put grooves in the paper, stretching and buckling it. Despite all these apparent disadvantages, however, they can be used successfully on larger scale works; you just need to work more quickly if you want to build up tones and solids efficiently. Even light tones can be achieved with practice.

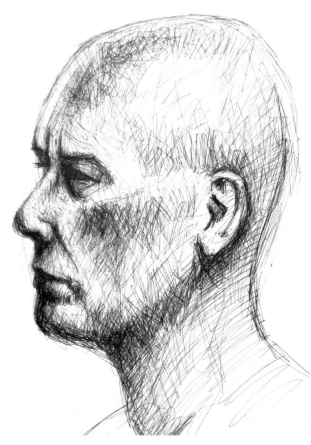

If you haven't drawn with biro before, you think that tones can't be achieved and it is like using pen and ink. But it's quite a different drawing experience in that the tip glides easily over the surface of the paper much more easily than a scratchy nib, therefore the faster you draw, the less ink it can put down. And if you back off the pressure then even lighter marks can be made.

Conversely, if you apply a lot of pressure and make hatching marks close together, then you are able to produce an almost solid area – so a tonal range is possible.

In use, the faster you make marks, the more they are likely to skip over the surface. Also the colour of the ink in a larger scale drawing can take on the appearance of dark purple, although when writing it appears black. These slight disadvantages aside, biros are still a favourite sketching and writing tool.

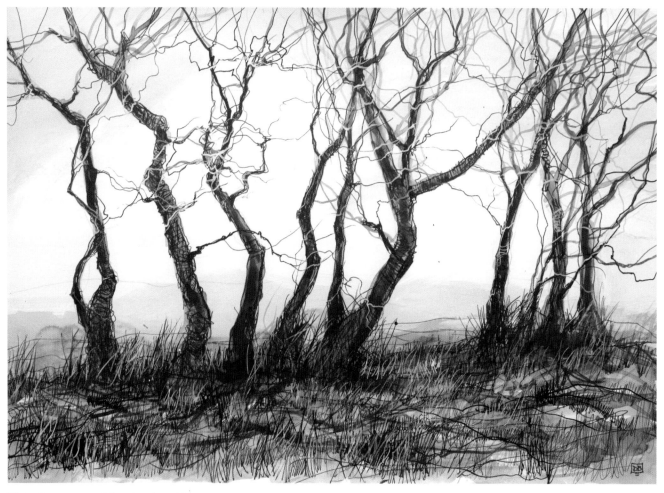

Winter Treescape, pen, ink and wash on A3 paper.

Looking through my archive of tree photos, I re-discovered this winter scene in which the row of trees sat on the edge of a wood with an expansive plain (the Cheshire Plain) and a big sky beyond. The trees stood together in a row, their branches, stripped of their leaves, reached out to each other. I loved their dynamic forms, there was so much movement – the scene was just asking to be drawn. The dark tree shapes were almost silhouetted against the bright sky, but there was ample texture in the trunks and branches to create enough interest to be explored with pen. I thought I would leave the sky unpainted, or maybe just paint a pale watery ink wash.

My intention was to create a monochromatic sketch using Payne's Grey acrylic ink, which I think has more interest and subtlety than black in certain applications. Because of the nature of pen and ink, this sketch would be an expressive response to the photo rather than a literal translation. I wanted to explore and experiment with my mark-making and just enjoy the drawing. I was using wet media so I worked flat on a table.

MATERIALS
Dipper pen, Daler Rowney FW Payne's Grey and white acrylic ink, a couple of containers for washes, a small container for ink and one for clean water, a rigger (a specialist watercolour brush with long soft bristles) and a larger flat brush, HB or 2B pencil for light underdrawing, A3 sheet of heavyweight cartridge.

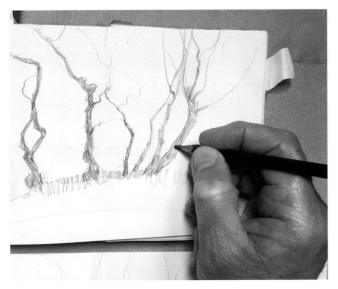

As with most things, this idea started with a brief sketchbook study to see if it would make an interesting painting.

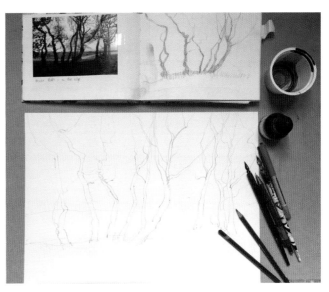

Photo reference and sketch are on hand to guide the drawing. A freehand pencil drawing was made on a sheet of A3 cartridge paper. The trees were drawn in outline.

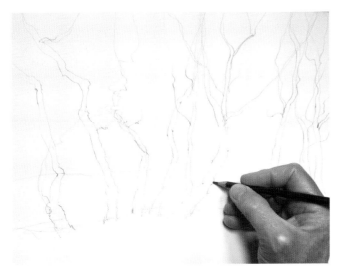

The undulating horizon line anchors the trees together. I didn't overdo the detail at this stage – it's just the basics.

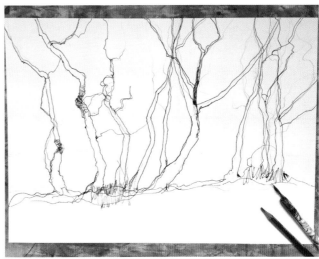

The drawing was inked in – I used Payne's Grey acrylic ink. The horizon line was strengthened; the trees are still in outline.

METHOD

Step 1: I tried a couple of pencil sketches in a sketchbook to get familiar with the image.

Step 2: Taking the sheet of cartridge paper and the pencil, I lightly sketched in the horizon line, carefully noting its position (in this case the lower third of the picture), then drew the tree shapes, confident that any stray pencil marks could be removed with an eraser before any washes were applied.

Note: If the pencil lines are too strong and a transparent wash is laid over the top, the lines will remain visible, and then be permanently fixed underneath this waterproof layer.

Step 3: I transferred some ink into a small container using the dropper, then added a few drops of water to make it flow better. I inked over some of the pencil guidelines, using the pencil underdrawing purely as a rough guide. I didn't slavishly ink over all the pencil drawing – the ink line doesn't have to precisely follow the pencil.

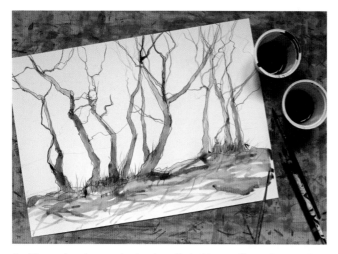

A mid-toned wash was mixed and applied with a small round watercolour brush and a rigger. The trees were washed and loose brushwork on the ground linked everything together. The first wash needed to be pale.

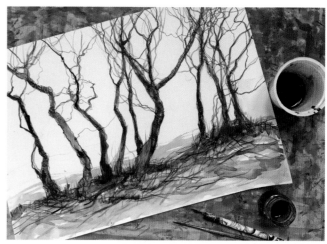

Darker washes have been added and more drawing with the pen helped move the picture forward. I've established a shadow area at the base of the trees to connect them, and painted in a few branches.

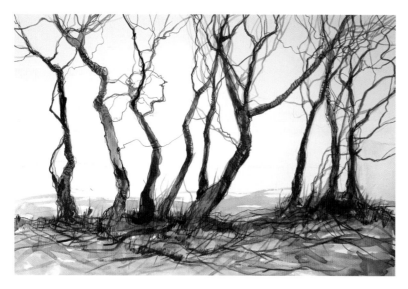

At this nearly finished stage there was a good balance between tonal washes and pen and ink drawing. This drawing was never meant to be a highly finished picture, just an expressive response to the subject.

Step 4: I stopped to assess the drawing, because when you have been sitting down working at a table, you can't pull back enough to see the work objectively. It is good practice to step back regularly, have a good look, and compare it with the original photo and sketch to see if you have captured the essential characteristics.

Step 5: Next, I mixed a light-toned wash and, with a large flat brush, loosely painted over the ground and between the 'tramlines' of the trees. The large brush ensured I didn't get too fiddly and simply 'filled in'.

Tip: Don't worry if the wash is too pale, subsequent layers will add interest and texture where they overlap. Because the acrylic ink washes are waterproof when dry, it is easy to work over them without disturbing the work underneath.

Step 6: I went back to pen and ink to do more drawing in the trees, strengthening the drawing and suggesting shadows and texture. I enjoyed drawing over the loose washes underneath. I used the rigger with the diluted wash to describe some of the smaller branches to add a variety of marks and interest in the ground. I painted a variety of flowing horizontal strokes.

Step 7: Mixing stronger washes, I worked into the shadows to darken them and to give more depth to the picture, while at the same time adding more weight to the ground and the trunks of the trees.

Step 8: Finally, I thought I had overdone some of the shadow areas and had lost some texture on the trees and groundwork. So, using white ink I drew back into the dark shadow areas to create a little texture to suggest grass and bark. I added one or two finishing touches by way of more small branches.

Watercolour

Very straightforward and rapid to use, watercolour nevertheless requires a lot of skill, knowledge and experience to achieve the best results.

The use of watercolour exemplified in this book is as a way to add colour to a sketch or study, or as a secondary medium in a larger work, rather than being the sole focus. Watercolour is a versatile and direct medium requiring very little set-up time, and because of its non-permanent quality it is less threatening to work with than oils or acrylics. Because of this non-permanent nature, care is needed when building up layers, and more planning is required, for example for highlights.

It is a great provider of instant colour for a sketch or study, enabling the artist to visualize its possibilities for a more considered work. Watercolour can be a spontaneous medium or one requiring a more thought-through, planned approach – such is its versatility.

Success relies on mastering certain techniques to get the best results, or at least being aware of them: laying flat washes, working wet-in-wet, lifting out, using masking fluid, spatter and dry brushing – these will all enhance your work. I intend to give just a brief overview of some watercolour techniques and terminology as there are literally hundreds of specialist books wholly devoted to these techniques. Practise some so you can better understand how this medium works.

Watercolour properties and techniques

Watercolours will appear lighter once dry, so allowance needs to be made for this. It is also a good idea to let the work rest often, so that judgements can be made as to how best to proceed. Often, in practice, the rich, vibrant, unpredictable effects of dropping one colour into another wet-in-wet can look sensational when wet, but a bit flat once dry.

Wet-on-dry

Applying watercolour to dry paper will give a hard edge once dry; if the paper is dampened beforehand it will bleed a little and give softer edges. This can be manipulated and softened off with clean water and a brush by gently agitating, but care is needed not to overwork things.

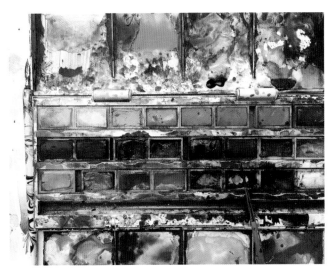

My well-used watercolour box is always close to hand to quickly apply colour to a pencil or pen and ink sketch. I have two versions: the other box has half pans, which doubles the choice of colours. I like the way a simple sketch can take on a completely different meaning with the addition of a simple colour wash.

Working light to dark

An accepted principle of watercolour painting is that you start with light colours and work towards darker or stronger colours. It is sound advice as it provides a logical, controlled way of proceeding with the painting. If you go too dark too soon and then find that you need to adjust things by going lighter, it will be difficult as you will have to lift out, which is never a predictable process. You could be stuck with what you have and have to adapt in some other way.

Better to lay light washes to start off, then build up carefully as you progress. Dark colours will work over light. However, layering has its own hazards. Watercolour, once dry, remains water soluble; as you add more wet colour over a previous layer, you run the risk of lifting that colour and blending it and this can give a muddy outcome. So, great care is needed not to overwork things. Sometimes you can just paint away intuitively and let it do its own thing, if you are prepared to work with the process and go with the flow.

In essence, working with watercolours requires some planning: what to paint first, what to leave unpainted, and so on. There is a certain order to do things in if you want the best outcome. Watercolours can, however, also be used spontaneously.

Masking fluid

Masking fluid is supplied in small bottles for application with a brush or dip pen, or in a clever applicator bottle that has a thin metal tube that the fluid runs down when the bottle is squeezed. You can draw with this applicator. The purpose of masking fluid is to stop out areas in the painting that you want to leave unpainted, like highlights. Some masking fluids are a pale blue colour, which aids visibility in use. Simply paint the masking fluid wherever you want white paper to show through. You can even draw in negative, as if using a white wax crayon, then lay a wash over.

Once the masking fluid has dried it can be painted over, and when the paint has dried the rubbery deposit can be easily removed by rubbing gently with a finger to reveal the white of the paper underneath. It can also be applied during subsequent stages in the painting, over lighter colours, and then darker colours added. This is particularly effective on areas such as undergrowth or on architectural features.

Lifting out

If a passage within the painting has dried too dark or needs some adjustment, it can be partially removed or 'lifted out', depending how dark or strong the colour is. This is done with a brush or sponge and clean water. Gently brush clean water onto the surface and agitate it to loosen the paint and use a tissue to dab and lift off the paint. This is a very useful and common technique; in effect it is like using a putty rubber with graphite. Use it to create variety in a wash that has dried too flat.

Spatter

This is a very effective technique for watercolours or acrylics, particularly where texture is needed for landscapes or buildings. The effect needs some practice as it can get out of control very easily; it can also be overused, and dominate the picture. Care is needed with a bold technique such as this to ensure it stays relevant. Areas can be masked off to prevent unwanted spatter spoiling areas where it is not needed. The idea is to spray droplets of paint onto the picture either wet-in-wet or wet-on-dry.

Mix a coloured wash in a flat container, use a toothbrush or bristle brush to dip in, then with a finger or ruler, flick the end of the brush so that the liquid is sprayed onto the surface. Always practise on some scrap paper first as the results can be unpredictable.

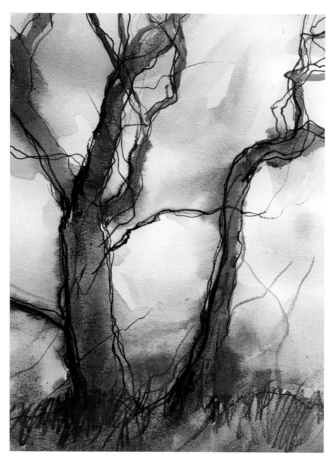

In this detail of a mixed media treescape, after the initial pencil drawing followed by the pen and ink work, a medley of watercolour washes was dropped onto the paper. I was interested in how colours ran and merged with other colours. This process is so addictive, I must admit to getting carried away and not knowing when to stop, wanting to mix new colours to drop into other wet colours.

Wet-in-wet

Obviously, this is a very natural way of working with watercolours. If you keep adding wet paint into more wet paint, the paints will merge and flow into each other, creating soft edges and blending the colours. You can keep adding more colour wet-in-wet, but at some point things will become muddy.

Taking a sheet of dry watercolour paper and applying two colours wet-in-wet will give a different effect if the paper is first wetted and the same two colours applied in the same way: the first colour will have already bled into the wet paper and softened edges, the second colour will blend and merge with the first. If the result is not quite what you wanted once the colours have dried, it will be difficult to amend as the more you keep working into the painting with wet paint or even clean water, the result may look overworked. It is not advisable to rework it too much as this will become quite noticeable once dry.

When I work with spatter, I find it best to work flat on the floor – it's a safer way to catch any errant paint spray. I put plenty of scrap paper underneath everything, then have one or two old toothbrushes to use along with a couple of pots of water, kitchen roll and a flat palette for the acrylic/water mix. It can be a hit or miss process to get the right consistency of paint for best effect.

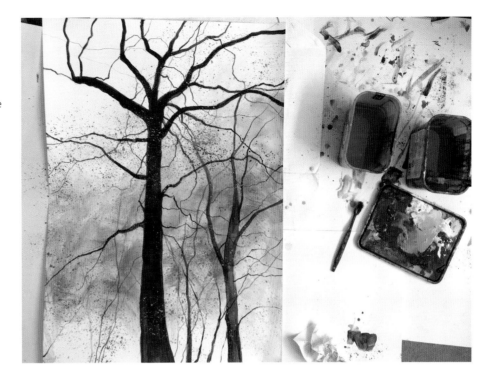

The effect will depend on a number of factors: how loaded or wet the brush is, how stiff the brush is, the distance from the paper, and so on. Once mastered, different colours can be spattered one over the other to build up texture and interest, for example yellows and greens to suggest leaves or foliage, or reds and browns to suggest rust.

Care must be taken to ensure the effect is not overused, however. All effects must be used appropriately and be sympathetic to the subject. If it is overdone, it can detract from the overall feel of the painting in the eye of the viewer. Make further adjustments with a brush and more washes.

Dry brush technique

For me this is an essential technique (for use with watercolour or acrylic). It can be used with spatter for a really textured result, or with more subtlety over plain washes. It can be controlled well if you understand how it works best. Practice is needed to discover its potential.

By definition, the technique requires an almost dry brush along with stiffer, more opaque paint. If the brush is too wet, it will paint normally; if it is too dry, it will be difficult to apply paint.

I find the most effective brush to use is a bristle brush, or even better an old bristle brush where the hairs are a little stiffer. An old toothbrush works fine. I keep a selection, because the bristles can become stiffer with use, especially if the brush has been used with acrylic paint.

Start with a damp bristle brush and take even more moisture out by brushing onto some clean paper. It will take a few attempts to get the right balance. Pick up some paint on the end of the bristles and test on some paper. Practise with some stippling or directional strokes; this will give great textural effects. If the brush or paint is too wet, scrub the brush into the paper to remove more liquid until you find the right balance. A particularly useful brush for this technique is a bristle fan blender, which will give great effects on grass, for example. Just make sure you have a good first layer of paint underneath. You could then keep building up layers of grass to achieve more density in the undergrowth.

Drawing with brushes means drawing with a flexible point. Use a long, soft-haired brush that will hold a good amount of liquid and you will be able to make flowing lines without the need to keep recharging the brush too often. I quite like the water brushes that are popular now because they have a reservoir that can be filled either with clear water or colour. A good idea is to take a number of these along when sketching outdoors, as they save time. They can act like coloured markers.

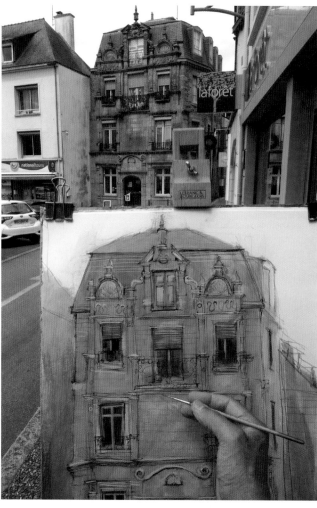

Here I'm using a rigger for detailed work on this beautiful building in Brittany. There are already a few layers of acrylic underneath, so the surface is nicely primed and not too absorbent. The paint flows well over the pre-painted surface. I achieved balance with this picture by applying detail then washing over it to soften it when necessary, followed by drawing with a pen to strengthen the drawing.

Drawing with a brush

This book does not hold any preconceptions about what does and what doesn't constitute drawing media or equipment. Indeed, anything goes: anything that can be held in the hand and used to make a mark on a surface, or indeed using the hand itself as a tool, or more usefully a finger, to apply pigment or liquid to a surface to stain it or otherwise make marks, constitutes drawing. Drawing with a brush is as relevant as drawing with a pen, stick, pencil, quill, and so on.

Using a rigger: When I am working on one of my small tree paintings in acrylic, I will use a rigger (a specialist watercolour brush with long, soft bristles) for the fine detail work of branches, grass or foliage. I consider it as 'drawing' with a brush, in the same way that I will draw a subject with pastel, pencil or pen and ink, and so on. I don't see any distinction. The rigger with all its flexibility to make multi-directional marks is light in use, and makes an excellent drawing instrument.

Certainly, when drawing with pen and ink, there will be occasions when you will need a thicker line than a pen nib can offer, or you might need to apply an area of solid black, for example. A brush will easily and quickly complete the task.

A range of brushes from the left: a flat brush with watercolour gives a smooth effect, the flexible rigger is a great drawing tool, a worn bristle brush is perfect for dry brush work, an old decorator's brush is very useful, and an old toothbrush for spatter.

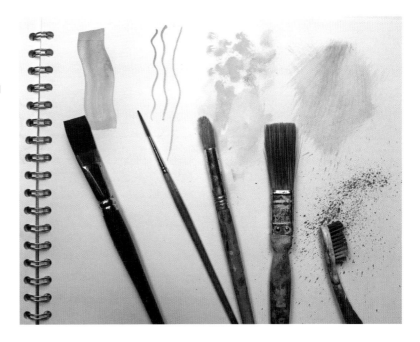

Using a round synthetic or natural hair brush: There will be other times when you might feel like producing the whole drawing using brushes. There are other types of brushes to consider apart from the rigger: a larger round watercolour brush with the ability to form a point. This should hold a reasonable amount of liquid to paint a consistent line for longer without the need to stop to recharge the brush, therefore risking spoiling the continuity of the line.

Using a synthetic flat brush to give a variety of lines: A versatile brush for broad sweeps that twist and turn; or use the side of the brush to make thinner lines. It's great for washes and also for painting into corners.

Using a bristle brush: For a bolder, less precise line, especially when the brush isn't quite as 'loaded'. The brush creates dry brush effects where the coarseness of the bristles comes through to give texture, for a 'looser' feel.

A long-handled bristle brush is capable of producing expressive drawing marks, especially with black ink with perhaps a coloured wash background. It's great for bold life drawing, for example. Use with inks, watercolour or diluted acrylic paint.

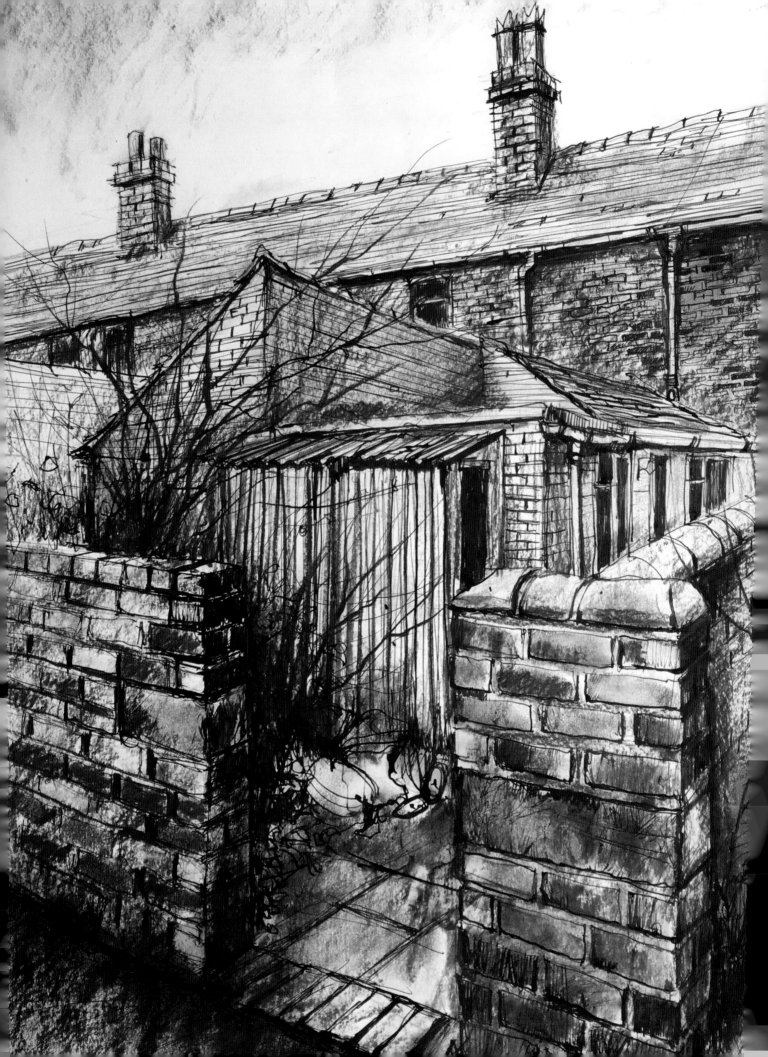

PROJECTS AND PRACTICE

n this chapter I describe processes and discuss techniques used in relation to some of my artworks. In some cases I have described the inspiration, materials and process behind the works – the story, if you will. In others there is a more structured and precise step-by-step project-based description – the project.

With some examples, the emphasis is on the broader rationale, discussing how the idea of the picture came about: the inspiration and background, followed by the development of the work. The description of the process is accompanied by a list of the materials used.

There are in-depth projects with technical descriptions and methodology. These are designed to encourage and motivate you to pursue your own ideas, based on your own subject interest. You can try out and test these techniques for yourself, or just enjoy seeing how the works have come together.

The ultimate goal is for you to discover ways to develop your own artistic vision through exploration and experimentation. I have supplied some technical knowledge combined with practical experience to enable you to achieve that goal.

Exploring mixed media

One of the most exciting things I find about working with different combinations of media is that often the outcome is totally unpredictable. Mostly this is a good thing and the results can be pleasantly surprising. Sometimes it can

◀ *Terraced Backs*, pen and ink with charcoal, 60 × 42cm.

be a disaster – but even if things don't quite work out the way I expected, I often learn something new along the way. Surely this is a good enough reason to try something new? A mark you expect to make confidently and predictably can quite easily turn out differently; what perhaps started out as a subtle and low-key passage can quickly turn out muddy and heavy.

The potential for an interesting outcome is great though, and often this can lead to a more adventurous piece. Take the wax resist technique, for instance, where it's almost impossible to predict exactly how things will turn out. It is a process that can be used over a previous passage in the picture, but some control and consideration needs to be exercised if this layering effect is to be successful.

Wax resist technique

Having previously discussed oil pastels and wax crayons, it is logical to follow on with the wax resist technique. A drawing is made with either oil pastels (or wax crayons), and a thin wash of watercolour is subsequently laid over the drawing. Because wax is resistant to water, the washes bounce off the waxy marks to give interesting effects. It is difficult to predict the outcome: if the wax marks are not strong enough the wash may not resist sufficiently for the effect to work effectively; if the wash is too strong or 'dry' then it won't bounce off the wax as much.

Of course, unpredictability is all part of the fun and excitement of this technique. It is why it is such an attractive combination of media for some artists. It demands a bold, confident approach. Imagine the possibilities of

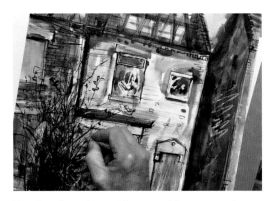

Mixed media on A2 cartridge paper. Like so many of my mixed media works, I started with a pencil drawing on cartridge, then at some point much later decided to add watercolour, then wished I had chosen a more appropriate paper. The wax resist seemed to match the derelict subject matter well. I've always liked a strong drawing element in a picture and black ink on top of watercolour washes seemed to satisfy this. It was an experimental piece.

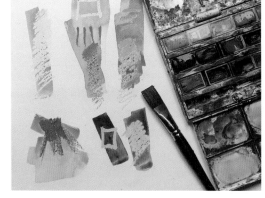

The wax resist technique relies on a watery colour wash being repelled by a waxy surface – like water droplets on a freshly polished car bonnet. It is a question of getting this balance right – too little wax, or too dry a wash, then it will be less effective. Here are a few random marks made with oil pastels prior to having a watercolour wash laid over. Try subtle colours as well as contrasting colours – the technique can be quite low key and still be effective.

The same page after washes have been applied. Clearly visible are the textural possibilities when the oil pastel marks are more open, allowing the watercolour to form smaller droplets.

using strong complimentary colours together: for example, a bold drawing using a vibrant blue with an orange wash laid over. Interesting things happen when the wash 'pools' on top of the wax. The effect works best when coloured washes are laid over a drawing, and the liquid moves around seeking places to pool. Naturally, the effect becomes more subdued as the watercolour dries and becomes paler.

Wax crayons are, naturally, excellent for use in this technique. They can be used either as the dominant medium or as a secondary medium to watercolour. Especially effective is when a white crayon is used to draw on the surface to leave areas unpainted. Wax resist is very effective when describing texture.

For the process to work effectively, the watercolour needs to be quite thin to bounce off the waxy marks, and crayons must be pushed hard into the surface of the paper. If only light or moderate pressure is applied, the watercolour will just make a transparent wash over the drawing. Experimentation is the key to success, so try out the technique first if you are new to it. It will always give an unpredictable result, depending on how much wax is applied or how watery the wash is. A 'stiff' watercolour wash may sit on top of the wax until dry.

The process offers great potential for creating unusual and different effects, but because of the unpredictable nature of using wet and dry media together, not all your efforts will be completely successful.

Tip 1: Use some scrap paper to make some marks with wax crayons or oil pastels, then wash over some watercolour to get used to how they work together. Once you have gained some experience and are used to how the different media behave, you can try pen and ink on top.

Tip 2: Because this process involves wet and dry media together, let everything dry before proceeding with further drawing. It might be an idea to work on two or three drawings at the same time and alternate between them.

Tip 3: There are many variables in this process, for example the watercolour may look really vibrant over a contrasting coloured wax crayon while fresh and wet, but will lose some impact once dry. More washes may be needed to build up the effect. Depending on the colour palette and the contrast between the crayons and the paint, the effect may get too muddy or indistinct. Some combinations work better than others. It is what you discover when experimenting with a process that is the most valuable thing here. This technique won't always go the way you planned, but you will be able to see the potential.

Artist inspiration – Henry Moore and wax resist

Sculptor Henry Moore (1898–1986) was a practitioner of this technique in many of his superb drawings for sculpture. His series on miners and people sheltering in the London Underground stations during air raids in World War II are excellent examples of a natural mixed media technique. Discover these beautiful, 'sculptural' works with their directional, contour mark-making and use of various media – pen and ink, watercolour, wax crayon and pencil – to see how he achieved powerful, emotional and expressive studies depicting the human form.

As well as being a world-renowned sculptor, Moore's drawings of ideas for sculpture involved the pioneering use of mixed media. The works *Two Seated Figures with Child in the Underground* (1941), *Shelterers in the Tube* (1941) and the emotionally charged *Pink and Green Sleepers* (1941) are prime examples of his technique. He used various combinations of pencil, pen and ink, watercolour and wax crayons on paper to achieve a great sense of texture and form.

Sculptors such as Henry Moore and Dame Elisabeth Frink (1930–93) produced really strong depictions of form and solidity. Moore produced hundreds of fascinating, original drawings; Frink produced powerful drawings of horses and the human form. Their two-dimensional works are often overlooked as beautiful artworks in their own right.

Discover and research the working drawings of other sculptors for yourself, and see how they have used various techniques to achieve the illusion of three-dimensional form.

Adding pen and ink to wax resist

With such a mix of wet and dry media, it is difficult to have complete control. The pen will scratch into the wax and clog up the nib. The ink and watercolour need to be dry before working with the wax crayon.

Paper choice

If using textured NOT (meaning not hot-pressed) watercolour paper, drawing with pen and ink can be tricky because the nib doesn't draw easily over the textured surface.

A more preferred choice of paper might be a smooth hot-pressed (HP) watercolour paper, or alternatively a really heavyweight smooth cartridge paper, but then some element of textural effect will be lost. With cartridge paper, drawing with the pen is easier, but the washes will buckle and cockle the paper. It is also worth experimenting with a dedicated mixed media paper.

For the wax resist

Try contrasting or complementary colours for maximum dramatic effect, for example an orange crayon with a blue wash or yellow crayon with a purple wash, or light-coloured crayons with a dark-coloured wash, and so on. It is quite a good idea to start the wax resist process with a white crayon, although if you are drawing on white paper this is difficult to see, only appearing when you lay a wash over it, as if by magic. If you start off in this way there is scope for layering and building up very subtle textures and interesting effects, alternating between drawing with the wax crayon and laying a wash, letting it dry, before repeating the process.

Once you have your idea, sketch it out lightly on the paper, then reinforce the drawing with pen and ink, before deciding where you want any texture or effect, then apply the wax crayon. The stronger the mark, the more it will resist the watercolour. After applying the wax, mix a wash of your chosen colour and lay it gently over the surface. Make any adjustments to the colour in terms of strength or dryness, until you are happy with the effect. Let this dry before continuing, as with watercolours the paint and paper need to thoroughly settle down before continuing.

Tip 1: It is not a bad idea to work on two or three other drawings at the same time. You can then rotate and alternate between other pictures. It is a more economical use of your time.

Tip 2: Instead of watercolour, try the Daler Rowney range of FW acrylic inks. These are available in a wide variety of colours and add more vibrancy to your drawing. If care is not taken with this process, however, there is a tendency for the work to become 'muddy', and it is then difficult to recover the contrast. Contrast in tone or colour is needed if the drawing is to work effectively.

Despite what I said earlier about using textured NOT watercolour paper for this process, it is worth trying as the difficulty of dragging a pen nib over the surface is often worth persevering with for the better textural effects created when the wax bites into the dimpled surface.

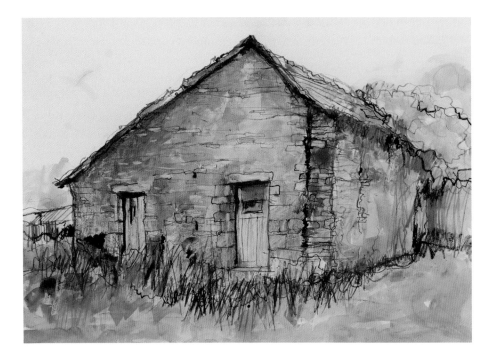

Abandoned Barn, Brittany, mixed media on A3 cartridge paper.

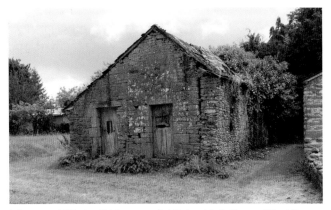

I discovered this derelict barn on a field trip while in France. I liked the contrast between the freshly mown grass and the neglected building. The three-quarter frontal viewpoint gave an interesting perspective.

I was inspired by the character of an old barn in Brittany (*see* photo). It was in a bad state of repair but I thought it would make an enjoyable subject for a small expressive work using mixed media. I liked the stonework and the paint falling off the doors. The roof was completely ruined and the side wall was separating from the front. I intended to produce a series of small works based on interesting abandoned buildings, such as old barns and derelict houses.

In contrast to this, the grass around the barn was recently mown, but there was a mass of vegetation around the base and a lot of foliage around the sides and roof. I liked the perspective of the three-quarter front view. There was an opportunity for a lot of drawing as there was much detail in the stonework, but also some paint techniques to exploit the bright summer greens. My idea was to use the wax resist technique selectively to add to the work.

MATERIALS
Selection of wax crayons and oil pastels, 2B pencil, cartridge paper, watercolours, a selection of brushes including a rigger, pen and black acrylic ink. Ideally, I should have used a sheet of watercolour paper, but I started the drawing on heavyweight cartridge because I was impatient to draw, then one thing led to another and I found myself wanting to ink the drawing then apply colour.

METHOD
Step 1: I lightly sketched in the building using a mechanical pencil with a 2B lead, and a 6B pencil, but didn't worry too much about exactness or precision as this was going to be a loose drawing – I wanted to capture its essence. I then strengthened the drawing with the 6B pencil, and used grey and green wax crayons to define the drawing a bit more and to suggest some texture and colour.

My idea was to do a series of small paintings. I've started with a loose pencil sketch, then added some wax crayon to suggest some early colour.

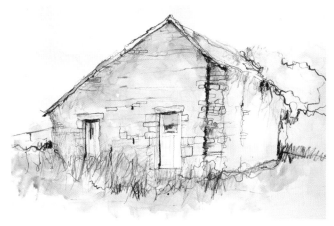

Having strengthened the drawing with pen and ink, I applied some loose washes of watercolour to help separate the different elements.

I've added some oil pastel, stronger washes of watercolour, and strengthened the drawing with ink, adding some marks to suggest the foliage.

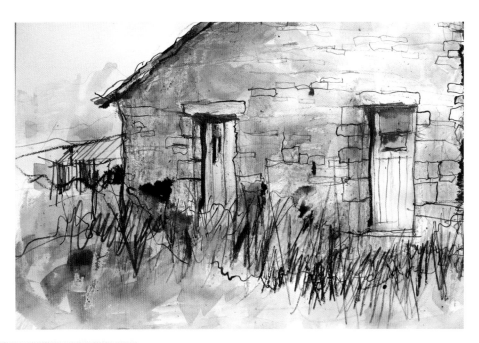

Tip: Using a lot of pressure to deposit more wax will repel the watercolour more effectively. Drawing lightly and not pushing the crayon into the paper means the watercolour will just cover the marks with a transparent wash rather than completely resisting. But this is all part of the process: it has unpredictable qualities but adds interest to the drawing.

Step 2: Using the pen and ink, I worked over the drawing. Next, I laid some simple weak washes of watercolour to separate the building from the rest, which enabled me to see the big shapes more clearly.

Tip: Take care when inking any areas that are very waxy as the nib will collect the wax and clog the tip. This will become apparent in practice, so keep some kitchen roll handy to wipe it regularly and keep it clean.

Step 3: I loosely worked some oil pastels into the drawing, then added more watercolour washes, working wet-in-wet to create interesting colour mixes. The cartridge paper naturally buckled a little with the washes, and the strength of watercolour is weaker when working on cartridge paper. The same watercolour washes would appear stronger on watercolour paper.

Step 4: I was enjoying watching the oil pastel repelling the contrasting watercolour washes, and this inspired me to do more and be freer with my mark-making. It is quite exciting watching different mediums reacting with each other to create new effects.

Step 5: At this stage it was time to rest the picture before I got too carried away. The sky was still untouched, and I needed to reflect exactly how I wanted the picture to look.

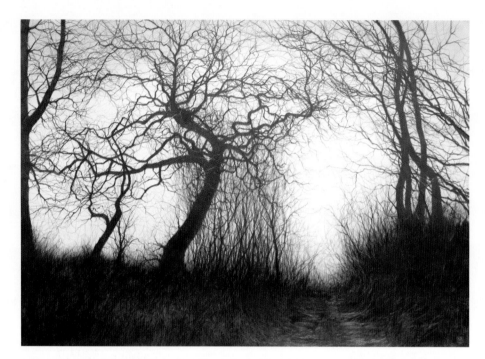

Winter Walk, graphite and tinted graphite on A1 220gsm cartridge paper.

INSPIRATION

The type of image I choose to work from suggests the approach I will take. In other words, I let the subject lead me. For example, with a treescape, if it is very busy with a lot of tangled branches and lively undergrowth, I may respond by taking a more impressionistic route, so I will be more intuitive with my mark-making and try not to be too 'literal' in interpretation.

The drawing may be 'looser', and I will try not to over-commit by making too many strong marks that may be difficult to manipulate later. By regularly 'cutting back' into the drawing with an eraser, I will try to maintain a balance of tones within the picture. I might work at building texture with graphite, then use an eraser like a pencil to 'draw' into the marks to create another layer of interest. I will then repeat the process, all the while adding to the texture. Painting is all about layers, and for me a drawing is the same: building it up and adding interest layer by layer.

With each drawing I do I search for a new challenge, and this is the exciting thing; I haven't found a formula that I magically apply every time I draw a particular subject. I don't want to draw something in the same way; I want to try something slightly different each time. If each drawing is approached from a new perspective, it enables your confidence as well as your repertoire of mark-making to expand with each picture.

MATERIALS

6B pencil and pencil-shaped graphite sticks, soft graphite sticks, green tinted graphite, hard and soft putty rubbers, sheet of 220gsm cartridge paper.

METHOD

Step 1: This drawing started out as a two-hour demonstration while exhibiting in France, so I had to work quickly to establish the picture so that, although it wouldn't be finished, I could at least show good progress. I selected an image with a lot of busy textures in the undergrowth and branches. The idea was not to produce a copy of the photograph, but to use it as a reference point. I was aiming for something that captured the essence of the view, an atmosphere.

Step 2: I started with a loose drawing to position the trees, then used powdered blue graphite to add pale colour into the sky.

Step 3: I applied some green graphite 'washes' to the bottom of the picture. I took a soft graphite stick and used it on its side, using my fingers to blend with the green. This was only a rough approximation to get the drawing started with its first layer.

Step 4: I used the 6B pencil and graphite stick to develop the tree shapes, adding more definition to the outlines by shading in a directional way (following the lines of the tree). I added some branches, worked over the green tone and drew some loose scribble marks to suggest undergrowth.

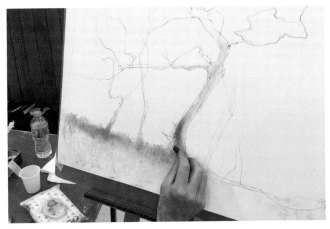

It can be quite daunting demonstrating to a large seated audience, and on this occasion it was a very hot afternoon in a room without air conditioning. I started more or less from scratch with a loose pencil drawing, establishing the trees and a rough horizon line. I have applied some tinted green graphite to the base and here I'm linking the trees to that.

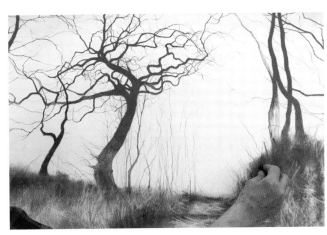

I've balanced the main tree shapes to firmly establish the composition. I am working some soft graphite into the undergrowth to give more depth, but at the same time I am trying to keep the solid areas 'open' with the use of an eraser, to create texture. With a demo, I think it's important to work quickly and try to establish the picture as soon as possible.

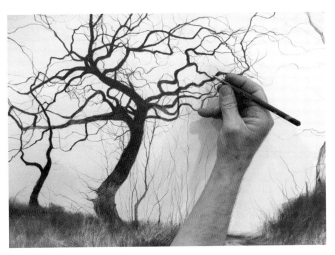

I'm trying to keep a balance between working broadly and more detailed. Here I'm redressing the balance a little by doing some detailed work on the branches to establish the character of the main tree. Doing slow detailed work in front of an audience can be a bit stressful – you are still working hard but the picture's progress has slowed right down.

Step 5: I used a slice of hard eraser to cut into the undergrowth as if drawing with the rubber. This would stop it from getting too heavy and dark too soon and also create more texture. I wanted to build up texture in a fairly controlled way, to keep everything balanced.

Step 6: I continued to strengthen the tree forms adding more branches. I wanted to capture the dynamic qualities of the trees as well as all the life coming from the undergrowth. With powdered tinted graphite and pencils I built up more subtle colour into the lower half of the picture. The heavier the layers, the more difficult it was to cut into with an eraser.

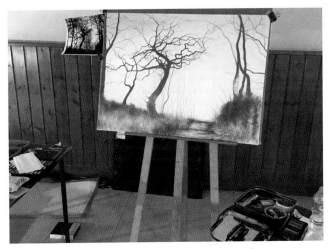

Here is a photo of the set-up. I worked standing at the easel, my materials on a small table to the right, the 'comfort' things such as water and wipes on the left. I kept stepping back at regular intervals, as is my usual practice. I could see gaps that needed resolving – the picture needed to be much busier.

Step 7: I added more detail in various places to keep the picture balanced, working darker tones in the shadow areas and adding smaller twigs to the branches. I regularly took a pause from drawing to step back and assess progress before proceeding.

ASSESSMENT

With this picture my intention was to produce a drawing that captured some of nature's energy and mystery. I tried to maintain a balance throughout the making of the picture, so that it progressed as a whole. I wanted to keep my mark-making lively and varied, and was pleased with the result. I especially liked the subtle hint of green.

After the initial demo, the drawing languished in a folder for some time before I rediscovered it and finished it off.

Many artists choose to cover the 'ground' (the drawing or painting surface) with a mid-tone to cover the stark white of the canvas, board or sheet of paper to give a more neutral starting point. In reality, unless you are painting a desert of white sand in blinding sun, having white as a starting point doesn't make a lot of sense, although watercolour needs the white of the paper to create the reflected light source required to make the colours work and appear luminous.

Naturally, the whites or very light tones need to be decided and preserved if necessary. Trying this mid-tone as a starting point means that highlights have to be created in the same way that shadows do. It's a more balanced, logical starting point. If I have spare time, I prepare papers and boards with different finishes, to 'kill' the stark white of paper or primed canvas.

METHOD

Step 1: I created some charcoal powder by scraping a stick of willow charcoal on a sheet of medium grade sandpaper, and applied it to the surface of the paper using a tissue (a brush or fingers can also be used). Some movement or texture can be suggested if you wish, by using a brush to apply the powder.

Step 2: Using a putty eraser, I lifted out highlights. The drawing therefore began by removing rather than applying material from the surface, which at first seems odd.

Step 1: I prepared the sheet of paper by using sandpaper and rubbing a thick stick of charcoal on it and letting it fall on the paper. I rubbed it in with a piece of kitchen roll. I judged the tone to be about right to give a mid-tone start to the picture.

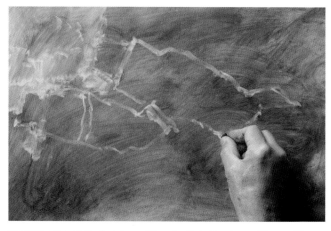

Step 2: I enjoyed the freedom of 'drawing' into the charcoal base with a piece of putty rubber. As it got dirty I cleaned it.

Step 3: I used charcoal to define the drawing in line and started to add shadows.

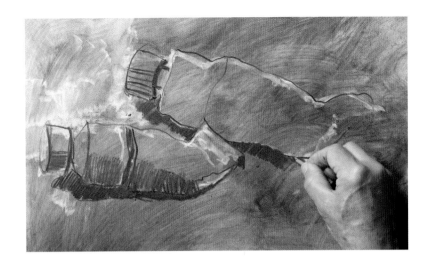

Step 4: As I progressed I tested how I would lift out large areas and also added some darker shadows. To really darken the shadows I would need to fix and then work over the top.

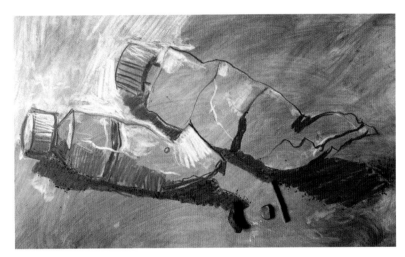

Step 5: I used a mechanical eraser to make finer 'white' marks. I lifted out the top quarter of the paper and darkened the remaining background to suggest the tubes of paint were resting on a table top. The whole sheet was now quite unstable so I decided it was time to fix the drawing before introducing a dark charcoal pencil to get more depth in the shadows. The drawing is just a sketch rather than a finished drawing – a way of seeing if there is any potential for a more detailed painting.

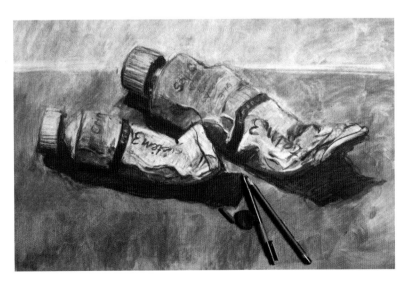

Step 3: I started the drawing by adding line and tone to describe the subject.

Step 4: I continued drawing, becoming bolder with my mark-making by darkening the shadow areas and maintaining highlights.

Step 5: Confident that no more lifting out was required, I decided to fix the drawing, then worked over it again with another layer to enable darker tones to be applied. It can then be fixed again to keep it more stable.

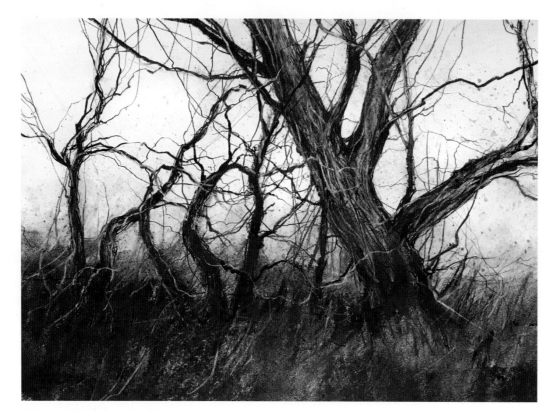

Winter Treescape, willow charcoal, ink and pastel on A2 heavyweight 220gsm cartridge paper.

With this treescape, I wanted to try some expressive drawing that would capture some of the energy and character of the exposed windswept trees. I wasn't interested in colour – more in texture and movement.

MATERIALS
Willow charcoal, charcoal pencils, Daler Rowney FW black acrylic ink, pen holder and nib, putty rubber, stick of white pastel, old toothbrush and water for spatter, sheet A2 220gsm cartridge paper.

METHOD
Step 1: I loosely outlined the trees in charcoal to give me a guide, quickly followed by drawing with ink. Working spontaneously, I drew more branches, trying to keep the drawing lively and fresh. I found myself trying some directional mark-making on the bark of the trees.

Step 2: I used charcoal on its side to block in some tone at the bottom of the picture to suggest the solid undergrowth, and also worked between the 'tramlines' of the trees.

Step 3: I followed with more drawing with the pen, enjoying the freedom of making random marks here and there. I found I was working intuitively and at speed, following my instincts.

Step 4: I progressed by alternating between ink and charcoal, making sure that the ink was dry before applying more charcoal. I worked on broader areas such as the undergrowth and the large tree to suggest solidity and texture and then added more detail, such as the small branches and bark.

Step 5: As the picture was coming to an end – as much as I had enjoyed working on it – I realized that I had overworked things and gone too dark and heavy. Using a putty rubber didn't lift off the charcoal as well as I had hoped.

Step 6: After allowing the picture to rest, and feeling a little disappointed with the outcome, I thought I would try and rescue it using a white pastel. It might open up some of the dark areas and create more interest. I only used the white pastel sparingly as I didn't want it to dominate.

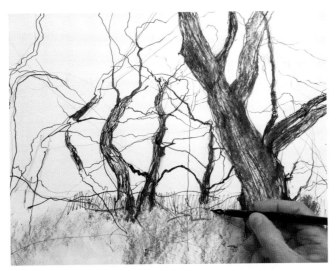

I especially like this early stage in a drawing where I'm trying to find my way. Clearly visible are the loose lines of the pen and ink. I've laid some tentative tonal washes with the charcoal and am now drawing the trees and connecting them together with the undergrowth.

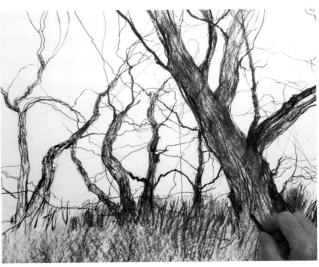

Now back to the charcoal to establish some broader tonal areas. The intention was to leave the sky untouched so it appeared as the white of the paper – there will need to be a soft transition where the undergrowth meets the sky. I liked the way the drawing captured the vitality of the trees.

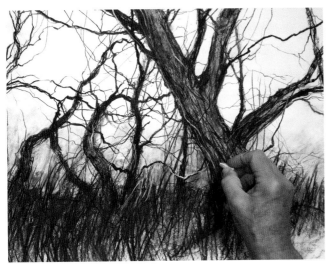

I used a white pastel to create highlights – an eraser wouldn't be up to the job as there was a combination of ink and charcoal to cut through. The tendency is for the work to keep getting darker and for detail to be lost.

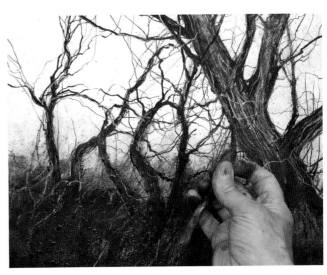

At this stage the picture could have ended there, but I saw an opportunity to try something else – I grabbed a toothbrush I use for spatter and flicked clean water on the surface. This technique gave the suggestion of leaves in a way that was more interesting than using the charcoal directly.

Step 7: Because I felt that the drawing wasn't that successful and might be consigned to the bin, I thought I would try one last thing. I started spattering water onto the bottom of the picture where there was a lot of charcoal on the surface. I didn't know quite what the effect would be, so I was pleasantly surprised to see that it was making interesting textures where the droplets of water were repelled by the dusty surface, some bouncing off and splashing to make other marks. These marks suggested leaves, which suited the picture, so it didn't turn out too badly in the end.

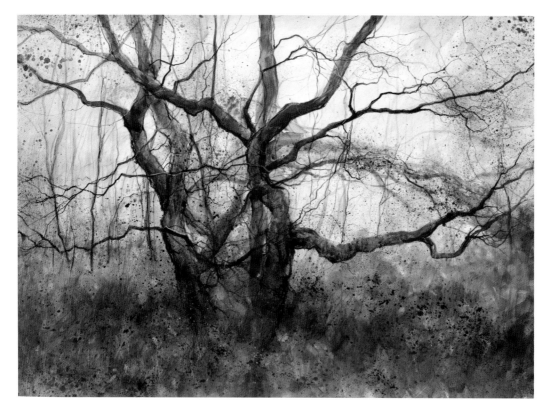

Tangled Trees in Autumn, acrylic inks with acrylic paint on A1 paper. In this large painting I was experimenting with acrylic washes, and wanted to see if I could create some soft edges and varied colour in the undergrowth. I wanted also to create a sense of distance and loose, suggestive drawing – an impression of woodland, rather than a literal translation. I was pleased that I stopped the painting when I did, but it was difficult to leave it; I just wanted to keep drawing. The fine line work is with pen and ink and a rigger. I like the contrast between the very loose washes with the tighter drawn marks.

These two mediums work really well together: both have the same properties of being waterproof once dry and are thinned down with water. They are not opposing each other like wax resist, or potentially problematic like charcoal with ink. Their different properties complement each other; you can use the best qualities of each to good effect.

THE ADVANTAGE OF USING PEN AND BRUSH TOGETHER

For me it is the ability to use both acrylic ink applied with a pen, and acrylic paint with brushes in the same piece that is refreshing: being able to work broadly with a large brush, but then more detailed with a pen. You can also work with opaque, impasto paint or delicate, subtle, transparent ink washes if you wish. Choose a heavyweight cartridge paper, smooth mixed media paper of a decent weight, or card. A well-prepared and smooth MDF board could also be used.

You can start in a number of different ways. Sometimes it is quite liberating to start with very little or even no underdrawing, for example. It's interesting to start a picture with a few subtle background washes so the picture is established in a broad way, before working in detail over the washes with pen and ink.

MAKING THE PICTURE

The inspiration for this work came from a photo taken on an atmospheric woodland walk. I found the photo while looking through my pile of reference material. There was dense autumn undergrowth, twisted trees and tangled branches. I wanted to create something that was not too literal – quite loose – yet something that would evoke the feeling of being there in that overgrown wood, deeply immersed in damp woodland with the smells, muted colours, fallen leaves and twisted branches.

I had investigated various possibilities in my sketchbook, first in pencil, then later with simple watercolour washes over a loose pen sketch. I was confident it would work large scale so I moved onto a sheet of A1 cartridge paper as a starting point. I wanted to retain some of the freshness and simplicity of the smaller sketch, so it was an experiment to see if I could capture its spontaneity in a larger work. That was the challenge. Sometimes a quick sketch can capture a lot of directness that doesn't always translate to a larger work: things can become too tight and tentative.

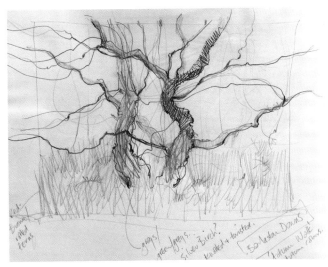

A small rough pencil sketch first enabled me to realize the potential of this busy picture. As I tried to figure out the complexity of the branches, I thought it would be a challenge to try a very loose painting to capture the feel of all the tangled branches rather than to try and draw everything. Sometimes a sketch can show potential at a small scale, which doesn't always translate to a larger scale.

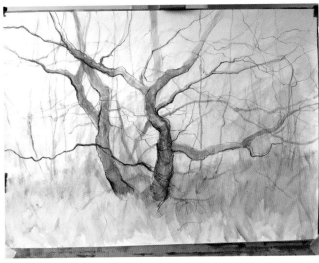

Early stage in the A1 painting clearly shows how the pale washes of acrylic have already established the intention. The tree is defined, some pen and ink drawing strengthens the lines of movement. The rigger has been used to draw in the thinner saplings and branches. Dilute washes of acrylic paint on paper can have the same appearance as watercolour.

When I am working on my preferred size of A1 paper, I like to stand at the easel so that I can move about when mark-making and can quickly step back to evaluate the work. While the drawing is securely attached to the board most of the time, it's easy to take it down from the easel to work flat when laying washes or drawing with a dip pen. Once dry I'll go back to working upright again on the easel. I can still apply washes while the drawing is upright on the easel and let them dribble downwards to add another element to the picture.

MATERIALS
Initial sketch and photo, 6B pencil, a range of synthetic long-haired flats, rigger, old toothbrush for spatter, old sponge, dipper pen, black acrylic ink, acrylic paints: burnt umber, burnt sienna, yellow ochre, sap green, French ultramarine, A1 sheet 260gsm cartridge paper.

INITIAL PREPARATION
The paper was clipped onto an MDF drawing board cut oversize to protect the edges of the paper. This allows the use of masking tape or strong clips to secure the paper as it responds to any buckling from the wet paint. I didn't stretch the paper, because after some initial buckling it usually flattens out once more layers of paint are applied: the paper gets heavier, becoming more waterproof and resilient.

METHOD
Step 1: I lightly sketched in the basic tree shapes, taking care with the position and scale.

Note: When you are scaling up, care is needed over the composition as everything is magnified. Some things that are insignificant at a smaller size may need some adjustment or adapting when enlarged.

Step 2: Once I was happy with the positioning and scale, I continued to draw freely and intuitively. Then the board was laid flat while I firmed up the drawing with the pen and ink. I continued to work expressively with flowing lines, trying not to worry too much about accuracy or detail. I enjoyed the freedom of responding directly to the movement of the tree. As this work was experimental I had no reservations about whether it would work or not – I was just enjoying the experience. It was a good subject to draw.

Step 3: Using a large flat synthetic brush, I painted thin, varied colour washes of pale red browns and orange browns (mixing yellow ochre, burnt umber and burnt sienna) that I thought would represent the died-back autumn forest floor. I then applied some pale washed-out greens (a base of sap green mixed with ultramarine and yellow ochre) to suggest a little distance.

Step 4: I created dark browns by mixing ultramarine with burnt umber, and worked this into the trees. I kept the paint quite diluted because I wanted an airy, open feel to the work, so I did a combination of layering darker paint over the dried paint or worked wet-in-wet. The trees started to appear more solid little by little. I tried to keep the brushwork lively. I then let the work 'settle' awhile.

Step 5: The picture had started to become more balanced with the addition of washes. But it was lacking texture and interest, so I decided to spatter different colour washes over the ground, using an old worn-out toothbrush, then started to suggest the branches. I did some sponge work as well. I was happy with how the effect was resembling the fuzziness of small leaves on the branches. Encouraged by this, I continued with the process by mixing stronger washes and spattering wet-in-wet. I enjoyed watching the wet paint move about and merge with the other colours.

Step 6: Painting is all about maintaining balance. If you work on one area and get carried away, the painting becomes unbalanced, so you work on another area to regain the balance. With this process in mind, I now needed to go back into the drawing with the pen and ink and strengthen up the trees, as they were getting lost. I added more branches and suggested texture for the bark.

Step 7: I then got out the flat brush and strengthened the tones and deepened the colour of the trees to create more solidity, then I used the rigger to draw in some of the smaller branches. I did the same with the pen and ink.

Step 8: The picture still lacked some depth and solidity in the foreground, so I painted the undergrowth with more solid colours. The flat brush had created angular, lively strokes to suggest movement and texture which I liked, so I continued alternating between line drawing with the pen and rigger, with broader areas of colour, until the imbalances within the picture were resolved.

FINALLY

Often, I am so taken with an image that I will produce several versions, interpreting it in different media. Sometimes just one version doesn't satisfy my expectations; I need to say different things about it. It's something of a personal challenge I often set myself – the possibility of producing a more effective response using a different medium.

With this train of thought pressing me to do another version, I decided on a small pastel on pastel card. I then find it interesting to compare the two pictures. I am equally satisfied with how both versions turned out – they are different, that's all. It's not always a question of which one is better; sometimes a picture gives out different messages, and they are equally valid.

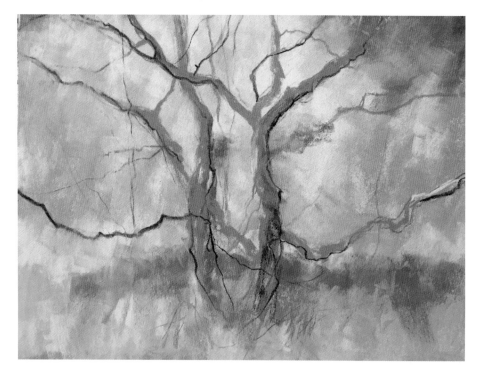

This small pastel was made after the large painting. It was also an interesting exercise to see if I could get close to the colours I mixed for the painting. Being so used to working at a larger scale in pastel, it was challenging to work in an impressionistic style at this small size (32 × 45cm). It was made with soft pastels on pastel card – I loved the warm grey and flat greens.

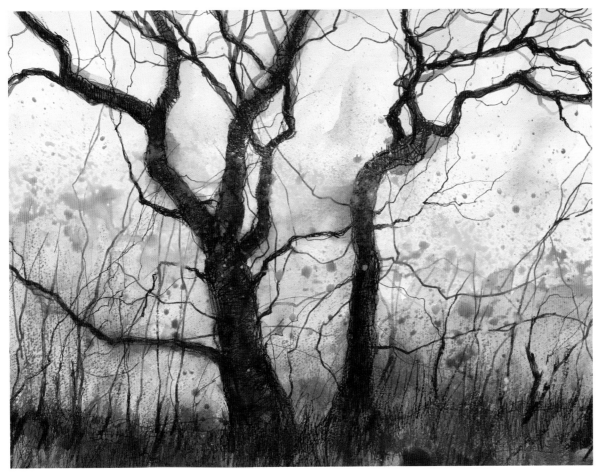

Two Trees in a Landscape, watercolour, pen and ink, oil pastels on watercolour paper.

IDEA

With this project, the intention was to produce an expressive landscape using a loose watercolour underpainting as a starting point. The inspiration was a small photo that I found interesting because it had a strong tonal contrast and was very busy, with lots of undergrowth and texture in the trees. I liked the rich dark colours and strong shapes, but I wanted a different feel and hoped for a picture that veered towards a semi-abstract approach, something that captured the rich earthy palette and also the vibrant energy of the trees.

My plan was to start off with minimal drawing – essentially just positioning the two main trees – followed by simple watercolour washes. I could then build up the layers with stronger colours – red browns, a variety of greens, yellows and blues. I wanted to enjoy watching this beautiful medium 'doing its thing' and creating a rich medley of colour and texture by pooling more concentrated washes and letting them run wherever they wanted. I would then focus on the drawing, using pen and ink to give structure to the main trees. I wanted to offset the looseness of the abstract watercolour washes against the detail and structure of the pen.

I wanted to capture the energy of the trees along with the rich autumn colour. But something not too literal, so I used the photo as a guide only, not as something to slavishly copy. Below I have described the process in detail, so that you can understand the methodology.

MATERIALS

Pencil, watercolours (a mixture of blocks and tubes), sheet of reasonably heavy watercolour paper, large watercolour brush for broad washes, smaller round watercolour brushes for detail work, No. 2 rigger, old toothbrush for spattering, small textured sponge, Daler Rowney FW acrylic inks: sepia, dipper pen, some small pots or palette for mixing washes, pastel pencils (I used dark brown and black), oil pastels.

Using the source photo as inspiration, I loosely sketched in the two main trees. Then, with a large brush I applied a pale blue wash for the sky and a mix of earthy colours for the undergrowth. This minimal colour work set the scene for the picture.

I didn't stretch the paper, although if it is your preference do it beforehand – then it can be secured to a board for the duration of the painting. I have my reference photo and small sketch as a guide.

METHOD

Step 1: Using the source photo as inspiration, I loosely sketched in the two main trees. Then, with a large brush I applied a pale blue wash for the sky and a mix of earthy colours for the undergrowth. This minimal colour work set the scene for the picture. I didn't stretch the paper because it was a relatively small sheet.

Step 2: After the first layer had dried, I strengthened the pencil marks on the trees with the pen and drew some lines to link the trees together at their base.

Step 3: I applied stronger washes and used extra water to help them flow into one another. I worked from top to bottom, using darker colours for the undergrowth. The picture was beginning to take shape.

Step 4: I rested the picture while I considered where to go next. I then defined the trees further with a dark brown pastel pencil, and used the rigger to draw some branches and smaller details with diluted watercolour.

Step 5: On reflection, I thought I had overdone things and gone too dark with the washes, particularly with the trunks of the trees. I think the reason for this was that in the original photo the trees were almost in silhouette, but I didn't want the picture to appear too heavy and lifeless. However, I continued drawing some interesting branches, and used the pen in a controlled way, moving around the picture to keep it balanced.

Step 6: Although I wasn't happy with the picture at this stage, I was determined to make it work, so I decided to spatter some brighter colours – yellows and greens – over the top of everything. I thought that this would balance some of the heavy, dark areas and give the picture a lift. I laid the picture flat on the floor and using the same yellows and greens, laid thick washes allowing the colours to pool together, giving the picture an overall lift.

Step 7: I felt the picture was rescued to some extent. The strong yellows and greens worked well with the dark tree shapes. I spattered some of the green to suggest falling leaves. It looked much more vibrant now.

Tip: It's good to have a spontaneous approach with a picture and follow your instincts, but with a work like this the watercolour needs to dry out and settle down between stages. If you just carry on laying in wash after wash, the result can be muddy and flat. It's not a bad idea to work on a couple of pictures at the same time so you can alternate between the two.

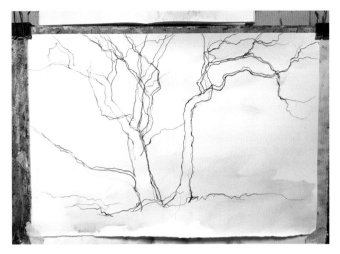

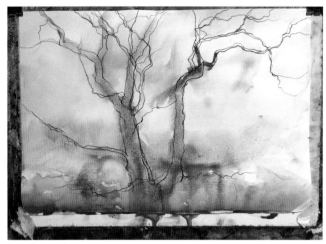

After the first layer had dried, I strengthened the pencil marks on the trees with the pen and drew some lines to link the trees together at their base. The pen lines only loosely follow the pencil marks – I wasn't looking for exactness. It all added to the impressionistic feel of the picture. The paper was bowing slightly due to the washes.

I applied some stronger washes and used water to help them flow into one another wet-in-wet. I worked from top to bottom, using darker colours for the undergrowth. The picture was beginning to take shape.

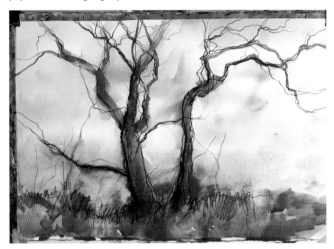

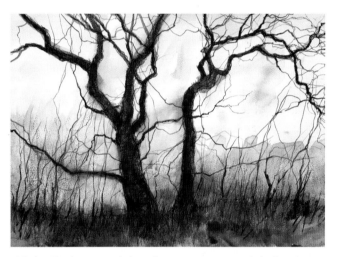

After resting the picture to let everything settle down, I defined the trees further with a dark brown pastel pencil, and used the rigger to draw in some branches and smaller details with diluted watercolour.

I felt that I had gone too dark on the trees; care was needed otherwise they would appear too heavy for the rest of the picture. However, I left them alone at this stage while I continued adding branches and undergrowth. It would be a problem I would try to resolve later.

On reflection, I decided to leave the trees as it would be difficult and messy to lift out – instead, I considered adding more vibrant colour to counterbalance. This certainly gave the whole picture a lift. Often a bold approach can save a picture.

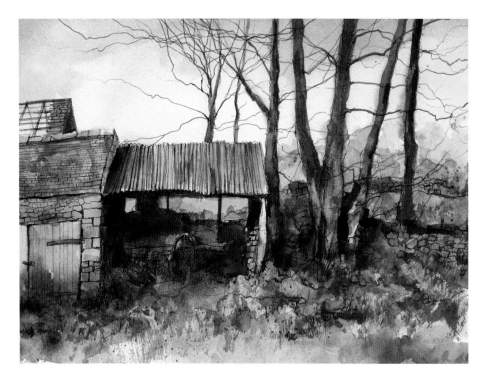

Abandoned Moorland Farm, watercolour and mixed media on NOT 300gsm watercolour paper, 38 × 57cm. This picture was hanging around unfinished for a while in a folder waiting for attention. I would come across it, look at it but was at a loss as to which direction I wanted it to go, so put it away again. I liked the feel of the abandoned stone outbuildings with the drystone wall – everything seemed to be co-existing in harmony. Much of my work progresses in stages – sometimes with a lot of time in between.

INSPIRATION

An old reference photo of some derelict farm outbuildings taken during a wet walk in the Peak District had many interesting features. I liked everything about this picture: the drystone walls and the collapsing stonework in and around the building. The corrugated-roofed lean-to housed some old farm machinery, which was only partly visible in the deep shadows. The tiled roofs had sagging timbers and missing tiles. The undergrowth softened the transition between building and ground, creating soft blurry edges. It had a lot of died-back vegetation, creating a busy carpet of colour. But my focus would be the buildings and their relationship with the trees, so I would have to find a way to suggest the grass and undergrowth without being too literal in translation.

I had previously done a large A1 portrait-format charcoal drawing from a similar image, then rediscovered the photo later and thought it had a lot of potential for a work in colour. Sometimes, changing the medium can create a completely different feel to a subject.

MATERIALS

Sheet of NOT heavyweight watercolour paper 38 × 57cm, watercolours, pencil, pen and ink, various watercolour brushes including a rigger, an old toothbrush for spatter, a sponge for texture, oil pastels.

METHOD

Step 1: I did an underdrawing in pencil on watercolour paper, taking care with the positioning of the shape of the barn in relation to the trees. I inked over some of the main lines, concentrating on the building and the drystone wall, but not the trees. For the trees I mixed a pale wash and tried not to overdo things by putting in too many branches too soon. Once dry I mixed some weak washes of watercolour and laid them loosely over the drawing, allowing wet-in-wet mixing. I enjoyed the quality of the heavyweight paper, as the colour soaked into it.

Step 2: I reflected that the drawing was too heavy for the watercolour, so the washes could now be stronger.

Step 3: With pen and ink I put more detail into the stonework. This is very addictive, and care was needed not to get carried away and draw every stone. I enjoyed working on the corrugated roof. Because this particular paper was heavily sized, I found that some of the ink marks would bleed a little if the pen was too loaded. I mixed some green and brown washes and applied these to the undergrowth with spatter from the toothbrush and flicked paint with the large flat brush to build up interest and depth. With richer colours and darker shadows, the painting gained more depth.

Step 1: This is what the painting looked like when I rediscovered it. My first job was to get re-acquainted, so I strengthened the watercolour washes. There was already a sound underpainting, although on reflection I didn't much care for the green I'd originally used.

Step 2: I felt much happier now that I'd done some more drawing. It wasn't detail as such, but it gave markers for shadow areas and colour changes.

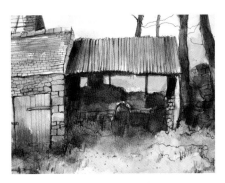

Step 3: Detail shot of the barn shows more pen and ink drawing. I worked on the stonework, the old tiled and corrugated roofs, and the sagging door. This gave me some structure so I could apply more paint. I liked the precision of the pen and the looseness of the paint working together.

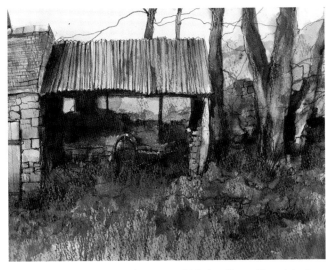

Step 4: This close-up shows the way in which the oil pastel has picked up the texture of the heavyweight watercolour paper. I particularly liked the olive green oil pastel on the dark grey shadow areas. I applied some strong red colour to old farm machinery hidden in the lean-to. I was beginning to really enjoy the picture now. Care was needed not to overdo the oil pastel; it needed the colour underneath to be effective.

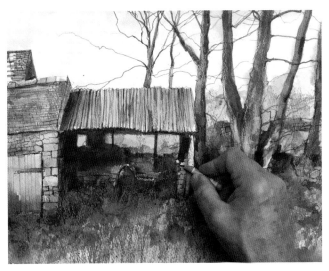

Step 5: I used the oil pastel mostly on the foreground foliage, which was going to be treated in a semi-abstract way. I wanted the focus to be the buildings and trees – the middle of the picture – but the stonework and corrugated roof needed texture too, so a delicate touch was needed. If the whole painting had the same treatment it would defeat the object. It needed to be subtle.

Step 4: I alternated between drawing with the pen and applying watercolour to maintain an equilibrium. I had the idea to highlight the old machinery in the barn with some opaque red watercolour.

Step 5: At this stage the painting was looking reasonably complete, but I felt it needed more texture. This particular watercolour paper had a wonderful surface and it would have been a shame not to exploit it in some way, so I worked some oil pastels into the foreground to bring out its texture.

CONCLUSION

Compared to the previous charcoal and pastel version (not illustrated), I found this smaller version of the same subject more challenging. It was intended to be a loose experimental response to the subject and I enjoyed working at two extremes: loose washes of colour combined with tight pen and ink drawing.

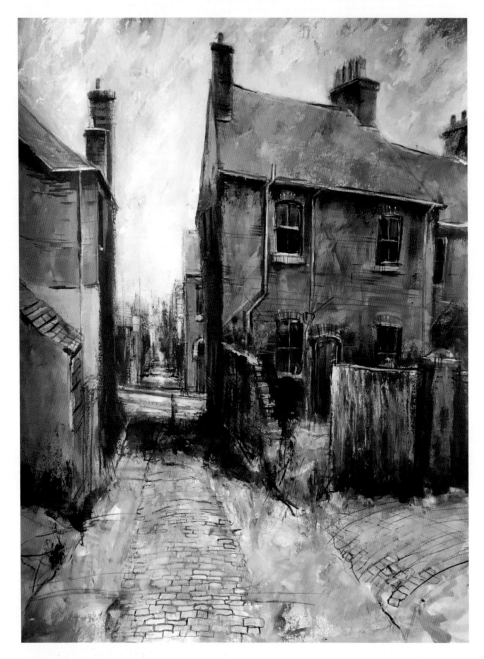

Potteries Memory: Alleyway, acrylic paint and acrylic inks on A1 heavyweight cartridge paper. The finished painting was, for me, a satisfying balance of painting and visible drawing. Painting in acrylics on paper works for me because initially, even though you might be drawing on top of paint, the surface still retains the feel of paper. I like the way the ink drawing can be modified with the paint.

INSPIRATION

Continuing my ongoing theme of abandoned buildings, I find the shape and style of terraced housing always interesting. There are cobbled rear alleyways providing access, decaying sash windows often painted in sombre or garish colours, and a varied selection of outbuildings that originally served as an outside WC or a coal store. Chimney pots in all shapes and sizes sit atop tall chimneys, curved brick arches frame back doors and windows. The brickwork at the back of the house used cheaper, inferior quality bricks in various colours and textures. Smoother, more consistently coloured red brick was used for the fronts. These were cheaply built houses but they have huge character.

The picture illustrated here was chosen for its off-centre composition. I also liked the interesting negative shape of the sky, which cut right down between the houses and around the chimneys and roofs. The street sloping downwards created a further off-kilter feel to the picture.

I had already produced many sketchbook studies at different times of this subject, having photographed it at

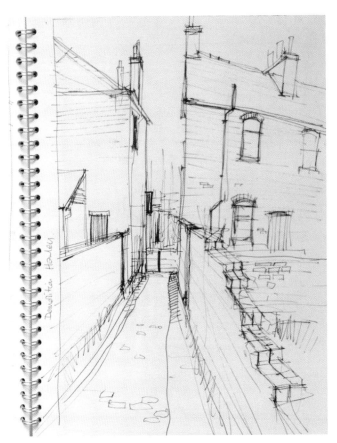

Step 1: Like a lot of my paintings, it all started with at least one or two pencil studies in the sketchbook. Until I drew it, I didn't believe how steep the lines of perspective were. I liked the dramatic converging lines in the lower half of the picture.

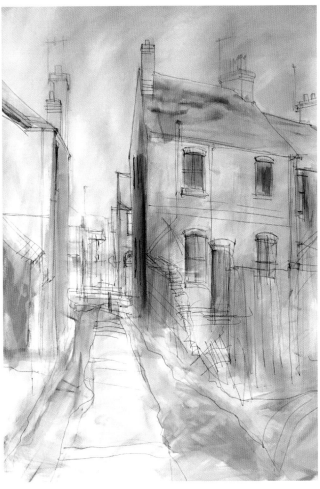

Step 2: For me this is an exciting stage in the making of a picture, and I work at speed to arrive here. The drawing was well established and the whole surface has had acrylic washes laid over to seal in the drawing. Everything was flexible though – things could be moved and adjusted. Making adjustments is an important part of the painting process, otherwise it is just painting by numbers.

various stages of demolition. When you draw something over and over again, you really start to get familiar with it – you start to see rhythms and make compositional improvements and formulate ideas on what to focus on.

MATERIALS
Sheet of A1 300gsm cartridge paper, acrylic paints, selection of flat brushes including a rigger, painting knife, acrylic inks, dipper pen, permanent pigmented drawing pens and markers, pencils.

METHOD
Step 1: I drew the picture directly from the photo. I didn't want a tight, exact 'architectural' drawing, so was happy to have some 'wobbly' lines, as long as the verticals remained reasonably vertical. I love this early stage in a painting where everything is fluid and things are being worked out and adjusted.

Step 2: Some thin acrylic paint was washed over the drawing, effectively sealing it beneath this thin transparent waterproof layer.

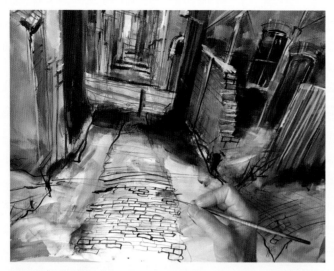

Step 3: In this close-up more layers of opaque paint have been added – rich red browns, and darker mixes for the shadow areas. It was important to link the two houses with the shadow that ran across the cobbled alley and up the sides of the houses. I'm using a rigger to draw some details on the cobbles with diluted paint – it makes thicker lines than the pen.

Step 3: Stronger washes of paint were added, freely mixing raw umber, burnt sienna and burnt umber to get varied effects on the brickwork. The dark shadow across the cobbled floor of the alley linked the two buildings. Further shadows were added to the bottom of the walls. For the windows, I opted to make them dark to give more depth and mystery. Sometimes window reflections can be lighter depending on the direction and strength of the light source – the sky and the sun. Now the painting needed some drawing to pull everything together. I used pen and black acrylic ink, and a rigger for thicker and more flowing line work.

Step 4: There were many interesting textures in the brickwork and woodwork to explore. I did some dry brushing with an old stiffish bristle brush and was happy with the effect on the fence in the right foreground.

Step 5: I wanted to make a painting that was sympathetic to the subject, and felt that more texture was needed, so I used a palette knife to scrape thin paint over a lot of the surface of the picture. I found I was able to blur edges this way, particularly where the sky met the buildings.

CONCLUSION

It's difficult to know where to stop with a painting like this; the danger is just to keep adding more and more detail. The main challenge was with the brickwork. I aimed for a balance between putting every brick in and just putting a few bricks in and suggesting the rest.

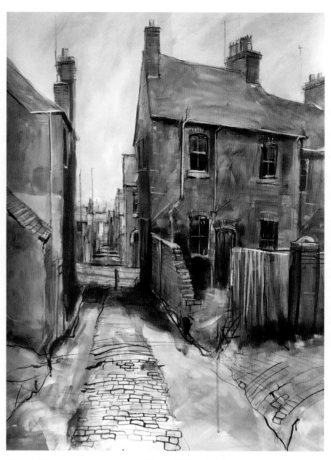

Step 4: The painting was now well established, with stronger colour. Some areas have had more layers and look more finished. It needed more work on the cobbled alley to achieve a better balance. I've used black and white acrylic ink to define architectural details. It is a sound underpainting.

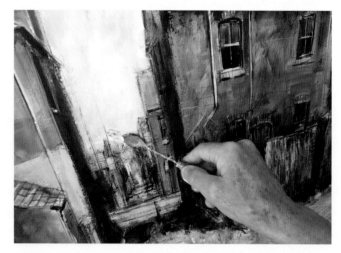

Step 5: I wanted the treatment of the surface of the painting to reflect the semi-derelict subject matter. I tried some dry brushing with a bristle brush and stiffer paint, which worked on the gate, but I wanted more texture in the large flat areas of the sky and the main house. I found that a painting knife gave the sort of surface I was looking for. I also used it to soften edges.

LANDSCAPE IN PASTEL ON PAPER

INSPIRATION

Always looking to expand my ongoing theme of treescapes, I was taken with this group of three tall trees. The vertical format would accentuate the height of the trees while allowing some space to work on the undergrowth. I always enjoy building up colour for texture for the grass, fallen leaves and branches that fall on the forest floor. I prefer trees in late autumn or winter when they are mostly devoid of leaves and their intricate branch work is exposed. Their true character is then revealed.

One of the reasons I chose this picture was because it had a featureless, colourless sky that showed off the trees to good effect.

My preferred way of working is to stand at the easel with a robust piece of MDF as a drawing board with the paper firmly clipped in position. My reference image is usually pinned to the left side of the board at eye level.

Tip: Working with pastels can be messy. I made a 'catch tray' to prevent stray pastel dust falling to the floor, taped to the bottom of the board. I also have a dust sheet laid down on the floor under the easel.

MATERIALS

Selection of pastels – the pastels I used for this project are of the 'harder' sort (that is not the soft artists' quality type which need more tooth than cartridge paper, which is not specialist pastel paper), pastel pencils, fixative, kitchen roll, A1 cartridge paper.

Note 1: There is a lot of choice with pastels, ranging from student to artist quality, and pastel papers and card that come in a range of different colours and textures. A lot of pastellists prepare their own customized surfaces designed to best work with their practice.

Note 2: Some artists choose a paper colour to contrast with the colours of the painting.

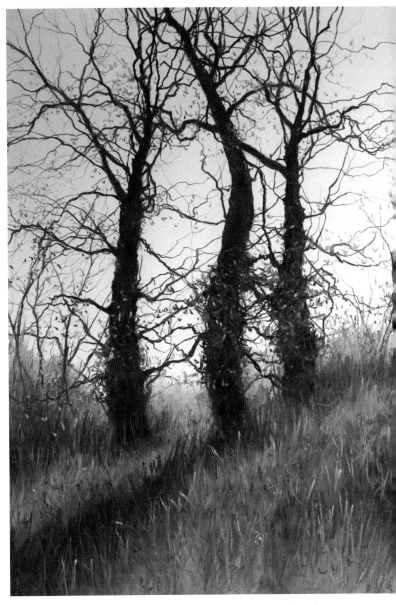

Three Tall Trees in Autumn, pastel on A2 paper (finished work). I've altered the shapes of the trees and added more branches. I worked some dark greys into the undergrowth to give more solidity and depth, before I could add more texture with various browns and greens. After applying fixative to the picture, more texture and detail can be added.

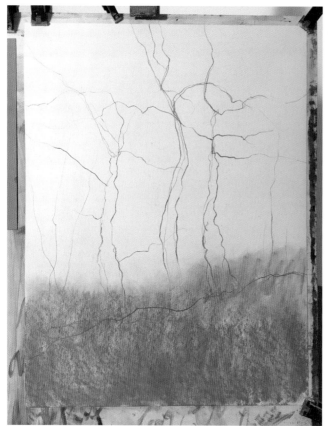

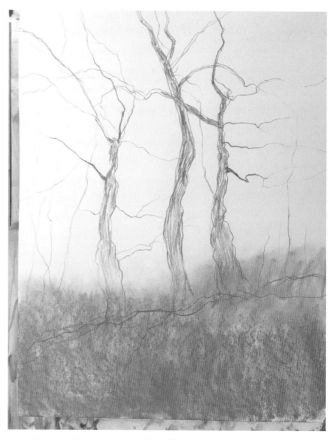

There is a layer of pastel covering the whole sheet of paper – white on the top and green on the bottom. I used a white pastel stick on its side and, starting from the top, covered most of the paper down to just below where I planned the green undergrowth. Next, I did the same thing with the green, starting from the bottom up, to where I visualized the horizon line. I kept a soft transition between the two. Once the horizon line was established the trees could be positioned in outline.

I continued with the pastel pencil to 'fill in' the outlines of the trees so I could judge if they were too thick or thin, and also if the relationship between them worked. I was reasonably happy with the positioning of the three main trees. It would be difficult to adjust the shapes later as the lines would show through the white pastel of the sky.

METHOD

Step 1: I lightly sketched a guide line for the horizon using a light-coloured pastel pencil. Then, taking a white pastel and working top to bottom, I covered the whole sky area to just below the guideline. Using fingers and a tissue, I pushed the pastel into the paper, trying to ensure an even coverage, then I took a mid-green pastel and did the same for the base. I mixed a little mid-brown into this for variety. The whole sheet of paper was now covered with pastel – the first layer. I then fixed the white area because the trees would be drawn on top of this layer, and the pastel pencil would pick up too much of the white, making it difficult to then continue drawing.

Step 2: I visualized where the three trees would be, and used a light grey pastel pencil to draw the outlines of the main shapes.

Step 3: Once I was happy with the relationship between the main three trees, I sketched in some of the smaller saplings so I could judge how everything would work together. I then used the pastel pencil to 'fill in' the trees. I had more control doing it this way, even though it didn't give much solidity yet.

Step 4: Taking a dark grey pastel, I carefully worked over the trees. I moved onto the ground and worked more greens and browns into it, blending with my fingers. This took a few layers to achieve solidity and the more layers and colour, the better it looked. I tried a few scribble marks to suggest grass and undergrowth.

Step 5: My objective with a picture is always to try and maintain a certain equilibrium, so that at whatever point I pause or rest, it is reasonably well balanced. With this in mind I moved back down to the undergrowth and started to suggest some of the underlying undulations in the topography: little rises and falls that caught light and shadow, but were softened by the texture of the grass.

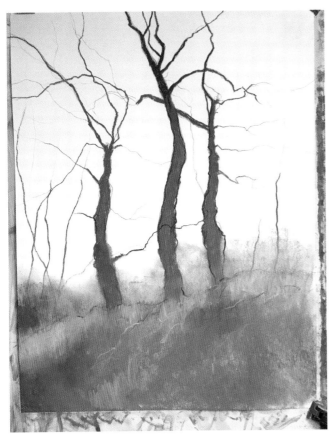

Next stage was to create more solidity with the trees and also the undergrowth. I carefully worked over the pastel pencil marks on the trees with a dark brown pastel, using a finger to gently push it into the paper. I applied more greens, browns and greys to the undergrowth and was pleased with the suggestion of variation in the topography. The foliage in the distance was starting to develop.

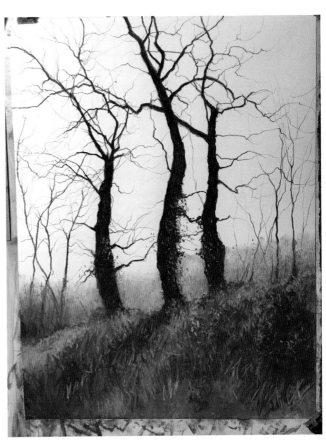

I kept going with the undergrowth, making it bolder, and started to develop the texture of the grass – it was beginning to work as a grassy bank. I continued to work on the trees adding more texture, and also some of the smaller branch work. I introduced some smaller saplings for interest, too.

Step 6: With a landscape, the trees need to be 'planted' and be part of the land. There is always some shadow at the base of a tree and around the roots, whether exposed or not, and they create changes in colour.

Step 7: I built up texture and interest in the undergrowth: a lot of layering, then adjusting, followed by putting in detail with the corner of the pastel or with pastel pencils. I used the pastels to make various marks, dotting into the surface with one colour, then another.

Step 8: At this well-developed stage, all the big decisions had been made so it was a question of building up layers of texture and refining the trees. There was a lot more work to be done in the undergrowth – adding more colours to create a thick carpet of fallen leaves while still maintaining the form

of the ground beneath. The picture is really about the trees, so refining these – adding small branches, falling leaves, and tweaking the shapes – is the focus during the closing stages. (*See* start of this section for finished work.)

CONCLUSION

Pastel seems the perfect medium to capture landscape. It is capable of a versatile range of effects, from subtle washes to delicate line work. If you are new to pastels, I think you need to allow plenty of time to get used to them. Some people take to them straightaway and handle them well from the outset – not minding the dirty hands or the dusty environment. Others like the effects they give but can't get on with them. They are worth exploring because the effects and control can vary greatly depending on the type of support or ground you choose and also the quality of the pastels.

This work is smaller than my usual A1 preferred size, so I found it a little more difficult working to this smaller scale.

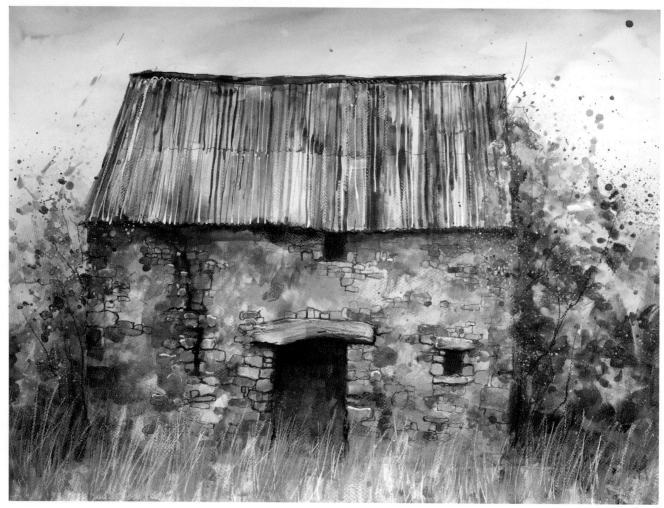

Old French Barn, watercolour and mixed media on NOT watercolour paper, 50 × 70cm.

BACKGROUND

While travelling through France for an exhibition a while ago, I came across a number of old derelict stone buildings and fascinating oak doorways – great subjects. Old doorways have so many interesting features: peeling paint, tarnished door furniture, decaying wood, collapsing masonry and so on, so for me they are ideal subjects to draw and paint. I was unable at the time to do a more finished work so took photos, but when I looked at them later, the memory of the place came flooding back and, in the studio, I enjoyed having the time to examine and extract much more detail from the photo. Having explored a number of similar images through small sketchbook studies, and larger drawings on paper, I settled on a few that especially interested me.

There was much of interest to draw in the area, especially for someone who is obsessed with characterful buildings. There were the faded blues, reds and browns of weathered paintwork, split and aged sun-bleached oak frames, little infill areas of red brick and cobbled stone pavements, worn steps and super bits of ornamental detail.

There was a host of options regarding appropriate media to capture all this inspirational subject matter: possibly the use of a single medium would be too restrictive? Should I capture everything with acrylics, or pastels? Would it need a combination of two or three different materials to do it justice?

All this experimentation started to create a body of work that formed a collection of different ideas that when viewed

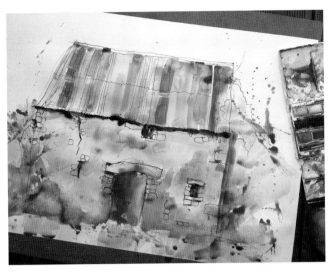

Step 1: After an initial pencil drawing followed by pen and ink to strengthen the lines, some pale washes of watercolour were applied. I was determined to set the direction I wanted the picture to take from the beginning – a loose impressionistic style – so I continued by spattering paint onto the surface. This would ensure that the painting did not get too 'tight'.

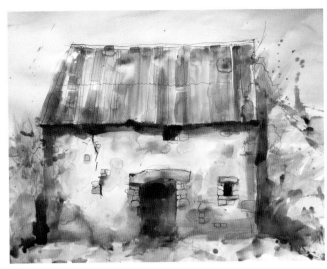

Step 2: The washes were strengthened, shadows were formed – but in several places the washes didn't work out very well. There was some wayward spatter in the sky and pooling of washes on the roof and sky.

as a whole suggested other avenues of exploration. In other words, the works started to bounce off one another to create new ideas. I ended up producing an (ongoing) series of large pastels, some pen, ink and watercolour studies, a lot of sketchbook studies and small acrylic paintings which became a personal diary, a memento of a visit.

So this painting is part of a larger body of work in different media. It would be nice at some point to bring all the works together to see how the series fits together.

INSPIRATION
What struck me about this building was its isolation and neglected state. The addition of a corrugated iron roof that had rusted created oranges and reds that contrasted with the vertical shadow lines that described the undulations. The yellow stone combined to great effect with the rusting reds of the iron and the green of the surrounding grass. Add to this all the crumbling masonry and the absence of mortar between the stonework, and it was a subject just crying out to be painted. I hoped I could do it justice.

IDEA
My idea was to produce a reasonably sound pencil drawing, over which I would lay some loose watercolour washes, lovely natural ochres and browns for the stonework, red browns for the roof and various greens and browns for the grass, and a pale washed-out blue for the sky to give the impression of a hot day. I would need some strong shadows around the base of the building to give it weight and depth.

The challenge was to keep variety in the washes, so some were paler, some stronger, to give tonal variation. I didn't want the work to look too heavy and dark. The colours in the wall needed to be more varied than they actually were to give it more texture. There is a fine line between the urge to put in every stone and to make just enough suggestion to make it 'read' well.

MATERIALS
Sheet of NO1 300gsm watercolour paper 50 × 70cm, watercolours, brushes including a 10mm flat, a rigger and an old toothbrush for spatter, dipper pen and acrylic ink, drawing pens, oil pastels.

METHOD
Step 1: Using the photo for reference, I sketched out the building with a 2B pencil onto the sheet of watercolour paper. With the large flat brush I laid some weak washes of watercolour over the building and ground, flicking some of the green for interest.

Step 2: With the sepia acrylic ink, I started to firm up the drawing around the main structure but couldn't resist drawing some of the stonework. I also put in some of the vertical lines of the corrugated roof.

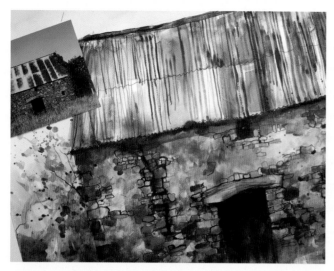

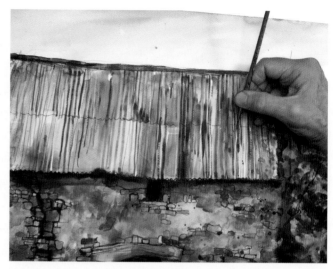

Step 3: Looking more closely at the reference photo led to some detailed drawing with pen and ink for the stonework and detailed painting for the corrugated roof and foliage. The picture was looking stronger.

Step 4: Here I'm using the rigger for some line work on the corrugated roof. I also used the rigger to apply texture to the foliage and put variety in the stonework.

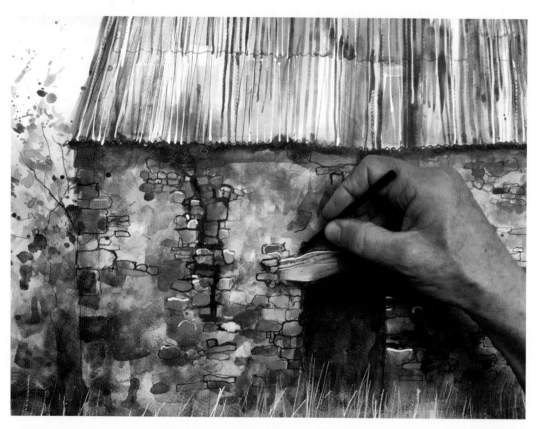

Step 5: I felt the whole picture was getting heavier and heavier – care was needed to keep a variety of tones otherwise the picture would be overall too dark. I used a mapping (or bow pen) with white ink to draw detail and add highlights in the roof. I also suggested highlights on some of the stones.

Step 3: Ensuring the ink was dry before continuing, I mixed some stronger washes of watercolour and added interest in the stonework. This set the scene for the painting and made sure it didn't start to get too tight. I encouraged the paint to merge wet-in-wet and softened off the edges. I continued with the stronger washes and added darker shadows under the eaves of the roof, the doorway and windows, and around the sides of the building at the bottom.

Step 4: To restore some balance, I did some more pen and ink drawing, and added details with the rigger.

Step 5: On reflection, I thought the picture had strong colour with detail and interest but lacked highlights, so with white ink I drew into the corrugated roof and the stonework.

Step 6: At this stage I needed a new direction with the painting – I was just adding more and more layers and the picture wasn't going anywhere. I thought it needed more texture but applied in a different way, so thought of doing some spatter with different colours. This softened off some of the harsher lines.

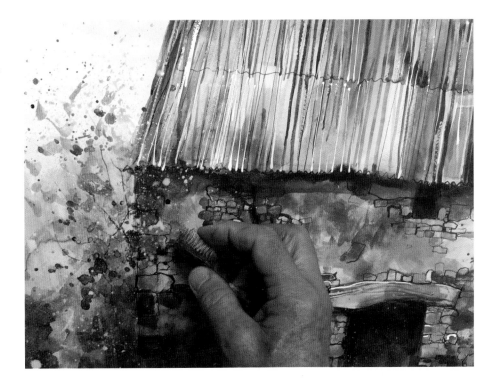

Step 7: There was no plan of action for this painting. I didn't set out to use this particular medium followed by that in a particular order. I introduced something different when I felt that something wasn't working. Towards the final stages, it definitely needed a lift – by way of more texture, both in the building and the undergrowth beneath. I grabbed some oil pastels and started to lightly work over the painted surface with a contrasting colour – with just enough pressure to let the textured watercolour paper show through.

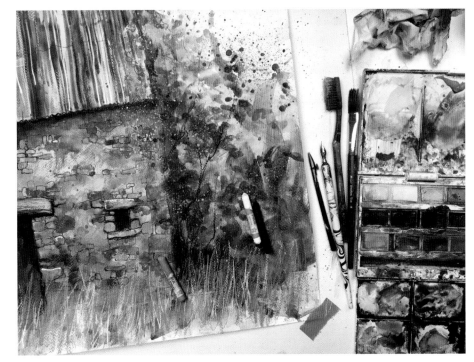

Step 6: There were now many rich washes of colour in the building, but I felt it was still lacking texture. The painting was not progressing well through just adding more watercolour. I resolved this by doing some fine spatter with the toothbrush, and used an oil pastel to pick out the texture of the paper, which worked well for the stonework.

Step 7: Finishing touches amounted to adding more spatter with the toothbrush on the trees, and adding texture and detail on the grass in front of the barn with oil pastels. This softened off the edges of the building.

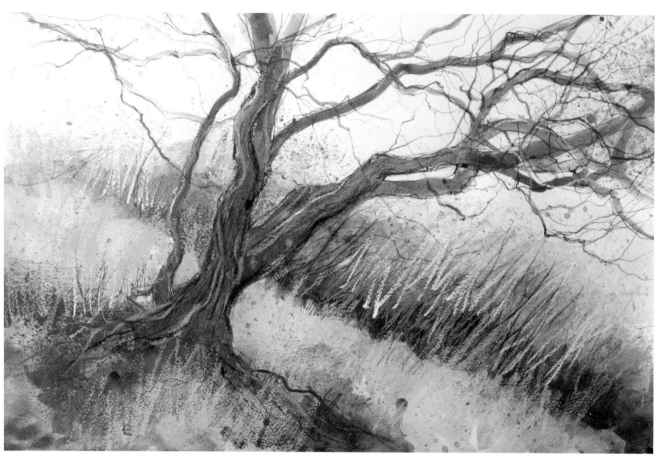

Windswept Tree, watercolour, pen and ink on A2 NOT watercolour paper.

What excited me about this image was the dramatic angle of the exposed, windswept tree against the hillside. The tree formed one diagonal and the hillside formed an opposing one. The challenge was to capture this directional movement and also the fantastic flowing texture of the long grass, creating a sort of 'X' motif. For me it is one of those images that is so powerful and has so much interest that it becomes a bit of an obsession to find the best way of expressing all this movement.

I wanted to try one or two different versions in different media to see if one worked better than another. I had already started a large drawing using tinted graphite, but was moving along too slowly because of all the detail. I wanted to try a large pastel to see the differences in each. This small work would give me some understanding of how to proceed with a larger work in terms of colour and texture.

MATERIALS
Watercolours, selection of brushes (I used a favourite large flat, a smaller round and a rigger), dipper pen and Daler Rowney FW sepia acrylic ink, sheet A2 NOT watercolour paper 300gsm (unstretched), oil pastels, pastel pencils.

Step 1: The start of the painting was a brief positional sketch to place the tree where I wanted it. I wondered if the crop was too tight – but then thought that it was primarily a tree study, so it needed to have a good scale and prominence.

Step 2: The next step was, naturally, to strengthen the drawing with some sepia pen and ink, then lay some earthy-coloured wet-in-wet washes.

Step 3: Another layer of washes strengthened the tree and its connection to the land. The washes were applied quite freely.

METHOD

Step 1: With the pencil I sketched in the main tree shape and the steep angle of the hillside.

Step 2: I followed by inking over the pencil marks, trying to keep the lines flowing, to echo the angled tree. Making sure the ink was dry, I mixed some pale brown and green washes and blocked in the tree and hillside.

Step 3: I then rested the picture for a while to allow the colours to settle down before going back and working in some stronger and brighter washes to build up layers and add interest.

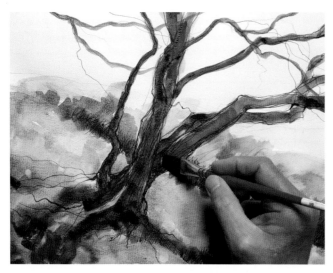

Step 4: Layer by layer and step by step, the painting got visibly stronger. Some pen and ink detail on the bark was followed by darker shadow coloured washes. Yellowy greens were added in the grass.

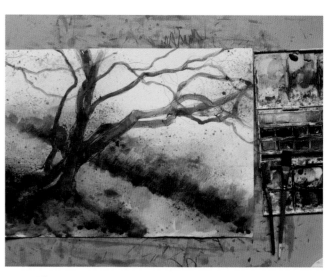

Step 5: The picture was looking quite finished but had too many 'empty' areas. I didn't want to paint the leaves conventionally, so I spattered some greens to suggest falling leaves and to add interest.

Step 4: I inked in some textural marks, suggesting the bark of the tree and the long grass. I added more washes to create depth and contrast.

Step 5: The next stage was to work into the darks to add solidity to the tree and shadows on the ground around the roots. I thought everything was looking a bit too flat, so decided to add interest and texture by spattering some colour wet-in-wet. Some of the lighter green spatter marks suggested leaves on the tree at the top of the picture.

Step 6: I left the sky unpainted to give more contrast to the picture. On reflection I wanted more texture in the undergrowth and tree. I finished off by adding some marks with oil pastels to give more texture, followed by pen and ink and pencil to add more detail by the addition of small branches.

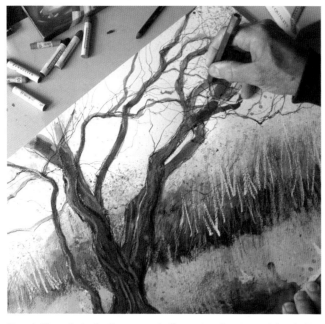

Step 6: Towards the final stages and after resting the picture, I decided it needed more texture, so I used oil pastels to suggest the windswept grass. I added more branches to support the leaves.

MAKING A MONOPRINT

The complete unpredictability of the monoprint means it can be a rather hit or miss affair. But the more you do, the more you are able to predict the outcome. Of course, unpredictability makes it fun and exciting and it can produce some amazing results.

If you are trying monoprinting for the first time, it is worth doing a batch of prints – more than you need. They will all be slightly different, and some will work better than others. The weaker, less successful attempts can be overprinted to give a second or even third layer. A flat surface is needed to make the prints and store them until dry.

The starting point of the print can be purely abstract: try selecting some interesting colour combinations, let them mix and blend on the surface and take a print. Or try a loose underpainting based on the image you are using. The corresponding print will then be a mirror image, so if the intention is to continue developing the image the right way round, the whole picture needs to be painted mirror image so the print is correct.

WHAT IS A MONOPRINT?

Essentially a monoprint is a simple print process that creates a unique version: no two prints will be the same. Any ink or paint can be used: watercolours, acrylics, oils. Any paper can be used, but the results will vary depending on its absorption and textural properties. Specialist printing inks and papers will give stronger, more consistent results.

Depending on your expectations, you can use the print as an end in itself. You can overprint it many times, or you can use it as a base on which to develop a drawing or painting.

There are many interpretations as to exactly what constitutes a monoprint. Essentially it's a method of producing a print where there is only one direct way of transferring paint from one surface to another. No two prints will look the same.

THE PROCESS IN BRIEF

A painting is made on an impervious surface such as a sheet of safety glass or Perspex/acrylic. A clean sheet of paper is then laid on top of this and rubbed down either by hand, roller or printing press. The paper is carefully peeled back to reveal the transferred painting. Once this has dried it can then be used as an underpainting or as a starting point to a painting or drawing. Further printing can be made on top of this.

There will probably be only enough paint or ink on the surface to make one 'pull', so the painting on the glass or Perspex will need to be refreshed before any subsequent printing can be done. The glass can then be cleaned and another painting made, followed by further printing.

The effect is an interesting starting point to a work. It requires a certain imaginative input as the results can be quite abstract. Some artists look at the print before making a decision regarding subject matter. It can be very flexible.

I think the process works particularly well with landscape because it can create effects that are unique and cannot be replicated by hand. It is interesting to let these effects show through in the finished work.

Mixed media work is all about using a specific medium and exploiting it to get the best out of it, so that the final result is very different in appearance from a work produced in a single medium. With the monoprint technique you will have an underpainting that can form the basis for a more precise drawing over the top.

EQUIPMENT AND MATERIALS

The materials list can be improvised. It is just a guide – and by no means elaborate – but is designed to give you reasonable results so you can see its potential.

Materials: A sheet of tempered safety glass, Perspex or acrylic sheet; ensure there are no sharp edges. Anything with a surface that is flat, non-porous and wipes clean easily will work. A printing roller, rolling pin or similar. Some paints or inks – choose water-based colours for environmental and health and safety reasons. For example, System 3 Acrylics offer a range of mediums that transform their paints for different uses. I have successfully done printing with the tempera blocks as used in schools; although these are not particularly lightfast, they are fine for experimenting with. Various brushes. Kitchen roll. Plenty of scrap paper for trials. Some sheets of your chosen paper for printing: heavyweight cartridge, watercolour paper, dedicated printing paper and so on. Water container.

Note: Try to get everything together first and mentally run through the process (do a dry run first) before starting so that time isn't lost searching for a missing item or finding there's nowhere to put your wet prints. Once you start printing, the process needs to flow uninterrupted. As soon as you have paint on the glass, you need to print straight away because it will dry out quickly.

For this demonstration, I am using simple watercolour blocks. I have my water container, brushes, paints, Perspex sheet and paper. I have enough flat space to put finished prints.

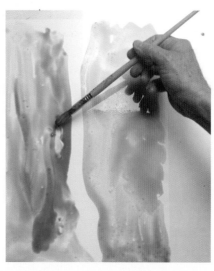

To show the process, I'm just painting a simple generic landscape in blues and greens. After this initial print, adjustments can be made to paint strength. Until the first print is made, it is an unknown quantity.

Here I'm just about to lay a sheet of watercolour paper over the painting.

The paper is sitting on top of the painting and I'm smoothing it out by hand.

Peeling back the paper to reveal the print – it's quite thin at this stage. Next step would be to recharge the painting with stiffer paint.

Shown here are the painting on the Perspex and the peeled back print. I am not entirely happy with the result, but I will use it as a background for a drawing. Next step would be to recharge the painting on Perspex to make it stronger.

A clear work surface is needed that is suitably protected. Lay the sheet of glass or acrylic on top of a sheet of white card or paper so you can see the colours of your painting clearly. To the side of the glass have your palette of paints, brushes, rollers and pile of clean paper. You will also need some flat space to put your wet prints to dry.

METHOD

Step 1: Choose an image to base your print on or just paint freely onto the Perspex sheet, enjoying different colours mixing together in an abstract way. Paint the image onto the glass.

Note 1: The resulting print will be mirror image.

Note 2: If you mix the paint fairly stiffly you will get quite a strong pull, but it may not print onto the paper well. If you paint a watery wet-in-wet style, you will get a paler impression. The paler the print, the more you can develop the subsequent drawing or painting, or you can overprint it again and again. One of the attractions of this technique is its lack of precision and unpredictability. The absorbency of the paper will affect the outcome.

Step 2: If you are using watercolours or acrylics you will need to act speedily as the paint will dry out quickly on the glass surface. But if this starts to happen it can be refreshed.

Step 3: Take the sheet of printing paper and carefully lay it over the painting. Gently smooth it using the palm of your hand, then use the roller to apply a more even pressure. Carefully peel back the paper and lay it down to dry. Assess the print for coverage. If there are areas that are missed, refresh the painting and take another print.

Note: Sometimes it takes a couple of 'pulls' for the process to start working properly. The more you do, the better they get.

Step 4: Make more prints than you need so you have more to experiment with. Remember, if you are using watercolour it will naturally dry lighter. Be prepared to waste a few sheets of paper. You will need one or two spares, and you can always save them for use with future projects.

That's about all there is to it. The next stage is deciding how to develop the prints. You may have produced a print that works in its own right and doesn't need any more work, but the idea is to do some further input: some extra drawing or painting to develop an image.

DEVELOPING A PAINTING OR DRAWING FROM A MONOPRINT

Materials: Pencil, watercolours, brushes.

Method: Having loosely based my monoprint on a landscape, using blues to suggest sky, and greens and browns for the ground, I then used a reference photo on which to base the drawing. I painted more layers over the print, then developed a drawing that would work it to best advantage. This is not a rigid process, rather one of adapting and working with what the print suggests. It is a question of 'reading' the monoprint, 'seeing' the potential and then going along with it, making something that is sympathetic and balances the qualities of the print with drawing and painting to produce something different.

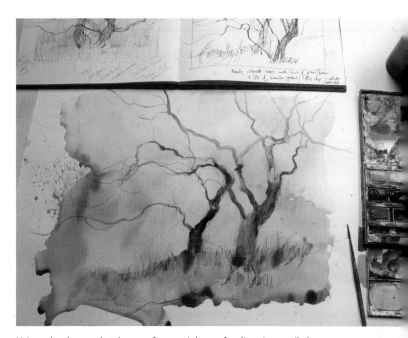

Using a landscape sketch as a reference, I drew a few lines in pencil, then used watercolour to develop the trees. I will wait for this to dry and settle before deciding how to proceed. I would like to keep the watercolour edges to the picture if possible, so will work with the print.

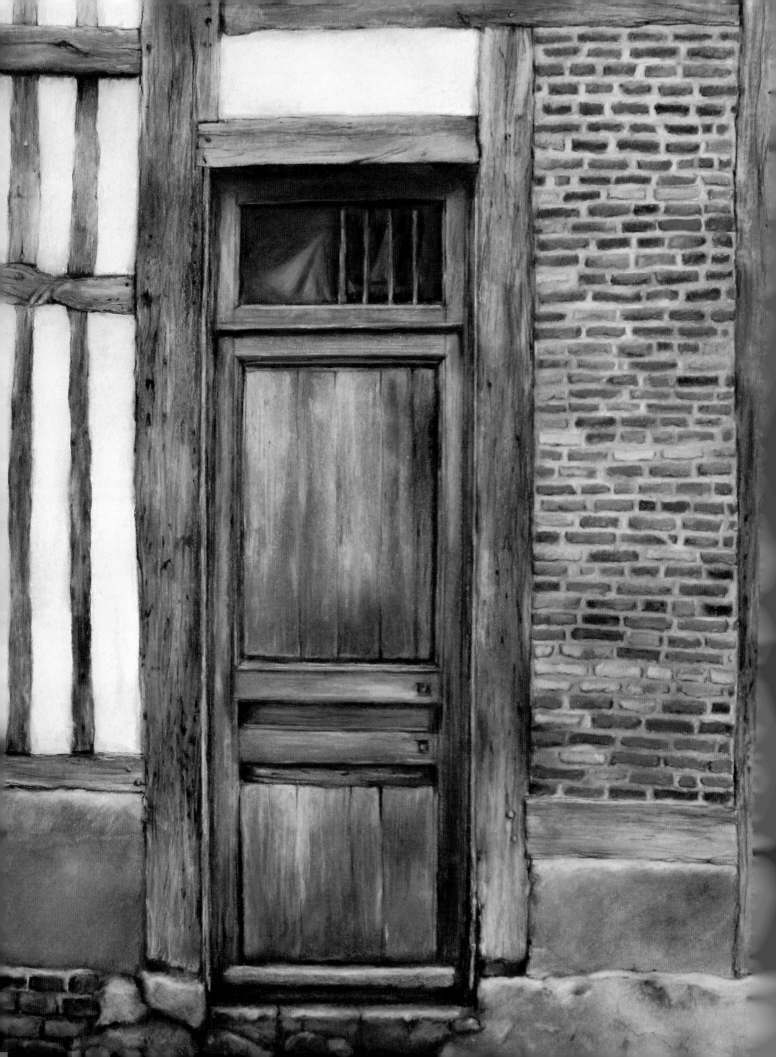

PRESENTING YOUR WORK

f you have been working for any length of time producing drawings, paintings, sketches and ideas, you will have built up a collection of works on loose sheets of paper, card and so on. This work will certainly have a personal as well as potential commercial value, and will form an interesting and visual point of reference, as well as building a portfolio to present to clients, galleries, agents and so on. After investing a lot of time and effort as well as money to produce your work, it is logical to protect and store it safely until the time comes to sell or frame it.

As soon as you start to build a body of work, it will become apparent that you need an effective way to store and archive it. Loose drawings can very quickly become dog-eared or damaged if they're left lying around. Wet paintings and drawings need to dry out thoroughly before being stored either temporarily or on a more permanent basis. Drawings in graphite, charcoal and pastel need to be protected for their own sake and also anything that is placed on top of them.

Work in progress needs to be accessible for the next session; finished work needs protecting from accidental damage prior to being framed; works awaiting framing need special care.

The beauty of producing works on a heavyweight cartridge paper is that it is a relatively cheap surface to work on. Certainly, the vast majority of my own archive comprises works on paper. This has meant that a lot of experimental techniques and ideas have been extensively tested on paper, which I buy by the pack. Naturally, most of this work is of no value as it has served its purpose as a test bed, but some of it will still be of personal value if it marks a fundamental shift in process or style. Such key examples are important records of an artist's developmental stages and, as such, are worth saving. There's something really satisfying about pointing to a work knowing that it was the start of a new path or approach.

This is about treating your work with care: it has great value in terms of your personal development.

◀ *La Vieille Porte (The Old Oak Door)*, detail, pastel on A1 paper.

Here are a couple of prints that have been window-mounted ready for signatures and labelling. They will be wrapped in cellophane to protect them until sold.

Presenting, storing and archiving your work

People work at different paces; it doesn't matter how quickly or slowly you work. Some people are naturally prolific and during a life drawing session, for instance, may produce ten or twenty drawings; over the weeks that is a lot of drawings. Some people spend a lot of time preparing and making sure each stage is controlled, and so work at a slower, more considered pace. There is nothing wrong with either approach; everyone is different. Obviously, the more prolific you are, the more you need an efficient storage solution.

My own collection of drawings got out of hand when for a long period I attended life drawing sessions and generated hundreds of works in graphite, charcoal, pastel and paint; over time it grew into a big storage problem – and a heavy one. Often, while the work is fresh it seems exciting and you rate it highly, but months later, compared to the work you are then currently doing, it can seem inferior. So regular self-editing is always a good idea, otherwise it seems like a mountain to climb. But there will still be a selection of drawings that you will want to keep.

Differing views

Some artists are quite content to keep producing work on a regular basis because they enjoy it. They do it for relaxation and personal development but have no desire to exhibit or otherwise show their work. There is absolutely nothing wrong with this. I know many very talented artists whose work is of a very high standard, and as much as I encourage them to get it framed and entered in an open competition, they are just not interested – for any number of different reasons. Personally, I think this is a waste of talent: good art deserves to be seen by a wide audience.

It is a big step from producing work for your own enjoyment, interest and development, and getting work ready for exhibition, which requires a lot of time, effort and expense. Choosing a frame, framer, and physically getting the piece to a gallery to exhibit, the cost of entry fees, transport, insurance and time involved all need to be factored in. Entering a competition takes effort, skill, luck and organization – work needs to be delivered, a private view needs to be attended and unsold work needs to be collected. So, at least three journeys are involved, which is sometimes just too much extra effort on top of producing the work in the first place.

No matter what your objective is – you still have to store your work.

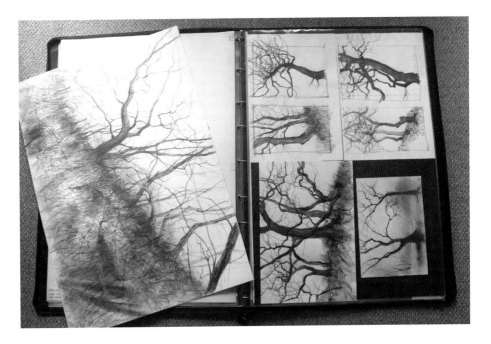

I have a number of these A1-size portfolios with punched plastic sleeves and black paper inserts for displaying smaller work for presentation. It has a zip closure with carrying handles and shoulder strap. It is a robust portfolio that is an excellent way of transporting several drawings from A to B.

Archiving

When I had a huge pile of drawings that had built up over years – it was occupying an ever larger amount of shelf and floor space, and the floorboards were creaking – I realized that something had to be done. It was just too chaotic to try to find a particular drawing and also the sheer weight of the pile was doing damage to some of the more delicate works such as charcoal and pastel.

Most of the work was A2 size, so I invested in several A2 presentation wallets, each one containing twenty clear plastic sleeves, inside which two drawings could sit back to back, so each book could hold forty drawings. It was cathartic to go through the process of selecting works, discarding the ones I didn't want to keep and then grouping works together according to subject.

I quickly learnt by trial and error that graphite, charcoal and pastel drawings needed to have a protective layer (such as tracing paper) before being inserted into the sleeve, otherwise the surface would offset onto the inside of the wallet through pressure and static.

I now have several of these books, all titled and numbered. The drawings can be viewed easily by flipping through the pages. It is very satisfying to see drawings presented in this way, but it took a lot of time to do it retrospectively.

There are many professional archival systems available, depending on personal choice, budget and space.

Portfolios

The professional zipped and transportable portfolio is great for taking a selection of drawings to show to clients or galleries and for storing work. They hold punched plastic wallets with black paper inserts; these are available to buy separately, so the book can grow with you. They are available in many sizes, for drawings from A4 to A1, and are quite robust, offering good protection for your work. The downside is that they get heavy as they fill up and need to be stored upright.

This style of portfolio or folder is a fairly universal way to present your work, and offers scope for creativity in showing. For example, a group of small drawings can be adhered to the insert with double-sided tape for display.

At the very least, a simple card or plastic college-type folder is essential to keep your works in progress as well as your finished works safe. I have many of these categorized for different subject matter. I always cut extra sheets of card to give more support. They need to be stored upright.

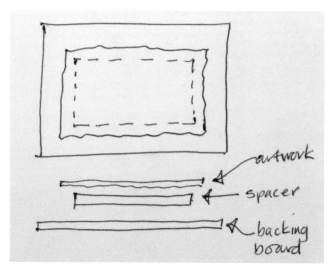

The diagram shows the principle of a float mount, where the artwork is fixed to a spacer smaller in size. The thickness of the spacer can vary according to the amount of shadow you want to create. The spacer is in turn fixed to a backing board, then the 'sandwich' can be framed according to your usual choice.

Framing works on paper

Works on paper need to be framed behind glass (glazed) for exhibition. There are many ways to frame a drawing or painting on paper; it doesn't have to be the traditional mountboard window mount.

Glass or acrylic

Some offer UV protection; there are non-reflective options; differences in weight and fragility. Some galleries stipulate museum-grade glass, which can add considerable costs to your framing. Some galleries will not accept frames with non-reflective glass.

Window mounts

The conventional and most common way to present drawings is to cut a bevel-edged undersized window in a sheet of mountboard and fix the drawing behind this, along with a backing board. The three components are inserted in a glazed frame. Variations on this are the thickness of mountboard, which can be super-thick and therefore offer a more dramatic surround, or double or triple mounts which involves cutting a progressively smaller window with each sheet.

The window mount method separates the surrounding frame from the work, giving it air.

Floating mount

The drawing is fixed (glued) onto an undersized piece of mountboard or similar, which has in turn been fixed to the backing board. The glass is then spaced out to give clearance to the drawing. When viewed through the glass, the drawing appears to 'float' in the space behind the glass, casting a shadow in the process and creating a more interesting presentation.

This method works especially well with a drawing or painting on paper that has a deckled or uneven edge.

If the drawing is on a thin piece of paper, it can be dry-mounted onto a piece of card to give more support, before in turn being fixed to a raised mountboard carrier.

This method also gives space around the work so it is clear of the frame.

Framing without a mount

Some pastellists cut the frame the same size as the work itself, then insert a spacer between the glass and the picture so that the glass stands clear of the work. From the front, the view is of the picture next to the frame. Pastel work will often shed dust or fragments that will collect at the bottom of the mount or frame. Some mounts allow the debris to collect behind it, hidden from view.

Larger works with custom hangings

Some artists, having produced a really large work on paper (for example, bigger than two metres), will, for reasons of weight and other considerations, fix the work to a lightweight but strong backing board, then cut a piece of clear acrylic to the same dimensions and use chrome bolts and spacers to fix the whole thing together. Such a system is not completely enclosed, so will be prone to gathering dust. The acrylic acts as a shield to protect the delicate paper from the front only. This is a contemporary way to frame but requires maintenance.

Note: Apart from the obvious necessity to protect relatively delicate works on paper behind glass when framed and hung, there are other considerations: the effects of daylight, and especially bright sunlight. Care should be taken when choosing where to hang a work on paper as extremes of heat or cold may cause stretching or condensation issues, and strong UV light may have an effect on the materials used, causing them to potentially fade. This is certainly true with watercolours as they rely on their transparent qualities for brightness and luminosity. Thinly

pigmented washes will fade over time as light hits the paper and the process will be accelerated if exposed to too much sunlight.

Thankfully, for many years now, papers and mountboards have been manufactured acid-free, so the risk of yellowing and other degrading of the materials making them brittle and fragile has been greatly reduced. The unsightly brown discoloration of a once-white bevel-cut edge on an old window mount is a thing of the past today.

Canvas or board

Your drawing may not be on paper, of course. It might be on canvas or board as part of a painting, and as a result may not actually need a conventional frame. So long as the drawing is protected behind a layer of varnish or clear medium so that it can be wiped and cleaned, then it is essentially the same as a painting that has a varnished surface.

Mounting work for potential sale, or display

Even if you have no immediate intention of exhibiting your work, you may have produced drawings that are quite special and need protecting until the time comes for framing. It is certainly worthwhile to have a mount cut, add a backing board and sandwich the drawing between the two, then wrap in cellophane to protect the package. When the time comes, you just need to order a frame. In the meantime you have a well-presented piece that can be stored easily and safely, or presented for sale.

Seek professional advice

Unless you possess excellent framing skills, I would certainly advise that you seek the opinion of a professional framer. They will look at your work objectively and have the experience to suggest ideas to display your work to best effect.

Some artists prepare their own mouldings and frames, and personalize them according to the feel of the picture. Others choose the same moulding for everything they do. It's very much a personal decision. Then of course, the collector buying the work may have a view on what the best frame choice might be for a particular picture, and may discard the frame you have fitted.

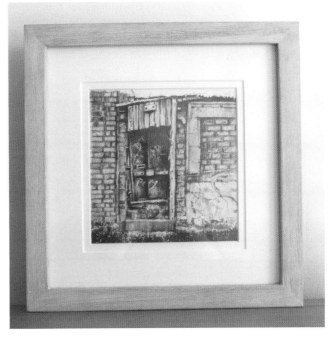

An example of a small pencil drawing that has been double-mounted and framed in a light oak frame that is durable and sympathetic to the work. I find choosing a frame one of the most difficult parts of the picture-making process. In the case of this work, it was a stipulation of the exhibition that all the frames were the same, so it took away any decision-making on my part.

I think framing is one of the most difficult parts of producing works of art. I have often chosen frames on the basis of holding a small corner against the picture, thinking it would look good, only to be disappointed on collecting the framed picture.

Thankfully, there are now computer programs that simulate a frame and picture so at least you can have some impression as to what the final picture might look like. Some can even place your picture in a room setting.

Finally

This chapter is not meant to offer a quick, one-size-fits-all solution to presenting work. The intention is to get you to think about the best ways to store your work safely that suit your own situation, and to think about showing off your work to its best advantage.

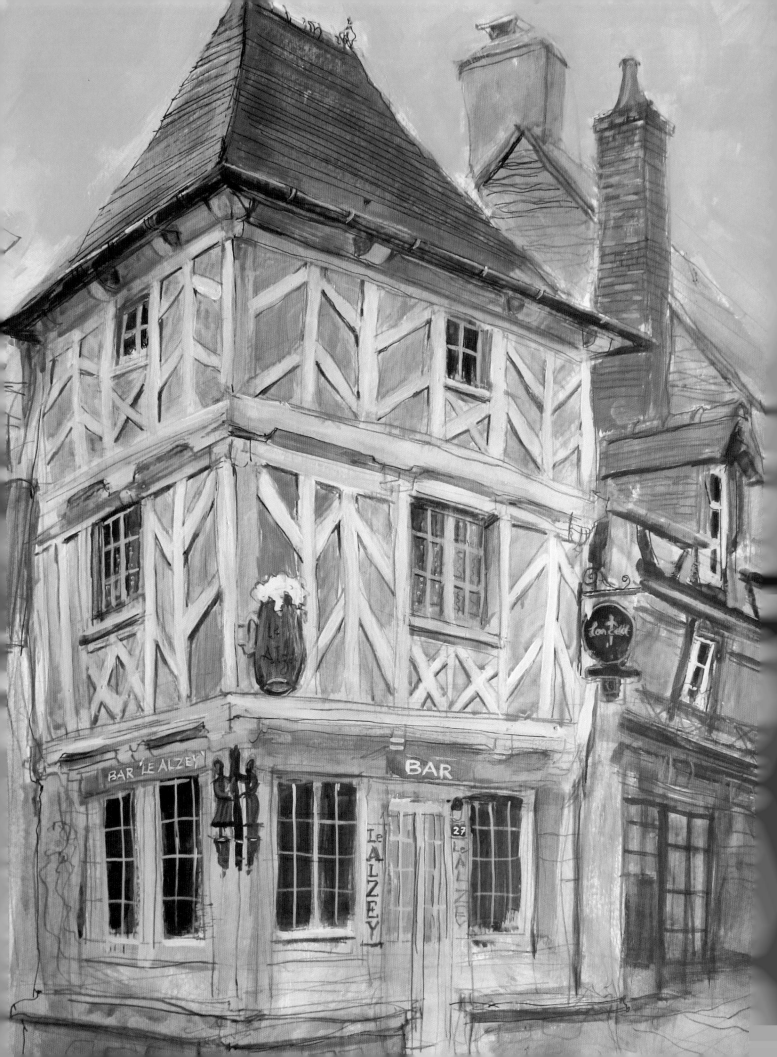

CONCLUSION

hope that you have enjoyed reading this book and have found it informative and stimulating. Its purpose is to impart knowledge and share experiences, and my aim has been to encourage and inform artists of all abilities to go further through experimentation and exploration of different ideas and media – to push themselves.

An artist's life is one of work. We are always working towards something: working for a forthcoming exhibition; working on a new body of paintings; working on research, gathering resources; working on a commission, and so on. I believe that art can be enjoyed by everyone.

As I have maintained throughout, this is not meant to be a definitive reference book. The information contained in these pages reflects my own experiences through the many drawings and paintings I have produced over the years, whether for exhibition or my own personal development. I have tried to be objective when giving preferred choices – but essentially if something has worked for me then I have shared it. If it hasn't worked, I have shared that too.

I wanted to give you glimpses of my own particular journey of discovery through a range of experiences (projects) so that you can take time to immerse yourself in the successes and failures I have encountered along the way. You may subsequently appreciate that it is through your own experimentation and experiences that your skills and ideas will progress.

I hope I have given you the confidence to try new things and not to get too hung up when things don't turn out as you hoped. It is what you learn along the way that's important.

Keep referring to the many illustrations for inspiration, and for words of encouragement and advice. Enjoy your artistic journey.

Happy drawing for many years to come…

◀ *Bar 'Le Alzey' (Yellow House)*, Josselin, France, acrylic on A2 paper.

SELECT BIBLIOGRAPHY

John Constable
Baskett, J. (1972). *Constable Oil Sketches* (third ed). Barrie and Jenkins, London.

David Hockney
Stangos, N. (ed., 1976, 1979). *Pictures by David Hockney.* Thames & Hudson.

Gustav Klimt
Metzger, R. (2005). *Gustav Kilmt: Drawings & Watercolours.* Thames & Hudson.
Koja, S. (2006). *Gustav Klimt: Landscapes.* Prestel.

Henry Moore
Henry Moore Foundation (2001). *Complete Drawings 1940–49, Volume 3.* The Henry Moore Foundation in association with Lund Humphries.
Henry Moore Foundation (1994). *Complete Drawings 1977–81, Volume 5.* The Henry Moore Foundation in association with Lund Humphries.
Compton, S., with contributions by Cork, R. and Fuller, P. (1988). *Henry Moore.* Royal Academy of Arts, London, in association with Weidenfeld & Nicolson, London.

Egon Schiele
Steiner, R. (2000) *Schiele* (2000). Taschen.
Nebehay, C. M. (1989) *Egon Schiele Sketch Books.* Thames & Hudson.

Georges Suerat
Herbert, R. L. (1991). *Suerat.* The Metropolitan Museum of Art, New York.

J. M. W. Turner
Warrell, I. (2014) *Turner's Sketchbooks.* Tate Publishing.

Euan Uglow
Abbot Hall Gallery (2003). *Euan Uglow: Controlled Passion [en] Fifty Years of Painting.* Abbot Hall Gallery, Kendal.

Vincent van Gogh
Ives, C. *et al.* (2005) *The Drawings.* The Metropolitan Museum of Art, New York, and the Van Gogh Museum, Amsterdam.
Skea, R. (2013). *Vincent's Trees.* Thames & Hudson.

RECOMMENDED MATERIALS AND SUPPLIERS

Recommended materials

Caran d'Ache Neocolor water soluble
 sticks, pastel pencils
www.carandache.com/gb/en

Conté à Paris charcoal pencils
www.conteaparis.com/en

Cretacolor 'lead' holder and range of
 6mm leads
www.cretacolor.com/en

Daler Rowney FW Acrylic Inks,
 System 3 Acrylics, oil pastels, soft
 pastels
www.daler-rowney.com

Derwent pencils, graphite sticks, XL
 Graphite Blocks, XL Charcoal,
 Derwent Drawing pencils, pastel
 pencils, erasers, tinted charcoal
 pastels
www.derwentart.com

Faber Castell pencils, graphite sticks,
 mechanical pencil, pastels
www.faber-castell.co.uk

Golden acrylics
www.goldenpaints.com

Jakar battery eraser
www.jakar.co.uk

Liquitex Acrylics
www.liquitex.com

Nitram liquid and powdered charcoal
www.nitramcharcoal.com

Pastels Girault soft pastels
www.pastelsgirault.com

Pentel mechanical pencil, drawing
 pens
www.pentel.co.uk

Rembrandt soft pastels
Available from www.cassart.co.uk

Rotring Art Pen, mechanical pencil
www.rotring.com

Schmincke soft pastels
www.schmincke.de/en

Seawhite fixative, cartridge paper
www.seawhite.co.uk

Sennelier soft pastels, oil pastels
www.sennelier-colors.com

Staedtler pencils, erasers, clutch pen-
 cils, mechanical pencils
www.staedtler.com

Terry Ludwig soft pastels
www.terryludwig.com

Tombow mechanical erasers
www.tombow.co.uk

Unison soft pastels
www.unisoncolour.com

Uni-ball Eye waterproof/fadeproof
 drawing pens by Mitsubishi Pencil
 Co. Ltd
www.uniball.com

Winsor & Newton acrylics, acrylic
 mediums, watercolour
www.winsornewton.com

Recommended suppliers

Cass Art
www.cassart.co.uk

Jackson's Art Supplies
www.jacksonsart.com

INDEX

Index of paintings by the artist